TYPOGRAPHY 14

TYPOGRAPHY 14
The Annual of the
Type Directors Club

WATSON·GUPTILL PUBLICATIONS
NEW YORK

First published in 1993 by Watson-Guptill Publications, a division
of BPI Communications, Inc., 1515 Broadway, New York, N.Y. 10036

The Library of Congress has cataloged this serial title as follows:

Typography (Type Directors Club [U.S.])
Typography: the annual of the Type Directors Club.—1—
New York: Watson-Guptill Publications, 1980—
v.ill.; 29 cm.

Annual.
ISSN 0275–6870 = Typography (New York, N.Y.)
1. Printing, Practical—Periodicals. 2. Graphic arts—periodicals.
1. Type Directors Club (U.S.).
Z243.A2T9a 686.2´24 81–640363
AACR 2 MARC-S
Library of Congress [8605]

Distributed outside the U.S.A. and Canada by RotoVision, S.A.,
Route Suisse 9, CH-1295 Mies, Switzerland

Manufactured in Italy
First printing, 1993

1 2 3 4 5 6 7 8 9 10 / 98 97 96 95 94 93

SENIOR EDITOR	Marian Appellof
ASSOCIATE EDITOR	Dale Ramsey
DESIGNER	Mark van Bronkhorst
PAGE MAKEUP	Jay Anning
PHOTOGRAPHER	Michael Newler
PRODUCTION MANAGER	Ellen Greene

Contents

Chairperson's
Statement

Mark Solsburg

Founder and president of FontHaus Inc., Mark Solsburg has been in the graphic design business for more than 14 years. His formal education began in 1971 at Arts & Crafts in Detroit, Michigan; he received a B.F.A. in drawing, and a B.F.A. and an M.F.A. in painting from Michigan State University. He has worked as an art director, design partner, and teacher, and was a freelance designer and design consultant as well.

Before launching FontHaus, a computer font reseller, development house, and type foundry, Solsburg was the worldwide marketing director for International Typeface Corporation, in New York, from 1985 to 1990. He was elected to his position on the board of the Type Directors Club in 1990, and he holds memberships in the New York Art Directors Club, the American Institute of Graphic Arts, and Association Typographique Internationale.

What made this year's show remarkable?

—other than the high quality of the work submitted and chosen?

To begin with, the competition reflected a truly international community. It was encouraging to see so many entries from so many different corners of the world: we received designs from 19 countries. The largest group was from the United States; coming in second and third were Germany and Japan, respectively. To a certain degree, these were predictable showings. Seeing entries from such countries as Malaysia, India, and Slovakia, however, was not so predictable— in fact, it was truly remarkable.

My belief is that the technology of type on the computer and the ECONOMY of setting type on the computer has actually provided more designers in more cultures than ever before the opportunity to express their ideas graphically.

It was remarkable, too, that the issue of "computer type" was absent this year—finally. In recent years, so-called computer type was enough of an issue to influence a juror's opinion and ultimate decision to include or reject work. It was believed that if type was generated on a Macintosh, it was inherently bad. Nonsense! We have finally realized that it is not HOW type is being set so much as WHO is setting it that really matters. In the wrong hands, any type—in any medium, for that matter—hurts the invention.

In a very short time, the computer and the computer designer have come a long way. Both the technology and the user have matured, as is evident in the pieces submitted and selected. Designers have learned how to manage type like typographers and to integrate type in graphics that inspire the imagination. Unencumbered by categorizing the work according to how it was created, the jurors this year were free to focus on more important issues like excellence in design and communication. The work selected for the 39th Type Directors Club show is not only of the highest quality, it is free of technological prejudice.

Also remarkable was the number of video entries. We received 36 videocassettes to judge, three times what we received last year. Clearly, type has become a new and very powerful element for the television advertising industry, which more than ever uses type to capture, inform, and entertain audiences.

All in all, it was a privilege to chair this year's competition. Not only was it a pleasure to work with the jury of dedicated professionals, it was a privilege to be part of an event that sets standards and ultimately influences the look of design for the future.

Judges

David Berlow

David Berlow entered the type industry in 1978 as a letter designer for the respected Mergenthaler, Linotype, Stempel, and Haas type foundries. In 1982 he joined the newly formed digital type supplier, Bitstream, Inc. In 1989 he left Bitstream, and with Roger Black he founded The Font Bureau, Inc., which has since developed more than 100 new and revised designs for custom fonts for publications such as THE CHICAGO TRIBUNE, THE WALL STREET JOURNAL, ENTERTAINMENT WEEKLY, ESQUIRE, ROLLING STONE, and for Apple, Microsoft, and Hewlett-Packard.

Berlow is a member of the Type Directors Club and the Association Typographique Internationale.

Ed Cleary

Born in England, Ed Cleary was educated in London. He began his career as an advertising typographer, and in 1971 he formed Filmcomposition, a high-quality type house with which he was involved until 1984.

In 1986 he moved to Canada to establish The Composing Room as part of Cooper & Beatty, then North America's largest typographer. In 1991, he was involved in forming FontShop Canada, the North American arm of the international font retailer and developer. Cleary is now president of The Composing Room, Cooper & Beatty, and FontShop, which are now independent of their former parent.

In addition to many typographic design awards he has won in Europe, Cleary has been awarded the Ben Franklin Award from Printing Industries of America, and for his poster for the Type Directors Club show he received the International Silver Award from the Designers and Art Directors Association of London—only the second typography silver award ever given by that organization. He has served as a board member on many typographic and art directors clubs both in England and Canada.

Cleary has written widely for graphic and typographic publications throughout Europe and North America and is acknowledged for both his girth and his humor.

Greg Leeds

A graduate of Beloit College and the Boston Museum School, Greg Leeds began his career in publication design as an art director at the alternative newspaper THE REAL PAPER, in Cambridge, Massachusetts. He has also worked as an art director at THE NEW YORK TIMES, GEO, and PEOPLE magazine.

Leeds became the design director of the daily WALL STREET JOURNAL, where he re-designed the paper from two sections to three and designed the start-up of THE WALL STREET JOURNAL REPORTS. Currently, he is the Special Projects design director at the JOURNAL, in New York City, heading a team that works on longer-term design- and tech-nology-intensive projects. In 1992, he directed the development of a new body text for the JOURNAL.

Leeds has received numerous awards, including awards from the Society of Publication Design, the Society of Newspaper Design, the New York Art Directors Club, and COMMUNICATION ARTS magazine.

George Pierson

Design director of HBO's Creative Services department for the past 11 years, George Pierson has also overseen projects for HBO's sister service Cinemax and for the parent com-pany, Time Warner, Inc. During his tenure, Creative Services has received more than 600 design awards—many of them gold and silver—including awards from the Broadcast Designers Association.

Pierson has worked as a graphic designer, as well as an art director, for Hallmark Cards, ABC-TV, WNBC-TV, and NBC. He currently serves as a trustee to Ringling School of Art in Sarasota, Florida. He also paints and is a researcher into the creative process.

Kathleen Tinkel

A type-loving graphic designer for decades, Kathleen Tinkel is editor and publisher of the weekly fax newsletter MACPREPRESS. She writes and gives talks on the effects of desktop computers on typography, design, and electronic prepress.

Tinkel's "Graphic Eye" columns appear monthly in STEP-BY-STEP ELECTRONIC DESIGN, and she writes for MACUSER, MACWEEK, ALDUS MAGAZINE, STEP-BY-STEP GRAPHICS, and other graphics and computer publications.

Carol Twombly

Carol Twombly became interested in type while working on her B.F.A. in Graphic Design at the Rhode Island School of Design. She received a master's degree from Stanford University, where she studied in the digital technology program under Charles Bigelow. She later joined the Bigelow & Holmes studio as a typeface production assistant and graphic designer.

In 1984, Twombly won first prize for a roman typeface in the Morisawa Typeface Design Competition; it has been licensed and released as Mirarae. In 1988, after working as a freelance typeface and graphic designer, Twombly became one of the designers of the Adobe Originals under the direction of Sumner Stone.

Twombly is the designer of the Adobe Caslon typeface family and the Trajan, Lithos, and Charlemagne display typefaces. She co-designed Myriad, the first sans-serif multiple master typeface, and Viva, a multiple master display typeface.

Mark van Bronkhorst

From an early age, Mark van Bronkhorst has loved experimenting with letterforms—he used to get into trouble for doing just that all over his third grade classwork.

After receiving his B.A. in Communications from the University of the Pacific, he worked as art director/designer for an insurance company based in San Francisco, whose annual reports won him several awards. He left corporate life to devote more time to creating typefaces and designing publications for a variety of clients.

He has designed several typefaces, the first of which won the silver prize in the Morisawa International Typeface Design Competition. He recently completed a large collection of pictures in font format and is the design director of X-HEIGHT, published by FontHaus.

He also designed this annual, including its text typefaces.

Judge's Choice

I chose the CD album cover of k.d. lang's
INGÉNUE as the best of the competition be-
cause, much like the music contained therein,
the type selection and use are simple and
clear. In other words, the form of the type and
the content of the product are well-matched.
The technical aspects of the typography are
equally good. The type is well-sized in each
instance of its use, the color and spacing are
good, and the selection of styles fits well with
the way the type is used. Overall, the design
and, particularly, the type are clear and com-
municative while remaining interesting.

—DAVID BERLOW

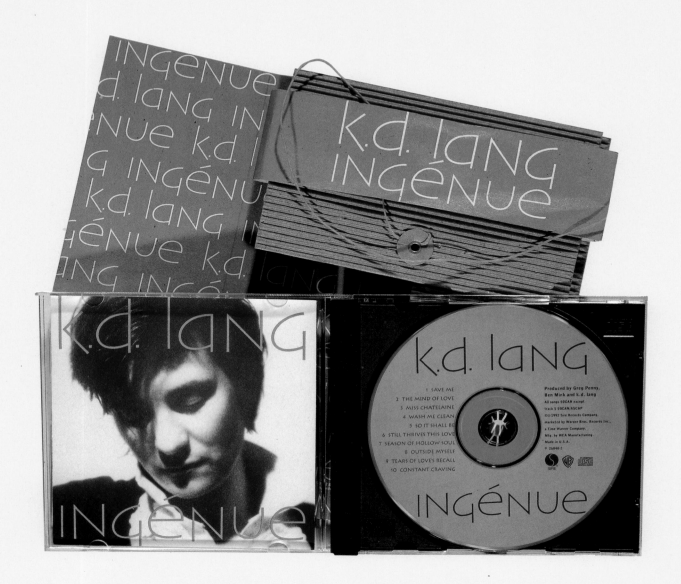

COMPACT DISC PACKAGING

DESIGNERS Jeri Heiden and Greg Ross, Los Angeles, California LETTERER Doyald Young ART DIRECTOR Jeri Heiden
PHOTOGRAPHER Glen Erler TYPOGRAPHIC SOURCE In-house AGENCY Warner Bros. Records
CLIENT k.d. lang/Sire Records PRINCIPAL TYPES Lithos, Bell Gothic, and handlettering
DIMENSIONS 5 × 5½ in. (12.7 × 14 cm)

The London Transport identity is good, solid
typography. The manual—usually an object
of derision among all whose task it is to imple-
ment its guidelines—is even better: clear,
straightforward, even attractive. If I recall
correctly (remember that judging day is a
hectic ordeal mainly spent avoiding brochures
bound with foliage, composed with line-
spacing suitable for a parking garage, and so
on), the manual actually ENCOURAGED correct
usage rather than taking the usual stance
of threatening punishment and banishment.
This was my second choice, but that was be-
cause I wanted someone else to take it as
a primary choice—then I would escape the
inevitable charges of bias, because of my
strange accent. —ED CLEARY

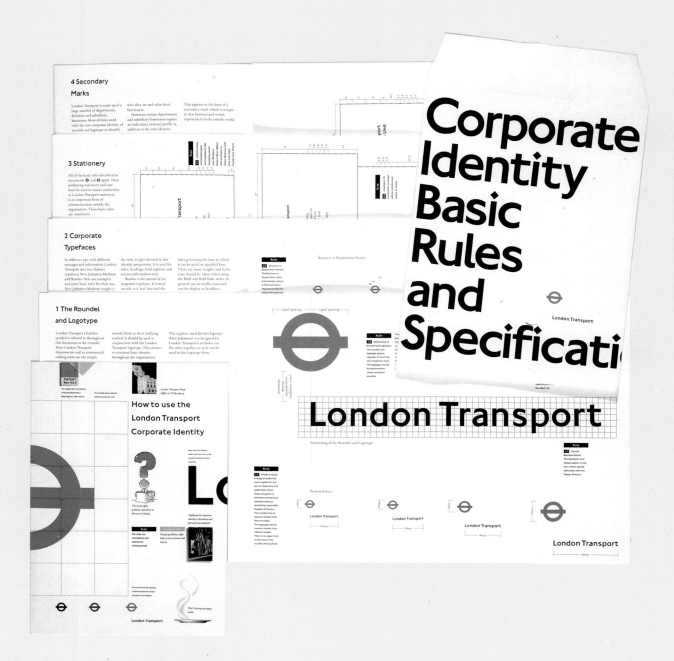

HANDBOOK

DESIGNER David Pocknell, London, England TYPOGRAPHIC SOURCE Paragraph Typesetters STUDIO Pentagram Design
CLIENT London Regional Transport PRINCIPAL TYPES New Johnson and Bembo
DIMENSIONS 11²⁄₃ × 8¼ in. (29.7 × 21 cm)

Finally, a paper manufacturer's promotional piece that is worth keeping! The Subjective Reasoning series, printed on Champion Kromekote, is a wonderful series of playful and serious subjects, masterfully executed, using both rational and humanistic approaches to typography. I especially liked issue number 2, on Useless Information—a topic I frequently explore. (Did you know that Drexel Burnham Lambert spent $46,000,000 copying documents for the Securities and Exchange Commission?) Close attention to typographic detail, send-ups of meaningless information graphics, and a humorous, meandering diatribe on chicken, eggs, and red meat make for a very entertaining read of otherwise useless information.

Kromekote never looked so good.

—GREG LEEDS

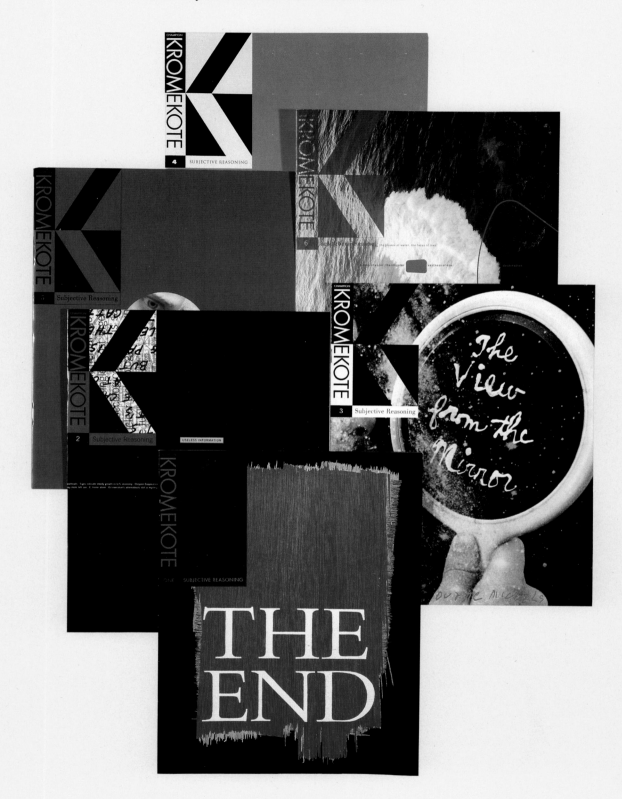

CAMPAIGN

DESIGNERS Stephen Doyle, Paula Scher, Duane Michals, Michael Vanderbyl, Chip Kidd, and Hard Werken, New York, New York, San Francisco, California, and Rotterdam, Holland ART DIRECTORS Paula Scher and Bill Drenttel STUDIOS Pentagram Design and Drenttel Doyle Partners CLIENT Champion International Corporation PRINCIPAL TYPE Various DIMENSIONS 9¼ × 11⅝ in. (24.5 × 29.5 cm)

23

My pick for this award goes to the MTV "Rock the Vote" poster because it communicates dramatically its strategy of encouraging young people to vote. The tattoo type treatment on the clenched fist is extremely powerful; it stopped me in my tracks. So many design pieces today use type more for stylistic effects than for helping capture the essence of the message.

The poster's retro, 1960s look is very effective, evoking an era in this country when young people became seriously involved in the nation's political process. It will be interesting to see how a new generation of young designers concerned with social issues affects graphics and typography in the near future.

—GEORGE PIERSON

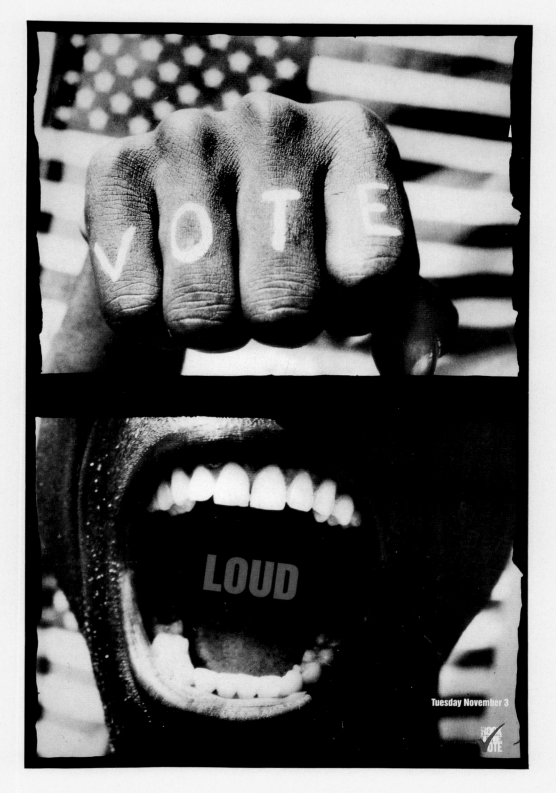

POSTER

DESIGNER Heather van Haaften, Los Angeles, California LETTERER Heather van Haaften
TYPOGRAPHIC SOURCE In-house STUDIO Let Her Press CLIENT Rock the Vote
PRINCIPAL TYPES Helvetica Inserat and handlettering DIMENSIONS 20 × 30 in. (50.8 × 76.2 cm)

A Printer's Dozen caught my eye because it
was an anachronism. The digital era may well
be the beginning of the Golden Age of Type,
but this small book of poems set in foundry
type reminded me of the typographic essentials
that still seem to be missing from the desktop:
for example, subtleties like hung punctuation,
optical alignment, natural character- and
word-spacing, and generous margins.

It's not that we cannot have these niceties
in type set on the desktop, but they're difficult
to achieve; or maybe something in the elec-
tronic medium and desktop tools leads us to
choose other design approaches.

Most of the submitted work was bold and
interesting. It exploited type in fresh, new
ways. Most of all, it was unabashedly digital,
which is appropriate, after all, to our time and
the language we use. I liked (and voted for) a
lot of it. But then this book spoke to me, like
a quiet voice at a bustling party.

—Kathleen Tinkel

Heeding Cockerell's Advice

I take *Webster's Third,*
Brand-new, fresh, shrink-wrapped,
 out of the box,
And spine cradled in left hand,
Open the cover, the endsheets,
And smooth my hand across the paper—
Now! if only it were letterpress—
Going like this as far as *B.*
Then from the back to *Y.*
Open it midway and go backwards
And forwards until, Done!
I forego the final pressing,
As it will lie open now—
And spine arched, it may flatten,
I think, maybe a support
For it, but no advice from Cockerell on that—
The Master can lead only so far—
I feel suddenly it will be all right—
The pages accommodating, arching open
Like a tree in summer. Then overhead—
A rustling of leaves like pages turning,
Releasing flights of birds
As I look up.

The Old, Hot-Metal Man Doesn't Let
The Type Go—And For The Very Reason
I Wouldn't Either

Alone in the shop I
Could have grabbed an ornament or two,
A frame or tail-piece, or at the very least
A fleuron—a little something
To pretty-up a page;
One gets tired of dinner alone.

Instead, I waited. And what I waited for
Was *no!* No, I could not have these ornaments,
Period.
 And angry,
Self-righteous as the book thief,
Secure in the knowledge that This Book
 Wants to Belong to Him,
I heard the type speak: "Give me a home,
You, who understand me so well. Set me
In the warm bed of your press, amidst the lovely,
The damp sheets."

BOOK

DESIGNER Gerald Lange, Los Angeles, California TYPOGRAPHIC SOURCE In-house STUDIO Bieler Press
PRINCIPAL TYPES ATF Garamond Bold and Trump Medieval Bold
DIMENSIONS 6¾ × 10¾ in. (17.1 × 27.3 cm)

This wedding announcement is my favorite
piece in the show. It appeals to me because
it is simple and straightforward, and the
message is clear even if you do not read the
smaller type. It is a fresh typographic solution
to a design problem that is usually given a
very predictable, formal appearance. It takes
clever advantage of a coincidental and unique
aspect of the betrothed couple and presents
it in a symbolic and charming way.

—CAROL TWOMBLY

ABCDEFGHIJKLMNOPQRSTUVWXYZ

INVITATION

DESIGNERS Willie Baronet, Kellye Kimball, and Bill Vance, Dallas, Texas LETTERERS Kellye Kimball and Willie Baronet
TYPOGRAPHIC SOURCE In-house STUDIO Gibbs Baronet CLIENTS Ron and Sheila Kostelny
PRINCIPAL TYPE ITC Berkeley Old Style DIMENSIONS 36½ × 4½ in. (92.7 × 11.4 cm)

Sure, ROLLING STONE is known for its clever use of type, and its spreads regularly grace the pages of journals and design annuals, including this one. But what a solution: this spread stood out for me as exhibiting especially successful display typography.

In selecting a Judge's Choice, I wanted to find a piece that demonstrated a strong sensitivity to letters as forms, capable of expressing and strengthening a message beyond their primary purpose of delivering language.

This jumble of letters is surprisingly direct. "The Bat's Meow" is easily read: the centered format leads you from the point of the M to the E, the whiskers outward to the O, followed by the W (which even creates a collar and tie). The resulting caricature helps set the tone of the article. The script E as cheeks/nose/mouth delivers a catlike smirk—playful, sly, clever— perfect for the subject.

—MARK VAN BRONKHORST

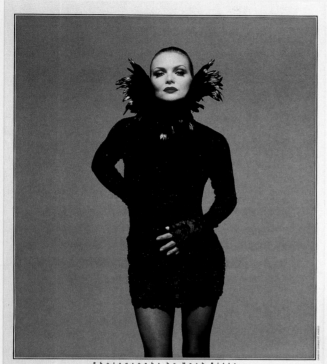

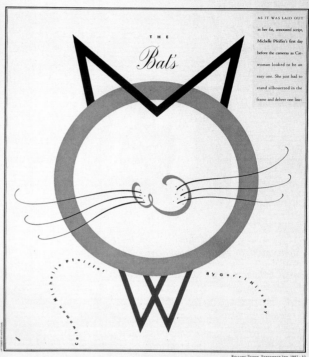

MAGAZINE SPREAD

DESIGNER Fred Woodward, New York, New York LETTERER Anita Karl, Brooklyn, New York
TYPOGRAPHIC SOURCE In-house STUDIO Rolling Stone CLIENT Rolling Stone
PRINCIPAL TYPE Various DIMENSIONS 12 × 20 in. (30.5 × 50.8 cm)

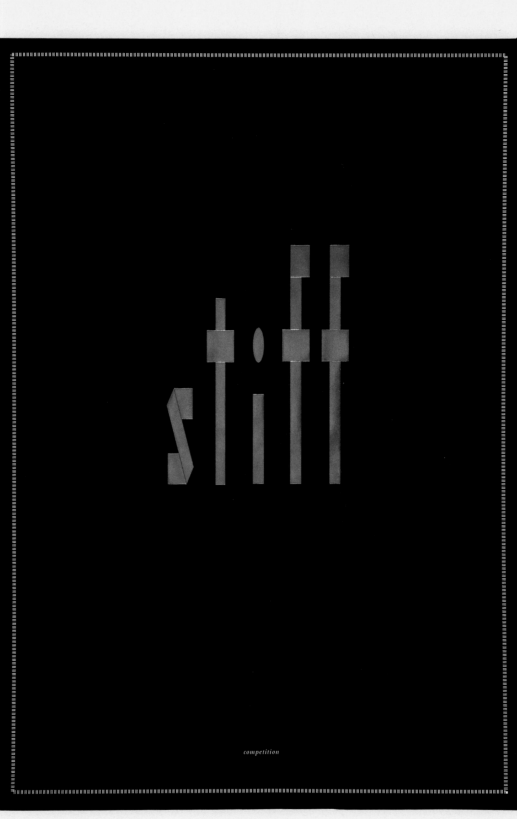

competition

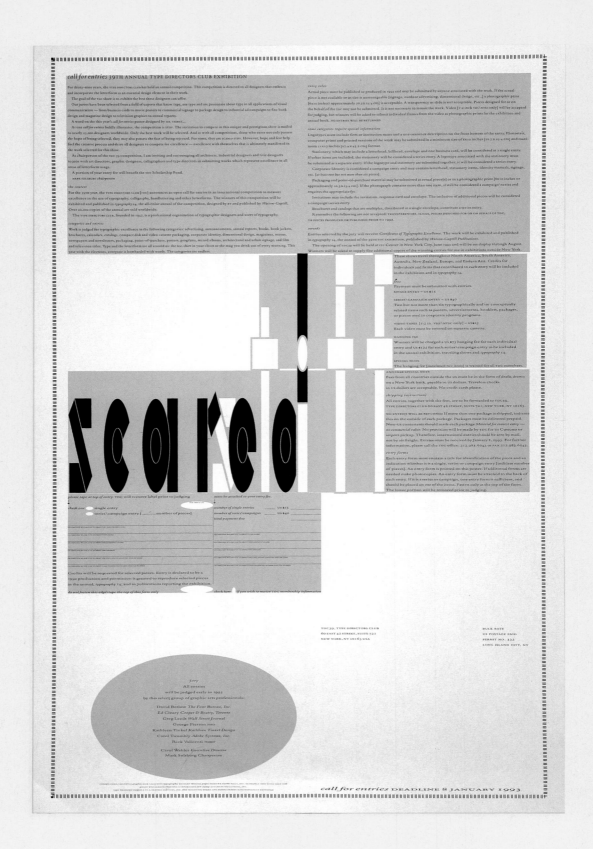

TDC39 CALL FOR ENTRIES

Concept Linda Valicenti Graphic Rick Valicenti Typography Richard Weaver Studio THIRST, Chicago, Illinois
Paper Mohawk Paper Mills, Inc. Printer Williamson Printing Corporation Foil Stamp Accurate Diecutting, Inc.
Linotronic Output A to A Graphic Services, Inc. Typefaces Monotype Bembo
and Bembo Expert (electronically extended)

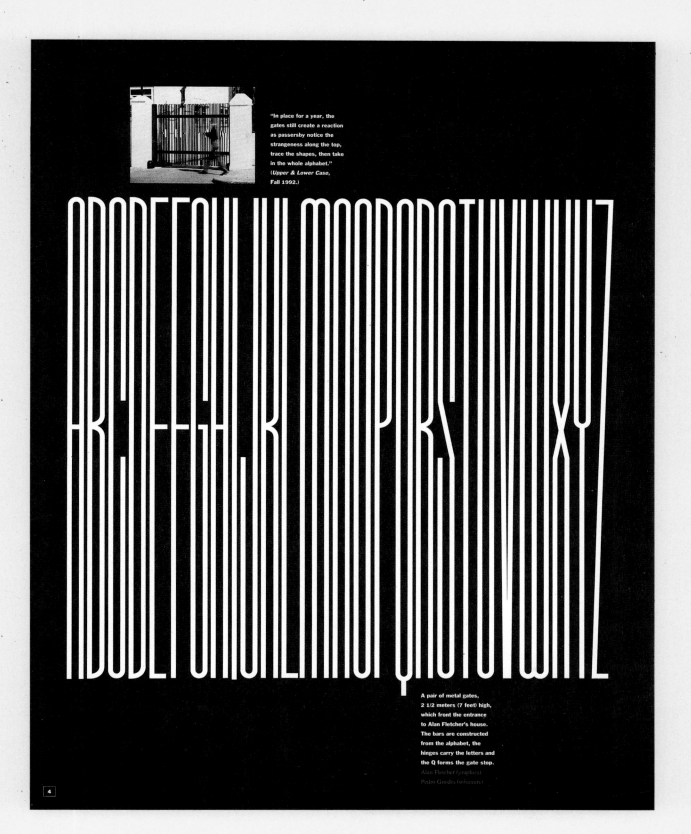

"In place for a year, the gates still create a reaction as passersby notice the strangeness along the top, trace the shapes, then take in the whole alphabet." (*Upper & Lower Case*, Fall 1992.)

A pair of metal gates, 2 1/2 meters (7 feet) high, which front the entrance to Alan Fletcher's house. The bars are constructed from the alphabet, the hinges carry the letters and the Q forms the gate stop.

Alan Fletcher (graphics)
Pedro Guedes (structure)

4

ARCHITECTURAL DESIGN

DESIGNER Alan Fletcher, London, England LETTERER Alan Fletcher STRUCTURE Pedro Guedes
STUDIO Pentagram Design CLIENT Alan Fletcher DIMENSIONS 86⅝ × 98⁷⁄₁₆ in. (220 × 250 cm)

POSTER

DESIGNER Ralph Schraivogel, Zürich, Switzerland LETTERER Ralph Schraivogel TYPOGRAPHIC SOURCE In-house
STUDIO Ralph Schraivogel Design CLIENT Serigraphie Uldry AG PRINCIPAL TYPE Perpetua
DIMENSIONS 50⅜ × 35⅝ in. (128 × 90.5 cm)

POSTER

37

DESIGNER Ralph Schraivogel, Zürich, Switzerland LETTERER Ralph Schraivogel TYPOGRAPHIC SOURCE In-house
STUDIO Ralph Schraivogel Design CLIENT Serigraphie Uldry AG PRINCIPAL TYPE Perpetua
DIMENSIONS 50⅜ × 35⅝ in. (128 × 90.5 cm)

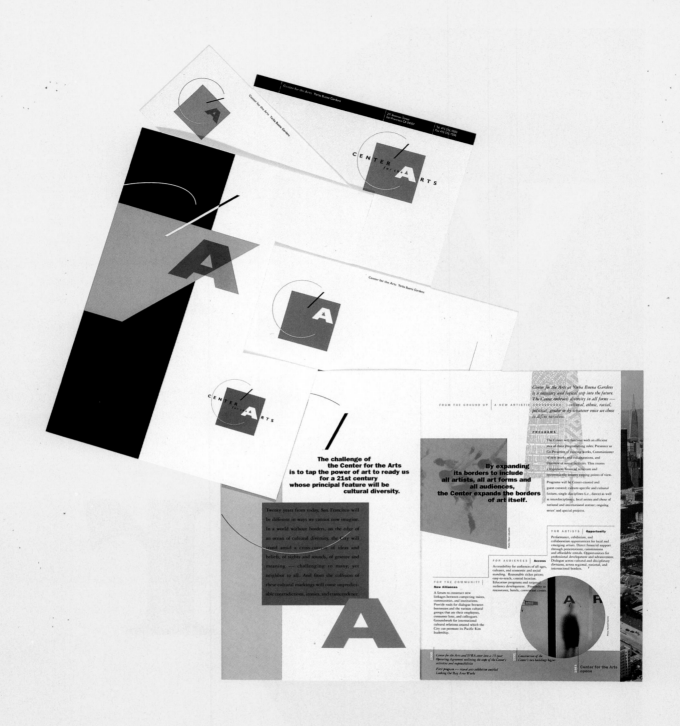

IDENTITY PROGRAM

DESIGNERS Lucille Tenazas and Todd Foreman, San Francisco, California TYPOGRAPHIC SOURCE Eurotype
STUDIO Tenazas Design CLIENT Center for the Arts, Yerba Buena Gardens PRINCIPAL TYPE Gill Sans
DIMENSIONS Various

What kind of chiever are you? bold? elegant? team player? unconventional? precise? informal?

ANNOUNCEMENT

DESIGNER Bill Prindle, Medfield, Massachusetts TYPOGRAPHIC SOURCE In-house AGENCY Envision
STUDIO Prindle Design CLIENT Lotus Development Corp. PRINCIPAL TYPES Bauer Bodoni and ITC Didi
DIMENSIONS 36 × 4 in. (91.4 × 10.2 cm)

James Salter

BOOK

DESIGNER Stephen Doyle, New York, New York TYPOGRAPHIC SOURCE In-house STUDIO Drenttel Doyle Partners
CLIENT William Drenttel New York PRINCIPAL TYPE Sabon DIMENSIONS 9 × 6 in. (22.9 × 15.2 cm)

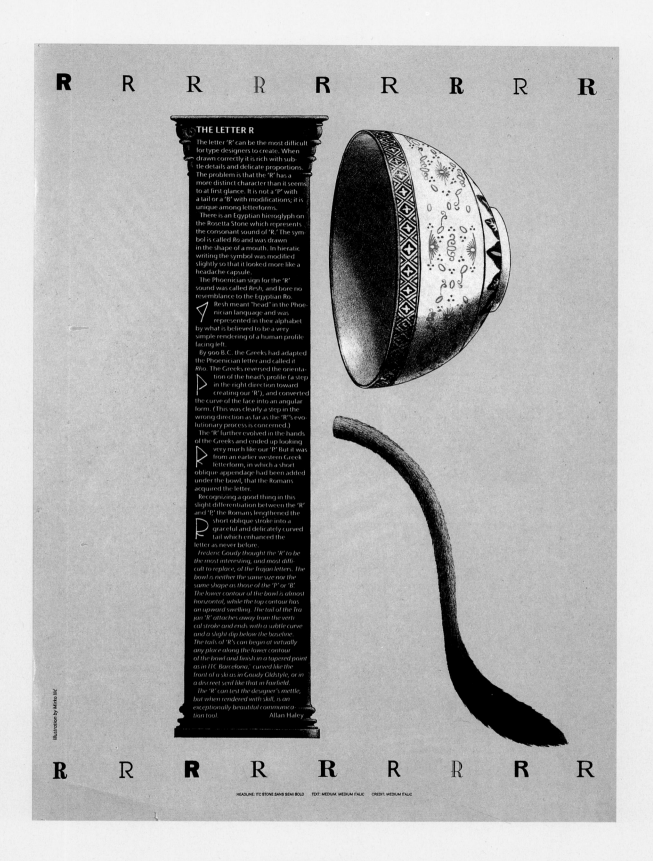

THE LETTER R

The letter 'R' can be the most difficult for type designers to create. When drawn correctly it is rich with subtle details and delicate proportions. The problem is that the 'R' has a more distinct character than it seems to at first glance. It is not a 'P' with a tail or a 'B' with modifications; it is unique among letterforms.

There is an Egyptian hieroglyph on the Rosetta Stone which represents the consonant sound of 'R.' The symbol is called *Ro* and was drawn in the shape of a mouth. In hieratic writing the symbol was modified slightly so that it looked more like a headache capsule.

The Phoenician sign for the 'R' sound was called *Resh*, and bore no resemblance to the Egyptian Ro. Resh meant "head" in the Phoenician language and was represented in their alphabet by what is believed to be a very simple rendering of a human profile facing left.

By 900 B.C. the Greeks had adapted the Phoenician letter and called it *Rho*. The Greeks reversed the orientation of the head's profile (a step in the right direction toward creating our 'R'), and converted the curve of the face into an angular form. (This was clearly a step in the wrong direction as far as the 'R''s evolutionary process is concerned.)

The 'R' further evolved in the hands of the Greeks and ended up looking very much like our 'P.' But it was from an earlier western Greek letterform, in which a short oblique appendage had been added under the bowl, that the Romans acquired the letter.

Recognizing a good thing in this slight differentiation between the 'R' and 'P,' the Romans lengthened the short oblique stroke into a graceful and delicately curved tail which enhanced the letter as never before.

Frederic Goudy thought the 'R' to be the most interesting, and most difficult to replace, of the Trajan letters. The bowl is neither the same size nor the same shape as those of the 'P' or 'B.' The lower contour of the bowl is almost horizontal, while the top contour has an upward swelling. The tail of the Trajan 'R' attaches away from the vertical stroke and ends with a subtle curve and a slight dip below the baseline. The tails of 'R's can begin at virtually any place along the lower contour of the bowl and finish in a tapered point as in ITC Barcelona,' curved like the front of a ski as in Goudy Oldstyle, or in a discreet serif like that in Fairfield.

The 'R' can test the designer's mettle, but when rendered with skill, is an exceptionally beautiful communication tool. Allan Haley

Illustration by Mirko Ilic

HEADLINE: ITC STONE SANS SEMI BOLD TEXT: MEDIUM, MEDIUM ITALIC CREDIT: MEDIUM ITALIC

MAGAZINE PAGE

DESIGNERS Milton Glaser, Walter Bernard, and Frank Baseman, New York, New York LETTERER Mirko Ilic
ILLUSTRATOR Mirko Ilic TYPOGRAPHIC SOURCE In-house STUDIO WBMG Design, Inc. CLIENTS U&lc magazine
and International Typeface Corporation PRINCIPAL TYPES ITC Stone Sans Semi Bold, Medium, Medium Italic,
and handlettering DIMENSIONS 10¾ × 14¾ in. (27.3 × 37.5 cm)

Once regarded as an image enhancement technique employed when four-color was not an option, the duotone has shed its second best image to become the treatment frequently preferred by designers of corporate annuals and

surprisingly, creating a duotone from a color photograph is a task frequently assigned to Overland's system specialists. • Unlike a conventional scanned duotone, the color image is manipulated as a monochrome to achieve the desired highlight-to-shadow range for each of the duotone colors. • Even the most subtle change

marketing brochures. • The duotone's unique qualities and distinctive appearance make a different kind of statement than either black-and-white or color images. • In a color-saturated market, the duotone piece stands out. • Not

is reflected on the monitor the moment it's made, making rescanning unnecessary. • Although any combination of colors can be used to create a specific effect, the usual duotone pairing is black and a lighter color. The example here reflects the richness, mood, and illusion of depth which are characteristic of the classic black-and-grey duotone.

BROCHURE

DESIGNER Douglas Joseph, Santa Monica, California TYPOGRAPHIC SOURCE Composition Type
STUDIO Besser Joseph Partners CLIENT Overland Printers PRINCIPAL TYPE Bodoni Book Italic
DIMENSIONS 9 × 13¾ in. (22.9 × 34.9 cm)

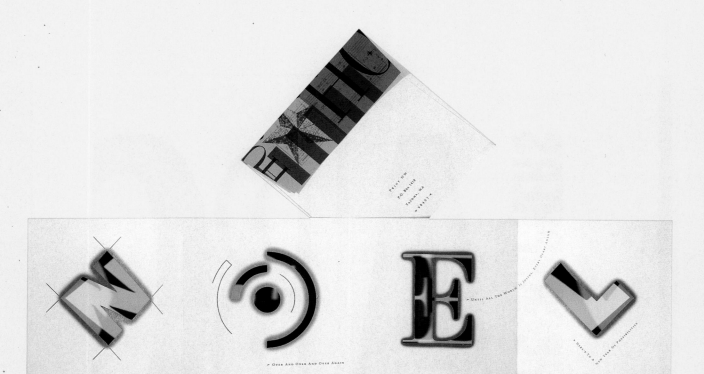

GREETING CARD

DESIGNERS Jack Anderson, Heidi Hatlestad, Lian Ng, and Julia LaPine, Seattle, Washington
TYPOGRAPHIC SOURCE In-house STUDIO Hornall Anderson Design Works, Inc. CLIENT Print Northwest
PRINCIPAL TYPE Weiss DIMENSIONS 5½ × 5½ in. (14 × 14 cm)

TYPOGRAPHER'S **ABC**

The second
EVE PRESS
ABC BOOK

Bellingham
1992

BOOK

DESIGNER Elsi Vassdal Ellis, Bellingham, Washington TYPOGRAPHIC SOURCE In-house STUDIO EVE Press
CLIENT EVE Press PRINCIPAL TYPES Wood Type and ATF Garamond Bold
DIMENSIONS 10 × 6½ in. (25.4 × 16.5 cm)

CALENDAR

DESIGNERS Robert Froedge and Howard Diehl, Nashville, Tennessee TYPOGRAPHIC SOURCE In-house
STUDIO Image Design Incorporated CLIENT Capitol Engraving Company
PRINCIPAL TYPES Remedy Double and Variex Bold DIMENSIONS 9½ × 6¾ in. (24.1 × 17.4 cm)

BOOK

DESIGNER Tim Sauer, Minneapolis, Minnesota TYPOGRAPHIC SOURCE May Typography STUDIO The Kuester Group
CLIENT CornerHouse PRINCIPAL TYPE Centaur DIMENSIONS 6½ × 12¼ in. (16.5 × 31.1 cm)

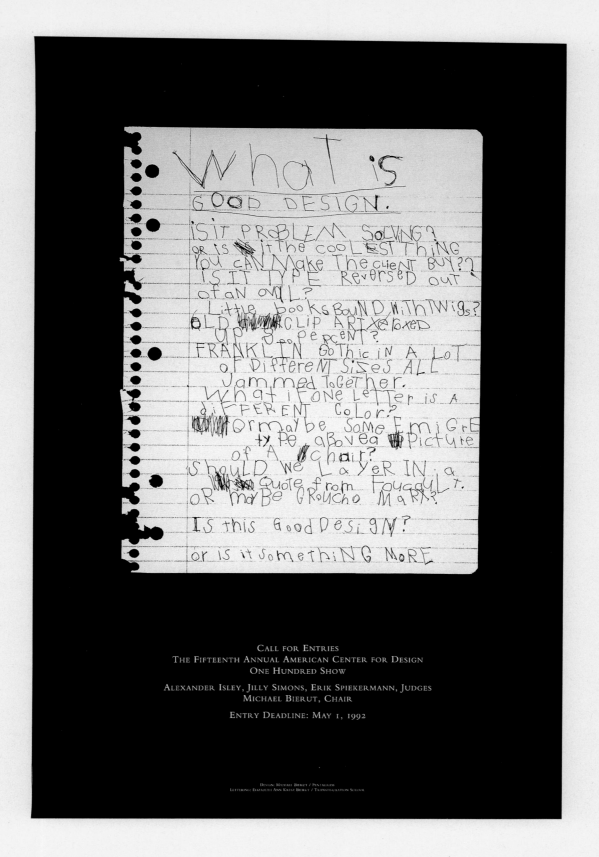

CALL FOR ENTRIES
THE FIFTEENTH ANNUAL AMERICAN CENTER FOR DESIGN
ONE HUNDRED SHOW

ALEXANDER ISLEY, JILLY SIMONS, ERIK SPIEKERMANN, JUDGES
MICHAEL BIERUT, CHAIR

ENTRY DEADLINE: MAY 1, 1992

POSTER

DESIGNER Michael Bierut, New York, New York LETTERER Elizabeth Krosz-Bierut, Tarrytown, New York
TYPOGRAPHIC SOURCE Typogram STUDIO Pentagram Design CLIENT American Center for Design
PRINCIPAL TYPES Sabon and handlettering DIMENSIONS 18 × 27 in. (45.7 × 68.6 cm)

POSTER

DESIGNER Paul Lavoie, Montréal, Canada TYPOGRAPHIC SOURCE In-house AGENCY Cossette
CLIENT McDonald's (Canada) PRINCIPAL TYPES McDonald's Arch "M" and Century Old Style
DIMENSIONS 16¾ × 5½ in. (42.5 × 14 cm)

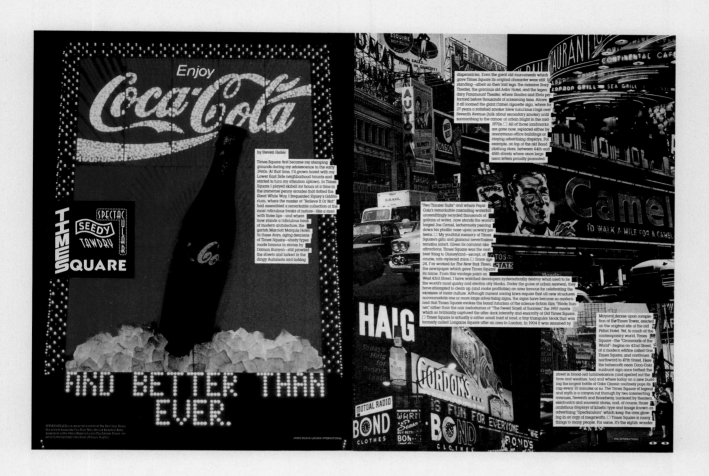

DESIGNERS Seymour Chwast and Greg Simpson, New York, New York TYPOGRAPHIC SOURCE Terminal Design, Inc.
STUDIO The Pushpin Group CLIENTS U&lc magazine and International Typeface Corporation
PRINCIPAL TYPE ITC Lubalin Graph Book Condensed DIMENSIONS 22 × 14½ in. (55.9 × 36.8 cm)

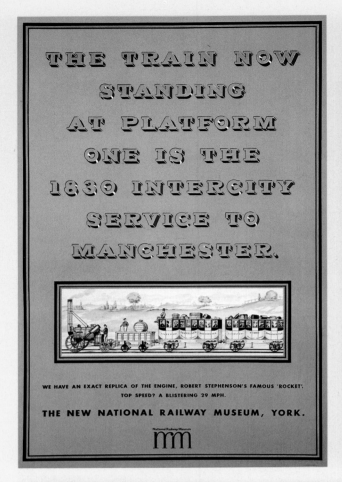

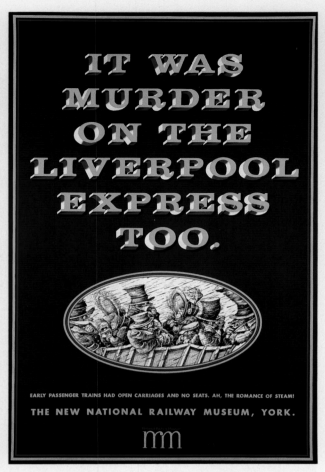

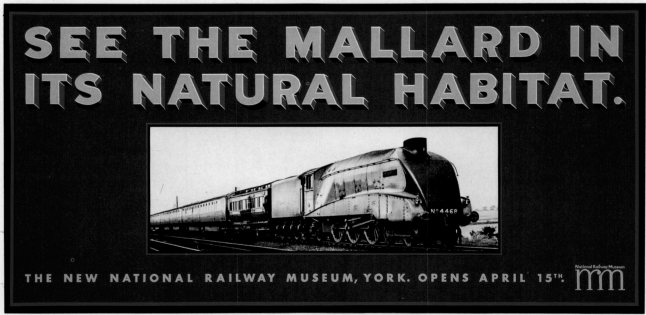

POSTERS

Designer Barry Brand, London, England Letterer Yanny Petters Art Director Andy McKay
Agency Simons Palmer Denton Clemmow & Johnson Studio Bloomsbury Art Client National Railway Museum
Principal Type Handlettering Dimensions 60 × 40 in. (152.4 × 101.6 cm)

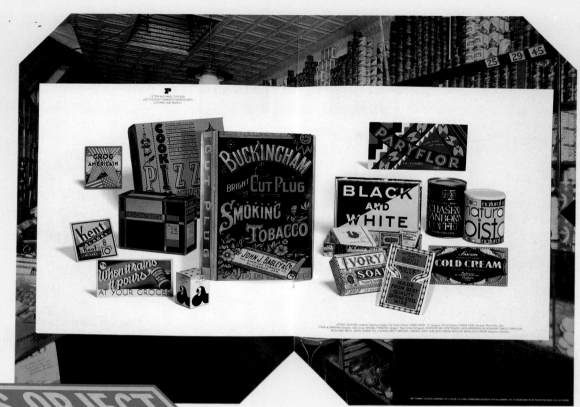

BROCHURE

DESIGNER Greg Simpson, New York, New York ART DIRECTOR Seymour Chwast
TYPOGRAPHIC SOURCE Boro Typographers STUDIO The Pushpin Group CLIENT Ivy Hill Corp.
PRINCIPAL TYPE Lightline Gothic DIMENSIONS 9½ × 13¼ in. (24.1 × 33.7 cm)

Some of my work has won awards. But most of it is good solid stuff that was done to do a job. And keep on doing it. Whether it was written on a typewriter, created on a computer or sketched on a napkin • So, if you need the services of a national hero, a member of the Beatles, a Red Sox player or a kid that loves type, logos, paper and colors, please give me a call. I'll bring over my crayons •

PROMOTION

52

DESIGNER Peter Lehndorff, Holyoke, Massachusetts TYPOGRAPHIC SOURCE In-house
STUDIO Peter Lehndorff Graphic Design CLIENT Peter Lehndorff PRINCIPAL TYPES Janson and ITC Zapf Dingbats
DIMENSIONS 4¾ × 6⅜ in. (12.1 × 16.2 cm)

STATIONERY

DESIGNERS Craig Markus and Robert Wakeman, New York, New York
LETTERER Banknote Corporation of America, Inc., Suffern, New York TYPOGRAPHIC SOURCE In-house
AGENCY Ogilvy & Mather CLIENT Chesterfield Cigarette Company PRINCIPAL TYPES Packard Bold
and Akzidenz-Grotesk Light Extended DIMENSIONS 8½ × 11 in. (21.6 × 27.9 cm)

CONCEPT MERCHANDISING IS THE INTEGRATION OF

LEVI'S JEANS, SHIRTS, JACKETS, SWEATS AND SHORTS,

PRESENTED TOGETHER WITH CURRENT MARKET TRENDS

IN THE LEVI'S AREA OF YOUR STORE.

CONCEPT MERCHANDISING WILL EFFECTIVELY INCREASE

DEPARTMENT TRAFFIC AND INCREASE SALES THROUGH

MULTIPLE PRODUCT PURCHASES.

BROCHURE

54

DESIGNERS John Pappas and Neal Zimmermann, San Francisco, California LETTERER John Pappas
TYPOGRAPHIC SOURCES In-house and "Lettering and Alphabets" by J. Albert Cavanagh
STUDIO Zimmermann Crowe Design CLIENT Levi Strauss & Co. PRINCIPAL TYPES Bank Gothic, Antique Extended,
Prägefest, Times Roman, and handlettering DIMENSIONS 11 × 14 in. (27.9 × 35.6 cm)

GAME

DESIGNER James M. Skiles, Boston, Massachusetts LETTERER James M. Skiles STUDIO Midnight Oil Studios
CLIENT Major League Baseball Properties PRINCIPAL TYPE Handlettering DIMENSIONS Various

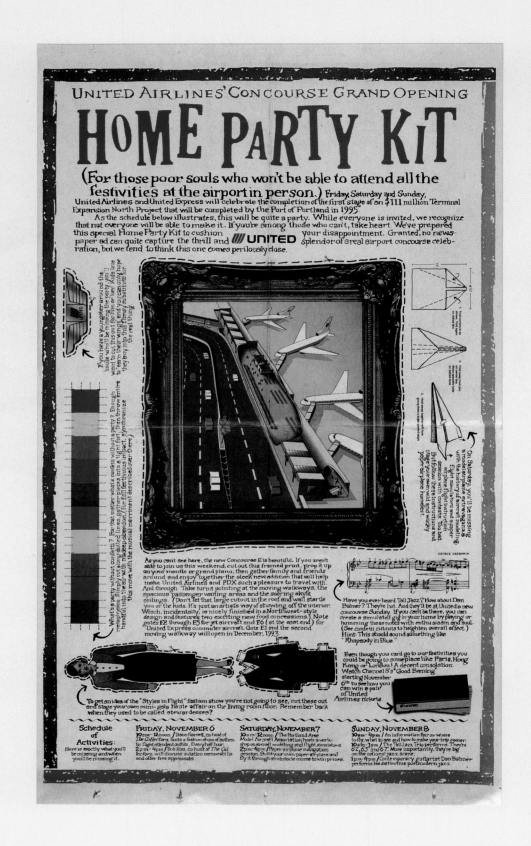

MAGAZINE

57

DESIGNERS Milton Glaser, Walter Bernard, and Frank Baseman, New York, New York TYPOGRAPHIC SOURCE In-house
STUDIO WBMG Design, Inc. CLIENTS U&lc magazine and International Typeface Corporation
PRINCIPAL TYPE Various DIMENSIONS 10¾ × 14¾ in. (27.3 × 37.5 cm)

PACKAGING

DESIGNERS Paul Curtin and Tim Clark, San Francisco, California LETTERER Tim Clark
TYPOGRAPHIC SOURCE In-house AGENCY Paul Curtin & Partners STUDIO Paul Curtin Design Ltd.
CLIENT Visualiner PRINCIPAL TYPES Futura Bold, Lunatix, Triplex Serif, Kaufmann, and handlettering
DIMENSIONS 7³/₈ × 4³/₁₆ × 1 in. (18.7 × 10.6 × 2.5 cm)

DIRECT MAIL

DESIGNERS Paul Curtin, Peter Locke, and Tim Clark, San Francisco, California TYPOGRAPHIC SOURCE In-house
AGENCY Paul Curtin & Partners STUDIO Paul Curtin Design Ltd. CLIENT Keena PRINCIPAL TYPES Triplex Serif,
ITC Beesknees, Xavier Black, and Monoline Script DIMENSIONS 9 × 12 in. (22.9 × 30.5 cm)

PACKAGING

DESIGNERS Charles Spencer Anderson, Daniel Olson, and Haley Johnson, Minneapolis, Minnesota
LETTERER Randall Dahlk TYPOGRAPHIC SOURCE In-house STUDIO Charles S. Anderson Design Company
CLIENT Overseas Products International, Inc. PRINCIPAL TYPES Spartan, Franklin Gothic,
and hand-drawn lettering DIMENSIONS 5½ × 2¼ × ¾ in. (14 × 5.7 × 1.9 cm)

PRODUCT DESIGN

DESIGNERS Charles Spencer Anderson and Daniel Olson, Minneapolis, Minnesota LETTERER Randall Dahlk
TYPOGRAPHIC SOURCE In-house STUDIO Charles S. Anderson Design Company
CLIENT Charles S. Anderson Design Company PRINCIPAL TYPES Gothic 13,
20th Century, and hand-drawn lettering

Do you serve it with coffee, ice cream or a cigarette homemade goodies in his and hers are the specialty at the erotic baker with our desserts, the last thing your guests will be looking at are the spots on your glasses 582 amsterdam avenue between 88th and 89th streets in new york city

2 out of three Freudian complexes satisfied in a single bite homemade goodies in his and hers can only be found at the erotic baker we can duplicate all of your favorite parts of the body and exaggerations are free 582 amsterdam avenue between 88th and 89th streets

give him a cake that looks like it jumped out of a girl homemade goodies in his and hers made fresh daily at the erotic baker where even if you can't get it, at least you can have it for dessert 582 amsterdam avenue in new york city

The world is *kinetic*. Can you be STATIC? ——— We are all going somewhere. **Fast!**

? # 3

Is it culture or Simply a Fungus Among Us.

?

Rsvp: 512-477-0050

Can You Compete?

Can You Succeed?

It's recycled paper. It can be recycled again...or not. It's up to you.

Why isn't the whole world a Mac World?

? # 1

Is a new corporate CULTURE *currently emerging* IN THE *high technology* INDUSTRY

A reminder from those Texans you met very late last night during the Full Body RAM Dance and Pub Crawl Contest down Union Street.

Some of our clients are **big** Others won't be until next year. Call to find out how we can help you.

WHY
I$ IT $0 IMPORTANT?

Hixo is an award-winning marketing design firm specializing in corporate and brand identity for fast-growing technology product manufacturers.

A. CAN YOU IDENTIFY?

B. YOUR HAND. YOUR PHONE.

C. OUR NUMBER: 512.477.0050

If your business is so interesting, why doesn't it appear interesting?

? # 2

ARE YOU MORE SUCCESSFUL THAN YOU
LOOK

More creative than an advertising agency.
More marketing horsepower than a design firm.
More expensive than a new pair of shoes.

&

We own a lot of recently outdated new computers and technowares just like the rest of your customers.

HIXO, INC
2905 San Gabriel, Suite 300
Austin, Texas 78705
Phone: (512) 477-0050
Fax: (512) 477-3892

HIXO MO BETTA 4 U

BEHIND
Don't be left
GET IN FRONT OF THE WAVE WITH HIXO

PROMOTION

DESIGNER Mike Hicks, Austin, Texas TYPOGRAPHIC SOURCE In-house STUDIO HIXO, Inc.
PRINCIPAL TYPE Various DIMENSIONS 3½ × 2 in. (8.9 × 5.1 cm)

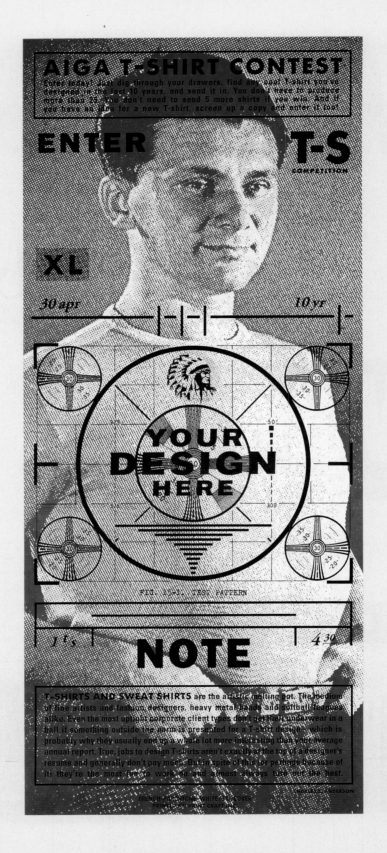

64

Designers Charles Spencer Anderson and Todd Hauswirth, Minneapolis, Minnesota Typographic Source In-house
Studio Charles S. Anderson Design Company Client American Institute of Graphic Arts/New York
Principal Type Various Dimensions 11 × 5¼ in. (27.9 × 13.3 cm)

STATIONERY

DESIGNERS Joe Parisi and Tim Thompson, Baltimore, Maryland TYPOGRAPHIC SOURCE In-house STUDIO Graffito
CLIENT Art Directors Club of Metropolitan Washington PRINCIPAL TYPES Linoscript, Cable, and Algerian
DIMENSIONS 8½ × 11 in. (21.6 × 27.9 cm)

FUN INTERIORS! FUN EXHIBITS! FUN FURNITURE!

Mr. Charles Doell

65 A ELMIRA STREET SAN FRANCISCO CALIFORNIA 94124
TEL 415 468.FUN1 FAX 415 468.FUN2

65 A ELMIRA STREET SAN FRANCISCO CALIFORNIA 94124
TEL 415 468.FUN1 FAX 415 468.FUN2

STATIONERY

Designers Paul Curtin and Peter Locke, San Francisco, California Typographic Source In-house
Agency Paul Curtin & Partners Studio Paul Curtin Design Ltd. Client Fun Display
Principal Types ITC Beesknees and Monoline Script Dimensions 8½ × 11 in. (21.6 × 27.9 cm)

ADVERTISING MICK EDITORIAL
Telephone **BROWNFIELD** *Facsimile*
081-940.1303 • 081-332.1451
24 Richmond Hill, RICHMOND Surrey TW10 6OX England

STATIONERY

67

DESIGNER Clive Piercy, Santa Monica, California TYPOGRAPHIC SOURCE In-house STUDIO Ph.D
CLIENT Mick Brownfield PRINCIPAL TYPES Franklin Gothic, City, and Linoscript
DIMENSIONS 8½ × 11 in. (21.6 × 27.9 cm)

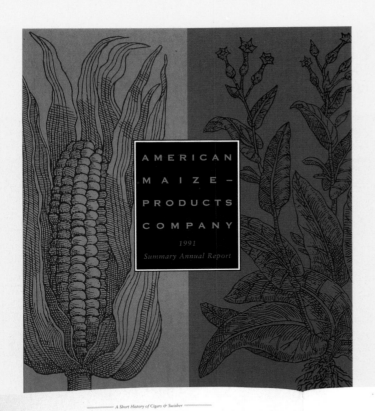

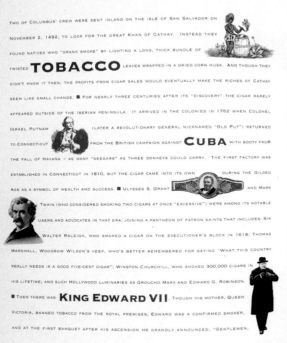

TWO OF COLUMBUS' CREW WERE SENT INLAND ON THE ISLE OF SAN SALVADOR ON NOVEMBER 2, 1492, TO LOOK FOR THE GREAT KHAN OF CATHAY. INSTEAD THEY FOUND NATIVES WHO "DRANK SMOKE" BY LIGHTING A LONG, THICK BUNDLE OF TWISTED **TOBACCO** LEAVES WRAPPED IN A DRIED CORN HUSK. AND THOUGH THEY DIDN'T KNOW IT THEN, THE PROFITS FROM CIGAR SALES WOULD EVENTUALLY MAKE THE RICHES OF CATHAY SEEM LIKE SMALL CHANGE. ■ FOR NEARLY THREE CENTURIES AFTER ITS "DISCOVERY" THE CIGAR RARELY APPEARED OUTSIDE OF THE IBERIAN PENINSULA. IT ARRIVED IN THE COLONIES IN 1762 WHEN COLONEL ISRAEL PUTNAM (LATER A REVOLUTIONARY GENERAL NICKNAMED "OLD PUT") RETURNED TO CONNECTICUT FROM THE BRITISH CAMPAIGN AGAINST **CUBA** WITH BOOTY FROM THE FALL OF HAVANA — AS MANY "SEEGARS" AS THREE DONKEYS COULD CARRY. THE FIRST FACTORY WAS ESTABLISHED IN CONNECTICUT IN 1810, BUT THE CIGAR CAME INTO ITS OWN DURING THE GILDED AGE AS A SYMBOL OF WEALTH AND SUCCESS. ■ ULYSSES S. GRANT AND MARK TWAIN (WHO CONSIDERED SMOKING TWO CIGARS AT ONCE "EXCESSIVE") WERE AMONG ITS NOTABLE USERS AND ADVOCATES IN THAT ERA, JOINING A PANTHEON OF PATRON SAINTS THAT INCLUDES: SIR WALTER RALEIGH, WHO SMOKED A CIGAR ON THE EXECUTIONER'S BLOCK IN 1618; THOMAS MARSHALL, WOODROW WILSON'S VEEP, WHO'S BETTER REMEMBERED FOR SAYING "WHAT THIS COUNTRY REALLY NEEDS IS A GOOD FIVE-CENT CIGAR"; WINSTON CHURCHILL, WHO SMOKED 300,000 CIGARS IN HIS LIFETIME; AND SUCH HOLLYWOOD LUMINARIES AS GROUCHO MARX AND EDWARD G. ROBINSON. ■ THEN THERE WAS **KING EDWARD VII**. THOUGH HIS MOTHER, QUEEN VICTORIA, BANNED TOBACCO FROM THE ROYAL PREMISES, EDWARD WAS A CONFIRMED SMOKER, AND AT THE FIRST BANQUET AFTER HIS ASCENSION HE GRANDLY ANNOUNCED, "GENTLEMEN,

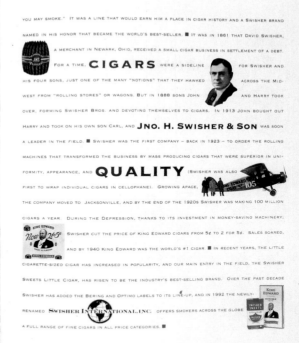

YOU MAY SMOKE." IT WAS A LINE THAT WOULD EARN HIM A PLACE IN CIGAR HISTORY AND A SWISHER BRAND NAMED IN HIS HONOR THAT BECAME THE WORLD'S BEST-SELLER. ■ IT WAS IN 1861 THAT DAVID SWISHER, A MERCHANT IN NEWARK, OHIO, RECEIVED A SMALL CIGAR BUSINESS IN SETTLEMENT OF A DEBT. FOR A TIME, **CIGARS** WERE A SIDELINE FOR SWISHER AND HIS FOUR SONS, JUST ONE OF THE MANY "NOTIONS" THAT THEY HAWKED ACROSS THE MID-WEST FROM "ROLLING STORES" OR WAGONS. BUT IN 1888 SONS JOHN AND HARRY TOOK OVER, FORMING SWISHER BROS. AND DEVOTING THEMSELVES TO CIGARS. IN 1913 JOHN BOUGHT OUT HARRY AND TOOK ON HIS OWN SON CARL, AND **JNO. H. SWISHER & SON** WAS SOON A LEADER IN THE FIELD. ■ SWISHER WAS THE FIRST COMPANY — BACK IN 1923 — TO ORDER THE ROLLING MACHINES THAT TRANSFORMED THE BUSINESS BY MASS PRODUCING CIGARS THAT WERE SUPERIOR IN UNI-FORMITY, APPEARANCE, AND **QUALITY** (SWISHER WAS ALSO FIRST TO WRAP INDIVIDUAL CIGARS IN CELLOPHANE). GROWING APACE, THE COMPANY MOVED TO JACKSONVILLE, AND BY THE END OF THE 1920S SWISHER WAS MAKING 100 MILLION CIGARS A YEAR. DURING THE DEPRESSION, THANKS TO ITS INVESTMENT IN MONEY-SAVING MACHINERY, SWISHER CUT THE PRICE OF KING EDWARD CIGARS FROM 5¢ TO 2 FOR 5¢. SALES SOARED, AND BY 1940 KING EDWARD WAS THE WORLD'S #1 CIGAR. ■ IN RECENT YEARS, THE LITTLE CIGARETTE-SIZED CIGAR HAS INCREASED IN POPULARITY, AND OUR MAIN ENTRY IN THE FIELD, THE SWISHER SWEETS LITTLE CIGAR, HAS RISEN TO BE THE INDUSTRY'S BEST-SELLING BRAND. OVER THE PAST DECADE SWISHER HAS ADDED THE BERING AND OPTIMO LABELS TO ITS LINE-UP, AND IN 1992 THE NEWLY-RENAMED **SWISHER INTERNATIONAL, INC.** OFFERS SMOKERS ACROSS THE GLOBE A FULL RANGE OF FINE CIGARS IN ALL PRICE CATEGORIES. ■

ANNUAL REPORT

68

DESIGNER Sara Bernstein, Brooklyn, New York TYPOGRAPHIC SOURCE In-house STUDIO Sara Bernstein Design
CLIENT American Maize–Products Company PRINCIPAL TYPES Copperplate Gothic and Sabon
DIMENSIONS 8¾ × 10¼ in. (22.2 × 26 cm)

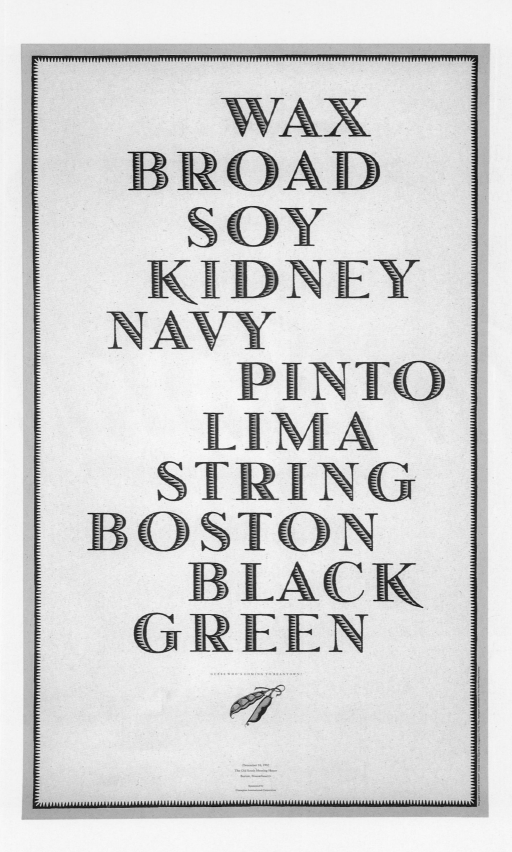

POSTER

DESIGNER Woody Pirtle, New York, New York TYPOGRAPHIC SOURCE Personal Collection STUDIO Pentagram Design
CLIENT Champion International Corporation PRINCIPAL TYPES Albert Select and Caslon 540
DIMENSIONS 24 × 36 in. (61 × 91.4 cm)

BOOK COVER

70

DESIGNER John Langdon, Philadelphia, Pennsylvania LETTERER John Langdon CLIENT Harcourt Brace Jovanovich
PRINCIPAL TYPE Handlettering DIMENSIONS 8⅛ × 8¼ in. (20.6 × 21 cm)

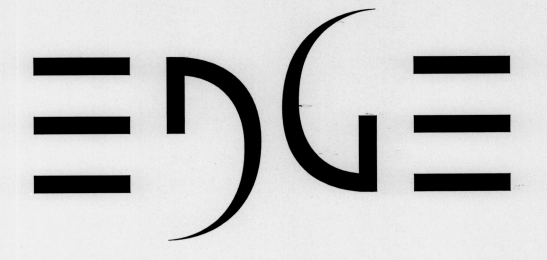

LOGOTYPE

DESIGNER Bennett Peji, San Diego, California LETTERER Bennett Peji STUDIO Bennett Peji Design
CLIENT Inside Edge PRINCIPAL TYPE Handlettering

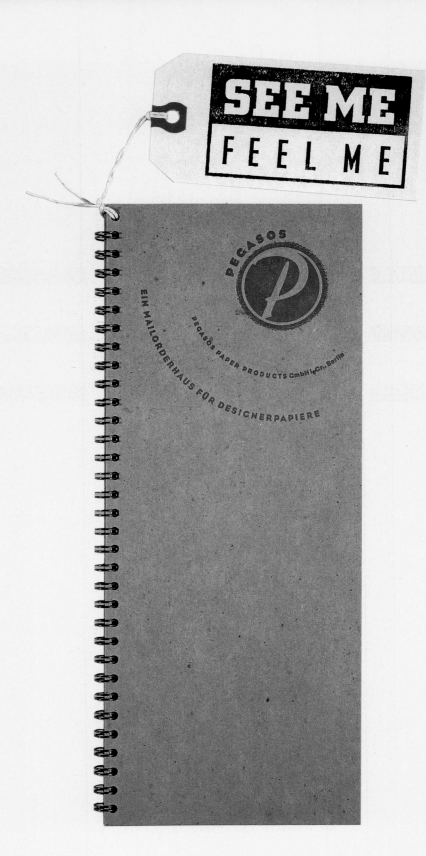

BROCHURE

DESIGNER Olaf Stein, Hamburg, Germany TYPOGRAPHIC SOURCE In-house STUDIO Factor Design
CLIENT Pegasos Paper Products PRINCIPAL TYPES Eagle, Berlin Sans, and Garamond
DIMENSIONS 4¼ × 11 in. (10.8 × 27.9 cm)

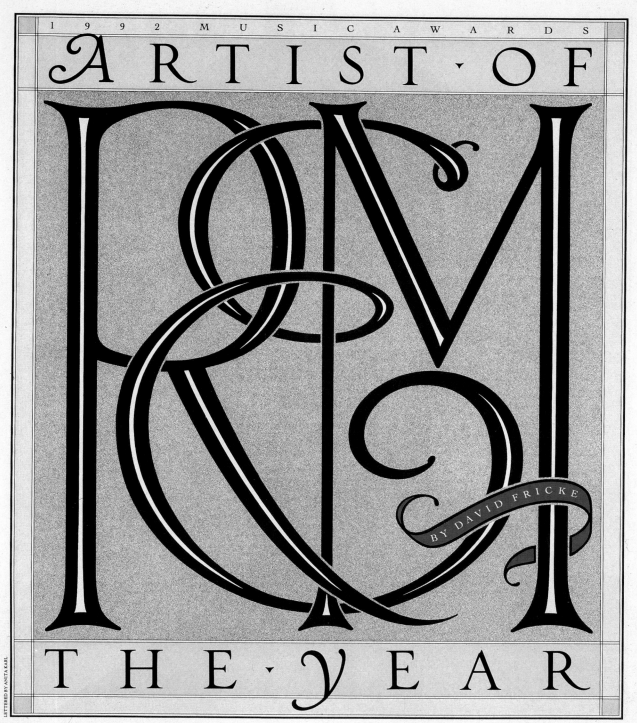

1992 MUSIC AWARDS
ARTIST · OF
R&M
BY DAVID FRICKE
THE · YEAR

LETTERED BY ANITA KARL

ROLLING STONE, MARCH 5TH, 1992 · 45

MAGAZINE PAGE

73

DESIGNER Debra Bishop, New York, New York LETTERER Anita Karl, Brooklyn, New York
TYPOGRAPHIC SOURCE In-house STUDIO Rolling Stone CLIENT Rolling Stone
PRINCIPAL TYPES Catherine Roman and Goudy Cursive DIMENSIONS 10 × 12 in. (25.4 × 30.5 cm)

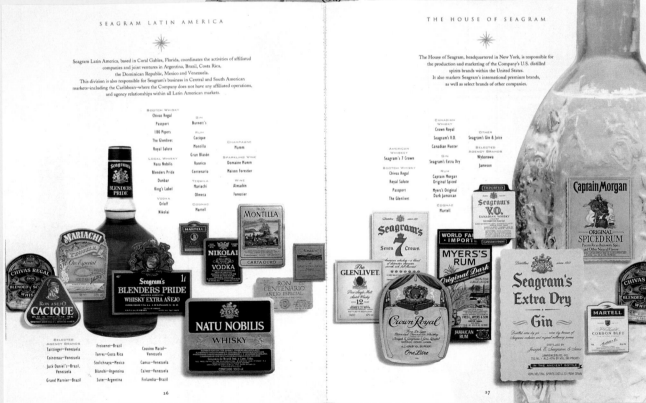

ANNUAL REPORT

DESIGNER Benjamin Bailey, New York, New York TYPOGRAPHIC SOURCE In-house AGENCY Frankfurt Gips Balkind
CLIENT The Seagram Company Ltd. PRINCIPAL TYPE Adobe Caslon DIMENSIONS 8½ × 11 in. (21.6 × 27.9 cm)

In the capital markets, we acted for a record number of clients and were the managing underwriter or agent in public and private debt and equity offerings across a wide range of industries. Our middle market and growth company business was particularly successful.

During 1991 our High Yield and Restructuring Group continued to implement a strategy instituted several years ago to increase our capacity to meet the needs of highly leveraged companies. Among our assignments in 1991 were capital raising and advisory services for clients in the cable television, energy, and machinery industries. We anticipate further growth in this area in 1992.

The Private Transactions Group completed 15 private financings in 1991, raising approximately $1.3 billion for such clients as AEA Investors Inc., Associated Natural Gas

General Mills, Inc.

Varity Corporation

JWP INC.

JWP INC. is a leading diversified technical services company providing integrated solutions for complex facility, information, and energy and environmental issues. Through its subsidiary, JWP Information Services, JWP has emerged as one of the nation's largest resellers of microcomputer equipment. In order to gain market share, in 1991 JWP acquired Businessland, Inc., a national reseller chain with strong corporate account penetration. Dillon Read served as advisor to JWP during the acquisition and acted as dealer-manager for the tender offer for the common shares of Businessland. During the year we also completed a $100 million private placement of senior notes for JWP. Our relationship with JWP dates from 1990, when the company acquired Neeco, Inc. for whom we lead managed an equity offering in 1989.

PAGE 8

Corporation, Fisher-Price, Inc., JWP INC., and PacifiCare Health Systems, Inc. The Group works closely with our corporate finance and marketing professionals to meet the senior and subordinated debt and private equity needs for companies across a broad credit range.

In the continuing unstable investment banking environment, we have been fortunate in being able to attract and hold talented individuals at all levels. We have strengthened our specialist capabilities by key additions in such industries as energy, financial institutions, forest products, housing, and media, while at the same time growing our capabilities from within. We are confident that management ownership, combined with the opportunities inherent in our new partnership with Barings, will contribute significantly to our organizational strength in years to come.

Intergroup Healthcare Corporation

Intergroup Healthcare Corporation is one of the largest managed care companies in Arizona with 225,000 enrollees. Owned by Thomas-Davis Medical Centers, P.C., a large physician-owned medical group providing services for over 70 years, Intergroup offers a variety of managed care options including point of service, preferred provider and third party benefits administration. In August of 1991, Dillon Read lead managed an offering of 3,250,000 shares at $14.50 per share, raising $47.1 million to support the expansion of Intergroup and its provider network.

intergroup

The Great Atlantic & Pacific Tea Company, Inc.

Associated Natural Gas Corporation

PAGE 9

ANNUAL REPORT

DESIGNER Stephen Ferrari, New York, New York TYPOGRAPHIC SOURCE In-house
STUDIO The Graphic Expression, Inc. CLIENT Dillon, Read & Co. Inc. PRINCIPAL TYPE Sabon
DIMENSIONS 8¾ × 11 in. (22.2 × 27.9 cm)

San Francisco International Airport introduced service abroad with the first West Coast flight to Asia. The *1992 Annual Report* is presented during a period of continued rapid growth in

1.

Over 75% of all visitors to San Francisco travel by air. Tourism is one of the most significant elements of the San Francisco Bay Area economy. According to the San Francisco Convention and Visitors Bureau, visitors to San Francisco spent approximately $3.918 billion in the area during 1991. This compares to $2.902 billion spent by visitors in 1990. San Francisco has been rated as the favorite destination by domestic and international visitors.

2.

Total Passengers

Fiscal Year Ending June 30 (Enplaned and Deplaned) (in millions)

The San Francisco Bay Area has over 927,000 residents of Asian descent and 970,000 of Hispanic descent. Asian Pacific Americans comprise 15% of the Bay Area's population. San Francisco has the highest concentration (30%) of Asian Americans of any large city in North America, based on 1990 U.S. census data. Approximately 60% of international visitors arriving at San Francisco International Airport come from Pacific Rim countries. Since 1987, the number of visitors from Asia and the Pacific to the Bay Area has grown 30% compared to 13% from the rest of the world. Bay Area businesses reflect the diversity of the community. Pacific Rim companies have invested $2.8 billion in the Bay Area. Additionally more than $12 billion in goods are exported from the Airport annually.

ANNUAL REPORT

DESIGNERS Jennifer Morla and Sharrie Brooks, San Francisco, California TYPOGRAPHIC SOURCE In-house
STUDIO Morla Design CLIENT San Francisco International Airport PRINCIPAL TYPES Bodoni Book,
Univers 55, 65, and 75 (extended 120%) DIMENSIONS 7½ × 11¾ in. (19.1 × 29.8 cm)

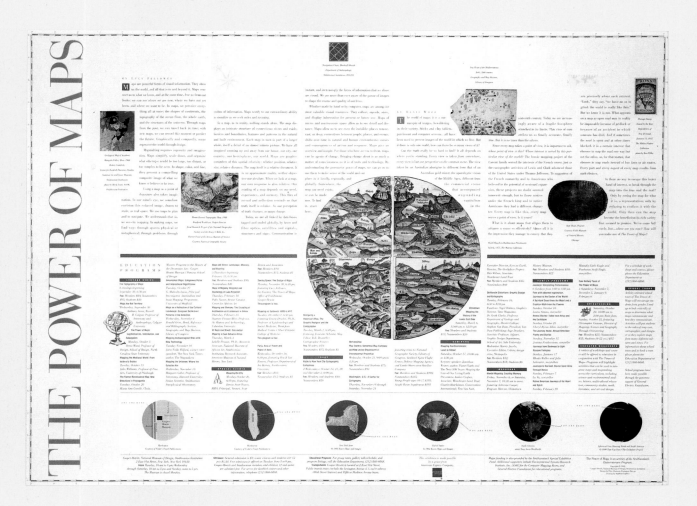

BROCHURE/MAP

DESIGNERS Peter Harrison and Christina Freyss, New York, New York TYPOGRAPHIC SOURCE In-house
STUDIO Pentagram Design CLIENT Cooper-Hewitt Museum PRINCIPAL TYPES Helvetica Condensed Bold
and Bodoni Book DIMENSIONS 3¾ × 9¾ in. (9.5 × 24.8 cm)

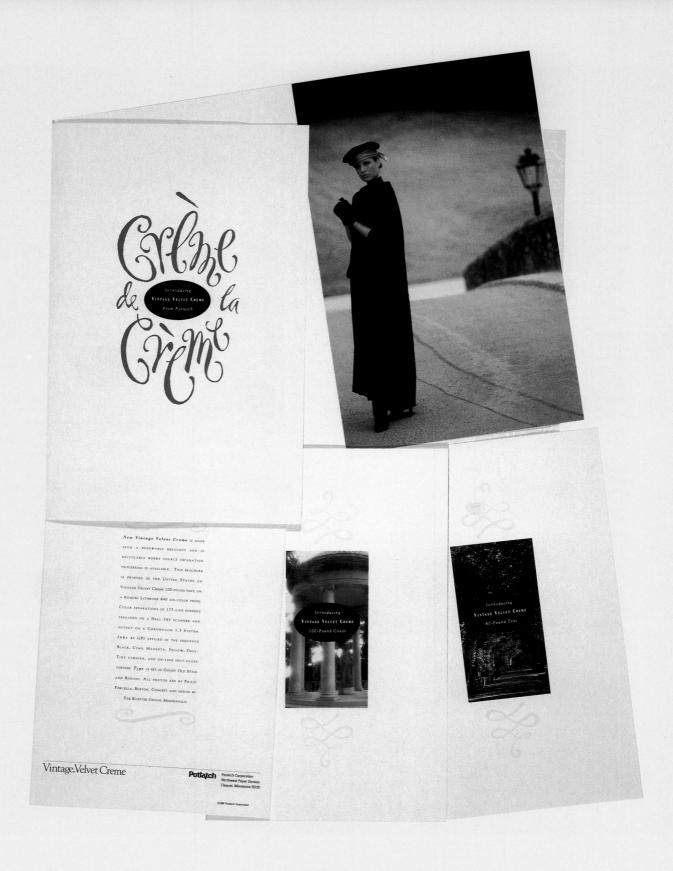

BROCHURE

DESIGNER Bob Goebel, Minneapolis, Minnesota CALLIGRAPHER Georgia Deaver, San Francisco, California
TYPOGRAPHIC SOURCE In-house AGENCY The Kuester Group CLIENT Potlatch Corporation
PRINCIPAL TYPES Goudy Old Style and Bodoni DIMENSIONS 7½ × 12 in. (19.1 × 30.5 cm)

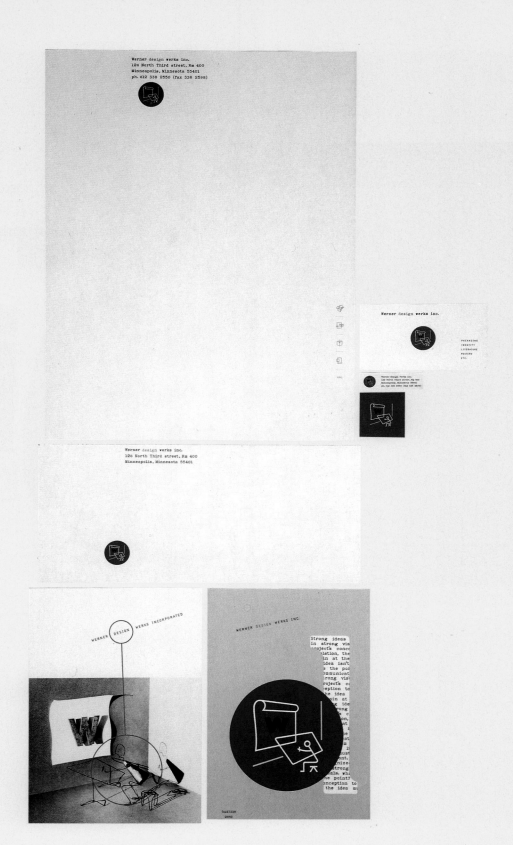

STATIONERY

DESIGNER Sharon Werner, Minneapolis, Minnesota LETTERER Sharon Werner TYPOGRAPHIC SOURCE Great Faces Inc.
STUDIO Werner Design Werks Inc. CLIENT Werner Design Werks Inc. PRINCIPAL TYPE Remington Typewriter
DIMENSIONS 8½ × 11 in. (21.6 × 27.9 cm)

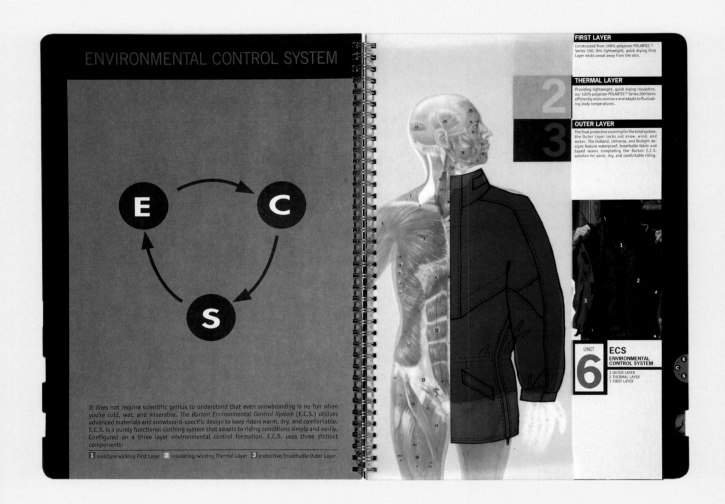

CATALOG

DESIGNERS David Covell and Adam Levit, Burlington, Vermont TYPOGRAPHIC SOURCE In-house
AGENCY Jager Di Paola Kemp Design CLIENT Burton Snowboards PRINCIPAL TYPES ITC Officina and News Gothic
DIMENSIONS 9 × 13 in. (22.9 × 33 cm)

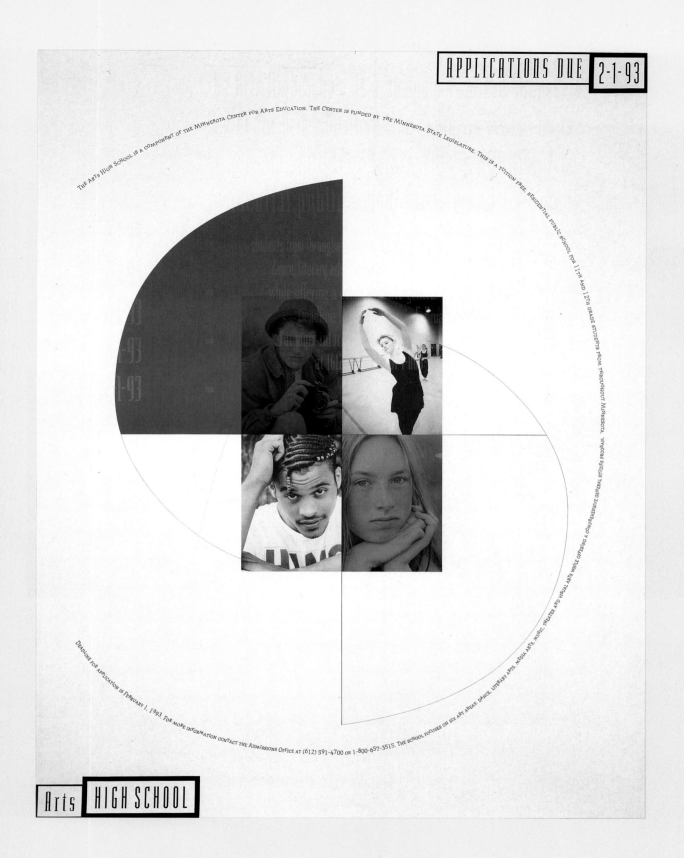

DESIGNER Sandra Harper, Minneapolis, Minnesota ART DIRECTOR Scott Barsuhn PHOTOGRAPHER Ann Marsden
TYPOGRAPHIC SOURCES P&H Photo Composition and Letterworx, Inc. STUDIO Barsuhn Design Incorporated
CLIENT Minnesota Center for Arts Education PRINCIPAL TYPES Senator Tall, Journal Text, Modula Tall, and Matrix Tall
DIMENSIONS 26½ × 34½ in. (67.3 × 87.6 cm)

TELEVISION PROMOTION

DESIGNER Jill Taffet, Los Angeles, California LETTERER David Sparrgrove ART DIRECTOR Jill Taffet
TYPOGRAPHIC SOURCE In-house STUDIO E! Entertainment Television CLIENT E! Entertainment Television
PRINCIPAL TYPES Franklin Gothic Heavy and Helvetica Extra Condensed

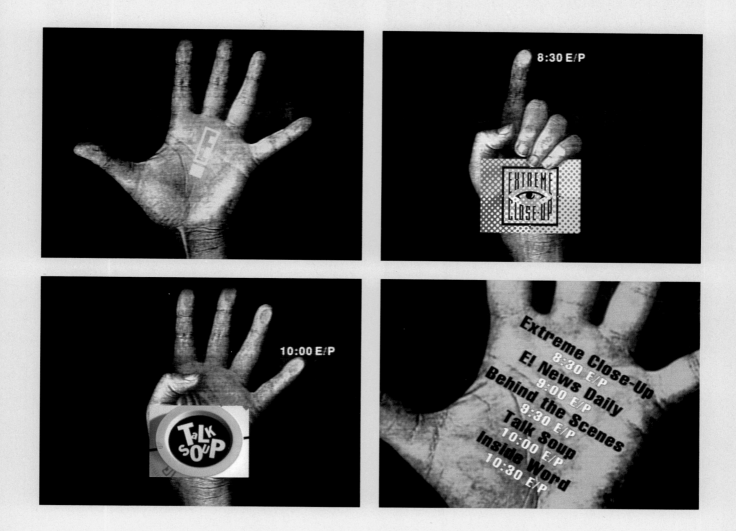

TELEVISION PROMOTION

DESIGNER Jill Taffet, Los Angeles, California LETTERER Jill Taffet TYPOGRAPHIC SOURCE In-house
STUDIO E! Entertainment Television CLIENT E! Entertainment Television
PRINCIPAL TYPE Helvetica Black

83

84

DESIGNERS Jill Taffet and Flavio Kampah, Los Angeles, California LETTERER Flavio Kampah ART DIRECTOR Jill Taffet
TYPOGRAPHIC SOURCE In-house STUDIO E! Entertainment Television CLIENT E! Entertainment Television
PRINCIPAL TYPE Helvetica Black

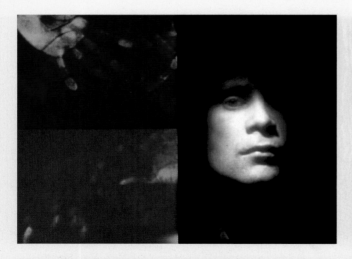

Geoffrey Burridge, Zohn F
Gene Taft, Robert Elston,
Ken Harper, Mark Reynold
Lee Blattau, Timothy Scot
Kevin Patterson, Craig Le
David Michael, Thor E. W

Jerry Block, Jorge Samaniego, Steve Selfert, Tanis
Raymond Clarke, Patrick Scott Slater, Sal Grasso,
T. Michael R Robert Good
Geoffrey Bur Scott, Rob
Gene Taft, R e, Henrique
Ken Harper, w, Stephen
Lee Blattau, Hayes, Matt
Kevin Patter ne, Jeff Ve
David Micha . Anderson,
Michael Mino, Robert Jacobson, Woody Wood, Cu
Kip Ohman, Michael Bennett, Richard Koepke, Art
Charles Ludlam, Eugene Earle, Keith Hein, Gerry F

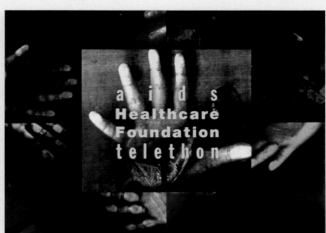

a i d s
Healthcare
Foundation
t e l e t h o n

TELEVISION TITLES

85

DESIGNER Jill Taffet, Los Angeles, California LETTERER Jill Taffet TYPOGRAPHIC SOURCE In-house
STUDIO E! Entertainment Television CLIENT AIDS Healthcare Foundation PRINCIPAL TYPE Helvetica Black

A little over one million years ago, an artist watched a sportsman battle a saber tooth tiger. Returning to his cave, the artist etched the sportsman battling a dinosaur (a stylistic lichotch that was rife on fighting Lalex that evening over drinks, his friends saw what was probably the world's first print ad.

Scholars call the period that followed word-histones I call it advertising. Copywriting was actually invented in 3500 B.C. by the Sumerians. In 1800 B.C. the first typeface appeared. It was called Caxxanite—a precursion to Helvetica Bold.

OME YEARS LATER, THE WORLD'S FIRST GREAT LOGO APPEARED — THE STAR OF DAVID. ONLY FOLLOWED BY AN EQUALLY POWERFUL ONE — THE CRUCIFIX. BOTH LOGOS LED TO "THANK GOD FOR GOD" BUMPER STICKERS. AND, AN ONGOING COMPETITIVE CAMPAIGN BETWEEN AGENCIES THAT MAKES THE COKE/PEPSI BATTLE LOOK FLAT. THIS BATTLE LED TO CHRISTIANITY'S BRILLIANT ADVERTISING COUP. CREATE A MEMORABLE CONTINUING CHARACTER. THE RESULT? THE POPE.

In 500 B.C., at a Chinese Restaurant, Confucius said, "Without knowing the force of words, it is impossible to know men." What followed was copywriting and fortune cookies. † Socrates won Best of Show the following spring. The product was "contentment." Socrates' ink was known by everyone. Perhaps to his disadvantage. By his own omission, the business killed him. † 200 years later, the world saw its first Big Campaign. It was created by Alexander the Great. HIS PEERS ATTRIBUTE THE CAMPAIGN'S SUCCESS TO EXCELLENT REACH AND FREQUENCY. UNFORTUNATELY, THE NEXT THOUSAND YEARS BROUGHT WITH THEM A CREATIVE DROUGHT.

the HISTORY of ADVERTISING

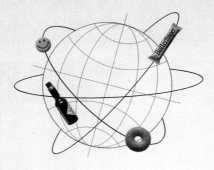

the 1st MILLION years

SURE, ST. PAUL AND ST. AUGUSTINE HAD A FEW REVELATIONS. AND MUHAMMAD AND GENGHIS KHAN OFFERED TWO UNIQUE SELLING PROPOSITIONS. BUT NO ONE SEEMED TO BE COMING UP WITH THE BIG IDEA. UNTIL 1300 A.D.— THE RENAISSANCE— AND IT HAPPENED IN ITALY. BACK THEN, ALL THE CREATIVITY WAS COMING OUT OF THAT PLACE.

The art direction was "Chic" all the way. And, a fellow by the name of Gutenberg opened the world's first typehouse there. In 1492, Columbus went worldwide with the biggest idea since the Renaissance.

AND A DECADE LATER, LEONARDO DA VINCI OPENED HIS DOORS WITH THE HOTTEST NEW BUSINESS THEORY TO DATE. "IF YOU DON'T HAVE THE PRODUCT, INVENT IT." IT'S RUMORED THAT DA VINCI, MICHAELANGELO AND MACHIAVELLI WOULD START AN AGENCY, BUT DMM NEVER TOOK OFF. APPARENTLY THE TWO CREATIVES THOUGHT MACHIAVELLI WAS ONLY OUT FOR HIMSELF. — SHAKESPEARE MADE LONG COPY FAMOUS IN 1600. REMBRANDT WON ALL THE ART DIRECTOR AWARDS 25 YEARS LATER. AND 50 YEARS LATER, ISAAC NEWTON PROVED THAT RESEARCH AND TESTING DIDN'T FALL FAR FROM THE TREE. AND, LET'S NOT FORGET THE INVENTOR OF THE STEAM ENGINE. THIS ALLOWED ADVERTISERS TO TRAVEL, WHICH LED, OF COURSE, TO T&E.

by CONCEPT—Joey Reiman, DESIGN—Maxey Andress, DESIGN STUDIO—EM2, AGENCY—Babbit & Reiman, WRITER—Joey Reiman, TYPOGRAPHY—The Alphabet Shop, A Division of Advertising Technologies, Inc., PHOTOGRAPHY—Pelad & Chambers, PRINTING—American Graphics, PAPER—Butler Paper Company

And as we all know, if the strategy is wrong, it can't be right. America had a bomb also. But, we dropped it in Japan's lap. When the air cleared, the world would see the most important development since the caveman created the first print ad—and this, of course, was television. The next 50 years of history can be seen in the last 50 years of television. Let's face it. Advertising's been around since the beginning. God started it. He created man in His own "image."

Ben Franklin lit up the industry when he and a bunch of account men got together and created the idea of the century. The U.S.A. Jefferson did the writing and Washington was Management Supervisor. The brief was "In God We Trust." The logo? Well, the account man wanted a turkey to acknowledge the pilgrims. Research said the Crucifix was proven and easy to make. Media wanted four different ones, targeted at different

groups. And Creative suggested the eagle. They knew it would fly. Francis Scott Key was hired to do the music, and the rest, as you know, is history. Back in Europe, Napoleon broke his campaign. A man of the world always seen with his hand tucked in his jacket. Apparently a strong mnemonic. A few miles down the road, Beethoven opened Bonn Music, a jingle house that worked for some of the great. Beethoven's real fortune came when he had a falling out with one of his clients. He had written the piece four times

and was fed up. Beethoven finally sold the Fifth, which was a hit. In France, Lou Daguerre invented photography or as we know it—swipe material. Back in America, the greatest demo of all times was being shot—the Civil War. The U.S.A. came out new and improved. A decade later, Bell reached out and touched someone. Edison brought good things to life and the only way to travel was Cadillac style. Marconi claimed that radio was hot. Freud claimed everyone in our business was hot. The Wright Brothers forced our industry to

double the per diem and Einstein said efficiency equals more cable squared. Lenin said he had the most revolutionary concept in the world. FDR claimed his New Deal was the biggest. But, Lenin and Roosevelt were beaten out by the biggest ad blitz of the twentieth century. Hitler's Third Reich. Armed with a powerful logo, excellent media placement, lots of dollars and hard hitting creative, Hitler's campaign couldn't fail. Except for one thing. World domination through genocide was a bad strategy.

POSTER

DESIGNER Maxey Andress, Atlanta, Georgia TYPOGRAPHIC SOURCE Advertising Technologies STUDIO EM2 Design
CLIENT Reiman Advertising PRINCIPAL TYPES Garamond, Modern, Futura Condensed, and Caslon
DIMENSIONS 22 × 36¼ in. (55.9 × 92.1 cm)

STATIONERY

Designers Klaus Hesse and Gerhard Schmal, Düsseldorf, Germany Letterer Gerhard Schmal
Copywriter Stefan Weigl Typographic Source In-house Agency Hesse Designagentur
Client Pechtl Beratende Unternehmer, München Principal Types Akzidenz-Grotesk and handlettering
Dimensions 8¼ × 11⅔ in. (21 × 29.7 cm)

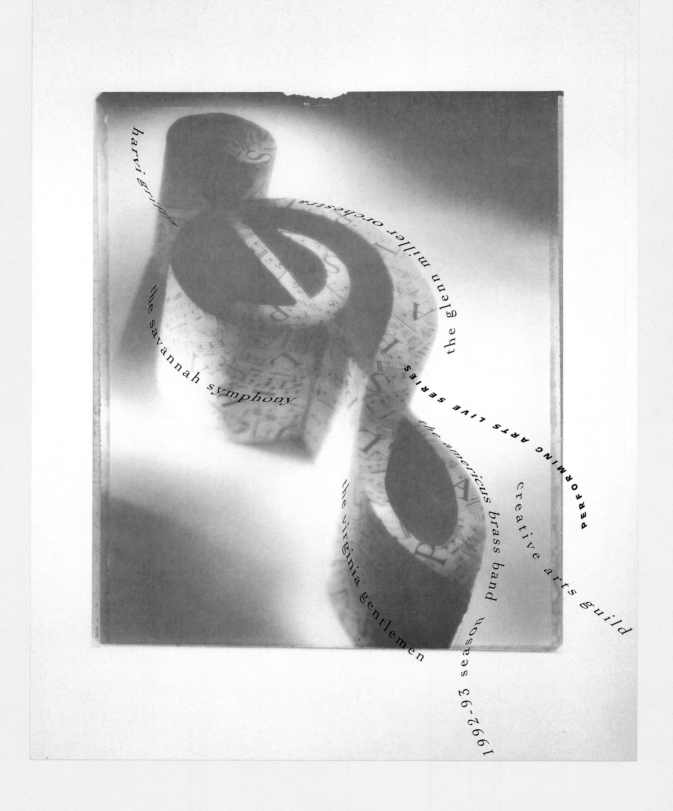

harvi griffin

the glenn miller orchestra

the savannah symphony

the americus brass band

creative arts guild

PERFORMING ARTS LIVE SERIES

the virginia gentlemen

1992-93 season

POSTER

DESIGNER Russ Ramage, Dalton, Georgia PHOTOGRAPHER Jerry Burns TYPOGRAPHIC SOURCE In-house
STUDIO DESIGN! CLIENT Creative Arts Guild PRINCIPAL TYPES Cochin and Antique Olive
DIMENSIONS 17 × 22 in. (43.2 × 55.9 cm)

BOOK

DESIGNER Andrej Krátky, Bratislava, Slovakia TYPOGRAPHIC SOURCE In-house
STUDIO Academy of Applied Arts, Prague PRINCIPAL TYPE Stempel Garamond
DIMENSIONS 8½ × 12 in. (21.6 × 30.5 cm)

DIRECT MAIL

90

DESIGNER Andréas Netthoevel, Biel, Switzerland ART DIRECTOR Andréas Netthoevel
CREATIVE DIRECTOR Andréas Netthoevel TYPOGRAPHIC SOURCE Studio Sulzener
STUDIO Second Floor South CLIENT Tailor Studio Ursula Wymann PRINCIPAL TYPE ITC Franklin Gothic Book
DIMENSIONS 8¼ × 23⅝ in. (21 × 60 cm)

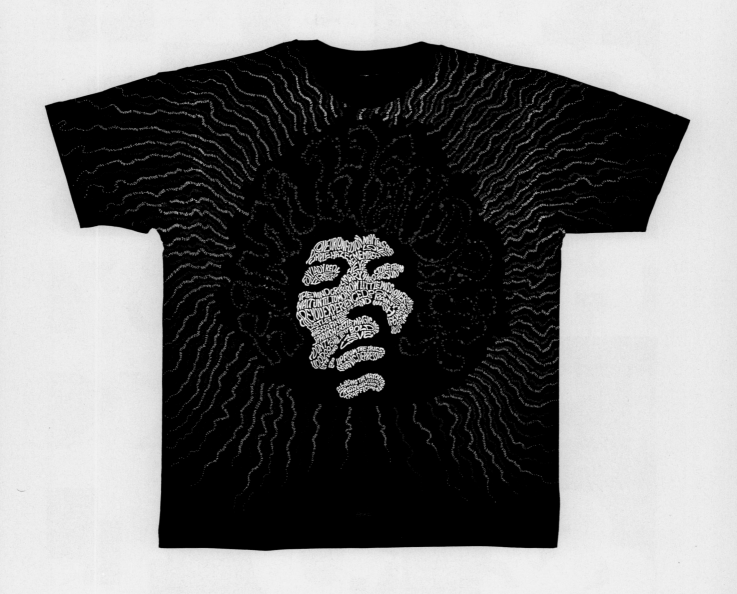

T-SHIRT

DESIGNER Roger Labon Jackson, San Francisco, California LETTERER Roger Labon Jackson
STUDIO Winterland Productions CLIENT "Are You Experienced," Inc.
PRINCIPAL TYPE Handlettering

The ROLLING STONE ILLUSTRATED HISTORY of ROCK & ROLL FULLY REVISED AND UPDATED · EDITED BY ANTHONY DeCURTIS & JAMES HENKE WITH HOLLY GEORGE-WARREN ORIGINAL EDITOR JIM MILLER

BOOK COVER

DESIGNER Fred Woodward, New York, New York TYPOGRAPHIC SOURCE In-house STUDIO Rolling Stone
CLIENT Random House PRINCIPAL TYPE Egiziano DIMENSIONS 11½ × 8¾ in. (29.2 × 22.2 cm)

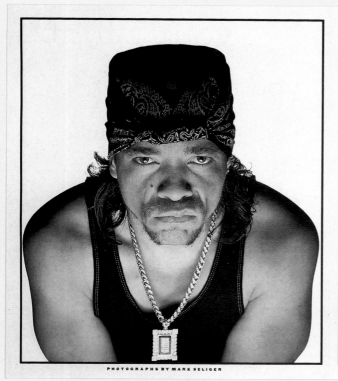

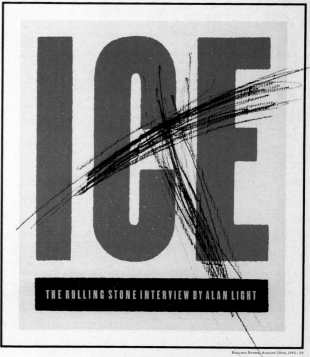

MAGAZINE SPREAD

DESIGNER Debra Bishop, New York, New York TYPOGRAPHIC SOURCE In-house STUDIO Rolling Stone
CLIENT Rolling Stone PRINCIPAL TYPE Woodblock Condensed
DIMENSIONS 12 × 20 in. (30.5 × 50.8 cm)

The Perils of Pauly Weazin' buff nugs and chillin' with MTV's Pauly Shore, the star of *Encino Man* "I'm in nug heaven," says Pauly "the Weasel" Shore. The scene in the swank Sunset Boulevard café is *La Dolce Vita* remade by L.A. headbangers: Tables of young women ("nugs") with plunging necklines and surging, surgically enhanced chests await their turns to flirt with the star of MTV's *Totally Pauly* show as he asks Tai Collins, featured on the cover of *Playboy* as "the woman Senator Charles Robb couldn't resist," for her phone number. Before the night is through, Pauly will woo ("weaz"— which can also be used to describe more advanced stages of dating) all comers. ¶ Pauly, at first glance, seems an unlikely Lothario, a short, burned-out-looking twenty-four-year-old with stringy brown hair ("Jim Morrison's retarded son," as Pauly — By Jay Martel

54 · ROLLING STONE, JULY 9TH–23RD, 1992

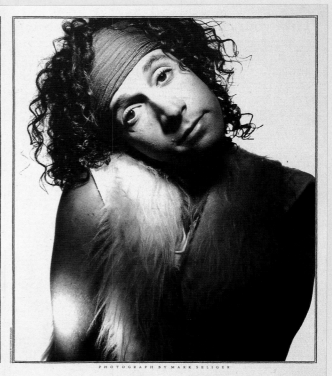

PHOTOGRAPH BY MARK SELIGER

MAGAZINE SPREAD

DESIGNER Debra Bishop, New York, New York TYPOGRAPHIC SOURCE In-house STUDIO Rolling Stone
CLIENT Rolling Stone PRINCIPAL TYPE Cloister DIMENSIONS 12 × 20 in. (30.5 × 50.8 cm)

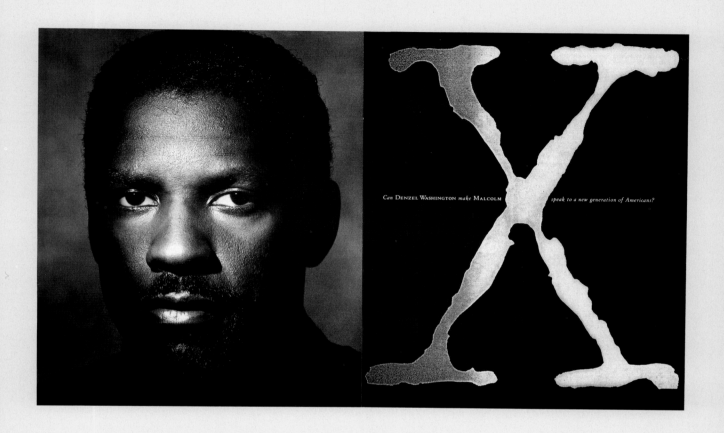

Can Denzel Washington *make* Malcolm *speak to a new generation of Americans?*

MAGAZINE SPREAD

DESIGNER Gail Anderson, New York, New York TYPOGRAPHIC SOURCES In-house and Personal Library
STUDIO Rolling Stone CLIENT Rolling Stone PRINCIPAL TYPE Lettera
DIMENSIONS 12 × 20 in. (30.5 × 50.8 cm)

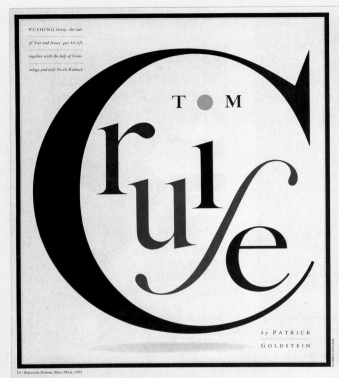

PUSHING *thirty, the star
of 'Far and Away' gets his life
together with the help of Scien-
tology and wife Nicole Kidman*

T O M

Cruise

by PATRICK
GOLDSTEIN

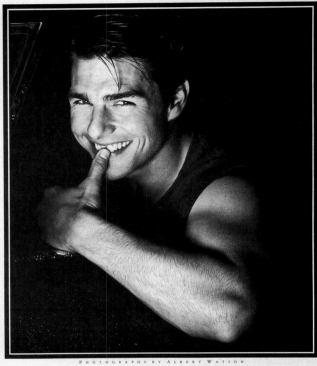

PHOTOGRAPHS BY ALBERT WATSON

MAGAZINE SPREAD

DESIGNER Fred Woodward, New York, New York TYPOGRAPHIC SOURCE In-house STUDIO Rolling Stone
CLIENT Rolling Stone PRINCIPAL TYPE Caslon DIMENSIONS 12 × 20 in. (30.5 × 50.8 cm)

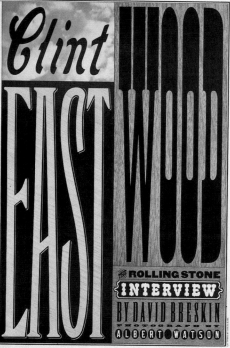

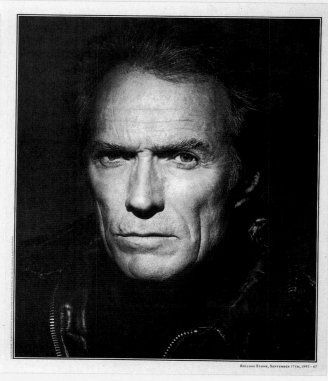

Clint
EASTWOOD

THE ROLLING STONE
INTERVIEW
BY DAVID BRESKIN
PHOTOGRAPH BY
ALBERT WATSON

MAGAZINE SPREAD

97

DESIGNER Fred Woodward, New York, New York TYPOGRAPHIC SOURCE In-house STUDIO Rolling Stone
CLIENT Rolling Stone PRINCIPAL TYPE Various DIMENSIONS 12 × 20 in. (30.5 × 50.8 cm)

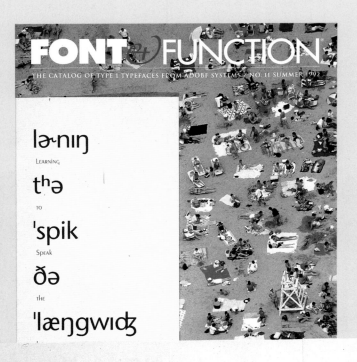

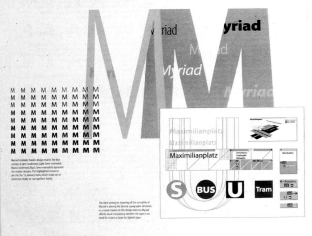

CATALOG

DESIGNERS Gail Blumberg, Ewa Gavrielov, Keala Hagmann, Susan Verba, and Min Wang, Mountain View, California
TYPOGRAPHIC SOURCES In-house and Metagraphics, Inc. STUDIO Adobe Marcom Department
CLIENT Adobe Systems Incorporated PRINCIPAL TYPE Adobe Type Library
DIMENSIONS 10½ × 15 in. (26.7 × 38.1 cm)

CATALOG

99

DESIGNERS Gail Blumberg, Ewa Gavrielov, Keala Hagmann, Susan Verba, and Min Wang, Mountain View, California
TYPOGRAPHIC SOURCES In-house and Metagraphics, Inc. STUDIO Adobe Marcom Department
CLIENT Adobe Systems Incorporated PRINCIPAL TYPE Adobe Type Library
DIMENSIONS 10½ × 15 in. (26.7 × 38.1 cm)

Arbor abcdefghijklmnopqrstuvwxyz
ABCDEFGHIJKLMNOPQRSTUVWXYZ
1234567890.,!? &$¢

14 point

Arbor was designed by Bonnie Ruth Barrett in Los Angeles in 1992. Her previous training and professional experience are in calligraphy and hand lettering. Arbor is based on a broad-pen alphabet derived from Carolingian models. The designer's intention was to retain the life and joy of hand lettering in a clear and legible typeface. A sample book based on her research into the symbolism and mythology of the tree was also produced. The design of an original typeface is an exacting and lengthy process requiring hundreds of hours of work. Over 60 letters and numbers must be drawn in such a

12 point

Arbor was designed by Bonnie Ruth Barrett in 1992. Her previous training and professional experience are in calligraphy and hand lettering. Arbor is based on a broad-pen alphabet derived from Carolingian models. The designer's intention was to retain the life and joy of hand lettering in a clear and legible typeface. A sample book based on her research into the symbolism and mythology of the tree was also produced. The design of an original typeface is an exacting and lengthy process requiring hundreds of hours of work. Over 60 letters and numbers must be drawn in such a way that they are distinct from one another, but still in harmony. Dozens of additional marks must be designed to make a working font, and the spacing between

10 point

Arbor was designed by Bonnie Ruth Barrett in 1992. Her previous training and professional experience are in calligraphy and hand lettering. Arbor is based on a broad-pen alphabet derived from Carolingian models. The designer's intention was to retain the life and joy of hand lettering in a clear and legible typeface. A sample book based on her research into the symbolism and mythology of the tree was also produced. The design of an original typeface is an exacting and lengthy process requiring hundreds of hours of work. Over 60 letters and numbers must be drawn in such a way that they are distinct from one another, but still in harmony. Dozens of additional marks must be designed to make a working font, and the spacing between every possible combination of letters must be set. Even when working to the exacting standards of typography the the final judgements must be made by eye, not measurement. An alphabet with harmony and grace cannot be achieved by mathematical formula. Arbor was designed by Bonnie Ruth Barrett in 1992. Her

9 point

Arbor was designed by Bonnie Ruth Barrett in 1992. Her previous training and professional experience are in calligraphy and hand lettering. Arbor is based on a broad-pen alphabet derived from Carolingian models. The designer's intention was to retain the life and joy of hand lettering in a clear and legible typeface. A sample book based on her research into the symbolism and mythology of the tree was also produced. The design of an original typeface is an exacting and lengthy process requiring hundreds of hours of work. Over 60 letters and numbers must be drawn in such a way that they are distinct from one another, but still in harmony. Dozens of additional marks must be designed to make a working font, and the spacing between every possible combination of letters must be set. Even when working to the exacting standards of typography the the final judgements must be made by eye, not measurement. An alphabet with harmony and grace cannot be achieved by mathematical formula. Arbor was designed by Bonnie Ruth Barrett in 1992. Her previous training and professional experience are in calligraphy and hand lettering. Arbor is based on a broad-pen alphabet derived from Carolingian models. The designer's intention was to retain the life and joy of hand lettering in a clear and legible typeface. A sample book based on her research into

TYPEFACE

DESIGNER Bonnie Ruth Barrett, Los Angeles, California TYPOGRAPHIC SOURCE In-house
STUDIO Grey Dove Studio CLIENT Grey Dove Studio PRINCIPAL TYPE Arbor

THE TREE AND THE CROSS
Bonnie Ruth Barrett

ARBOR

ABCDEFGHIJKLMNOPQRSTUVWXY&Z

BOOK

DESIGNER Bonnie Ruth Barrett, Los Angeles, California PHOTOGRAPHER Ann Summa TYPOGRAPHIC SOURCE In-house
STUDIO Grey Dove Studio CLIENT Grey Dove Studio PRINCIPAL TYPE Arbor
DIMENSIONS 10 × 10 in. (25.4 × 25.4 cm)

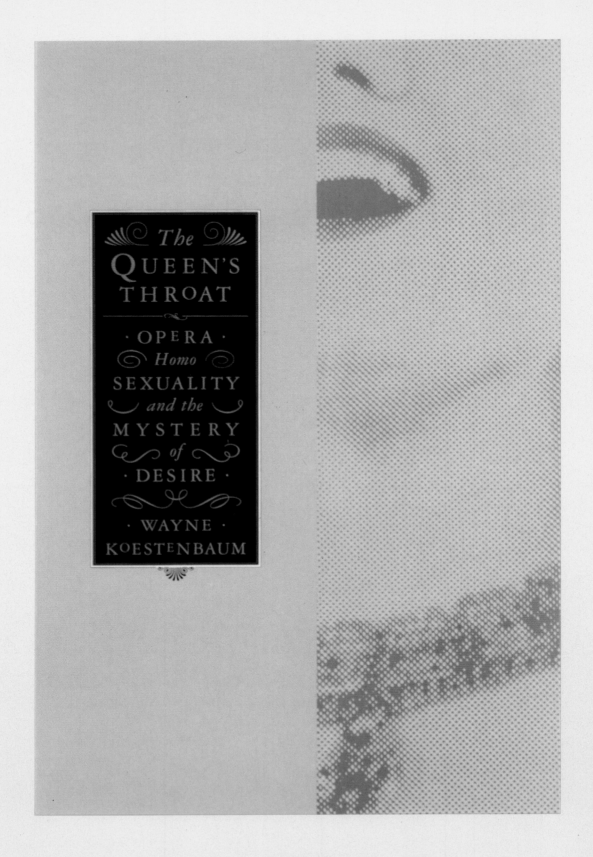

BOOK COVER

DESIGNER Carin Goldberg, New York, New York TYPOGRAPHIC SOURCE Franklin Typographers
STUDIO Carin Goldberg Design CLIENT Simon and Schuster PRINCIPAL TYPE Garamond
DIMENSIONS 6¼ × 9½ in. (15.9 × 24.1 cm)

PROMOTION

DESIGNER Laurie Jacobi, Twin Pines, Minnesota LETTERER Laurie Jacobi TYPOGRAPHIC SOURCES AlphaGraphics One
and Treasure Bay Printing STUDIO Laurie Jacobi CLIENT The Madden Corporation of New York
PRINCIPAL TYPE Various DIMENSIONS 6¼ × 27 in. (15.9 × 68.6 cm)

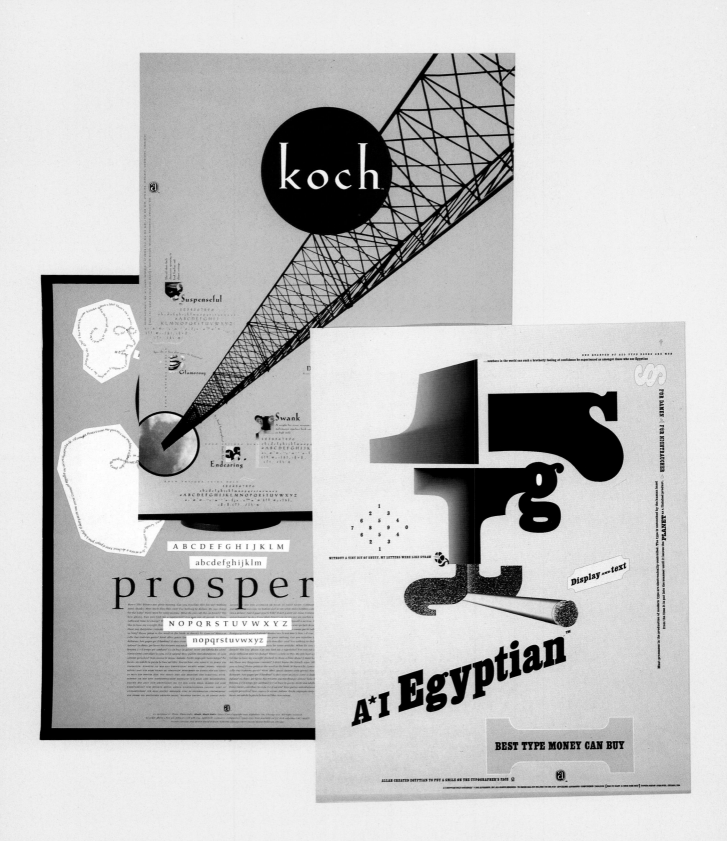

DESIGNER Ejaz Mujeeb Syed, Evanston, Illinois TYPOGRAPHIC SOURCES In-house and Robert McCamant (type revived)
STUDIO Alphabets Design Group CLIENT Alphabets, Inc. PRINCIPAL TYPE A*I Egyptian Bold Condensed
DIMENSIONS 17 × 22 in. (43.2 × 55.9 cm)

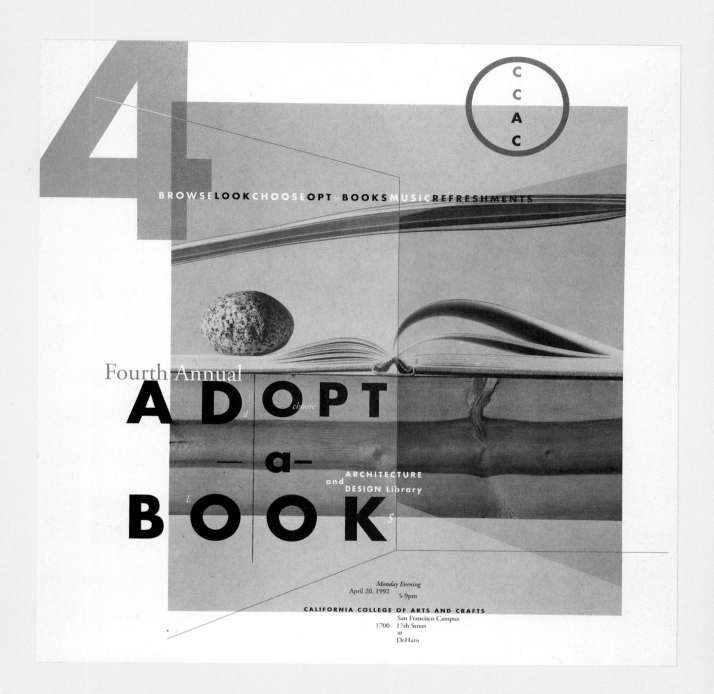

POSTER

DESIGNER Lucille Tenazas, San Francisco, California TYPOGRAPHIC SOURCE Eurotype STUDIO Tenazas Design
CLIENT California College of Arts and Crafts PRINCIPAL TYPES Futura and Garamond No. 3
DIMENSIONS 18 × 18 in. (45.7 × 45.7 cm)

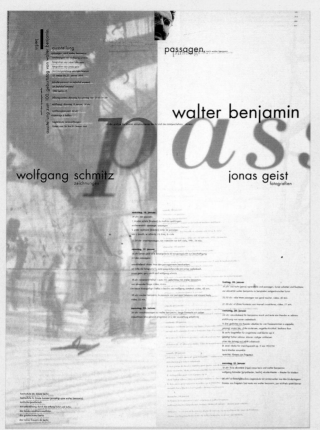
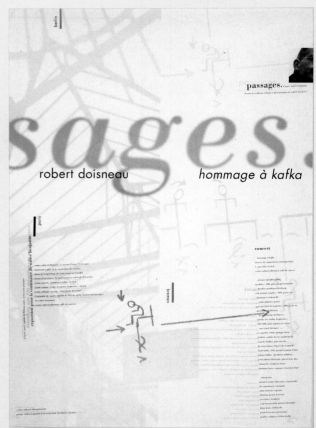

POSTERS

Designers Tammo F. Bruns, Frank Schulte, and Karsten Unterberger, Bremen, Germany
Typographic Source In-house Agency kleiner & bold Client Projektgruppe Benjamin,
Hochschule für Künste Bremen Principal Types Futura Book and Bodoni
Dimensions 23½ × 33¹⁄₁₆ in. (59.7 × 84 cm)

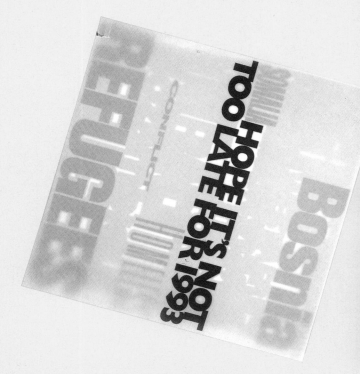

GREETING CARD

DESIGNER Jurek Wajdowicz, New York, New York TYPOGRAPHIC SOURCE In-house
STUDIO Emerson, Wajdowicz Studios, Inc. CLIENT Emerson, Wajdowicz Studios, Inc.
PRINCIPAL TYPES Akzidenz-Grotesk, Franklin Gothic, Gill Sans, and Helvetica
DIMENSIONS 7¼ × 7¼ in. (18.4 × 18.4 cm)

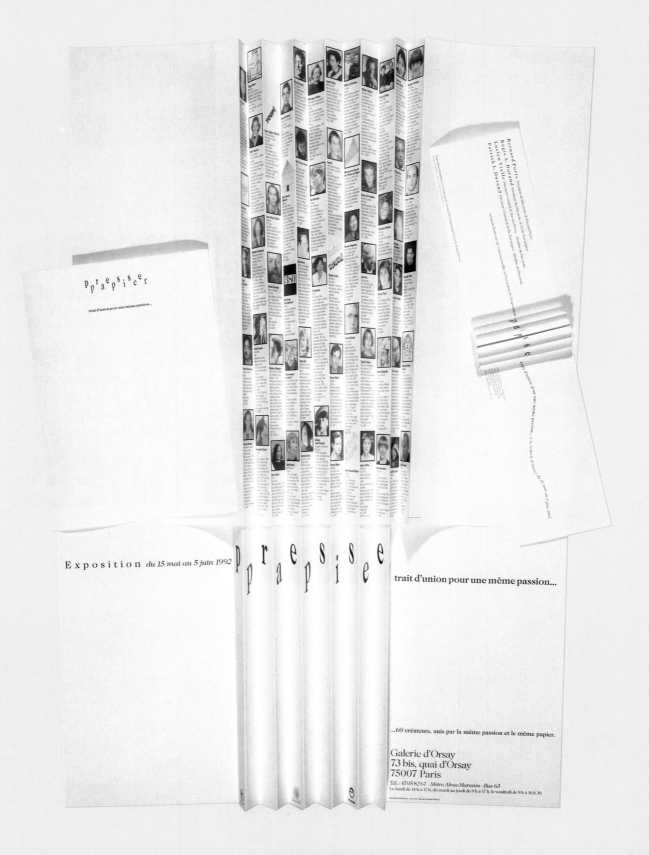

PROMOTION

Designer Michel Olivier, Paris, France Typographic Source Goldfinger-Tygra Studio M. O' Design
Client Bayard Presse Development Visual M. Rémondière Principal Type Caslon
Dimensions 29½ × 21⅝ in. (75 × 55 cm)

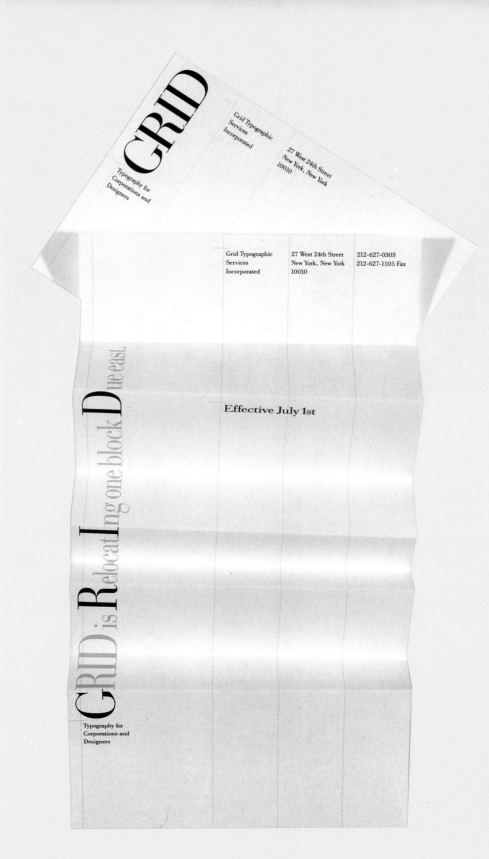

DESIGNER Robert R. Rosenberg, New York, New York TYPOGRAPHIC SOURCE Grid Typographic Services Inc.
STUDIO Richard Rogers Inc. CLIENT Grid Typographic Services Inc. PRINCIPAL TYPES Bauer Bodoni and Bodoni Book
DIMENSIONS 6¹⁄₁₆ × 4½ in. (15.4 × 11.5 cm)

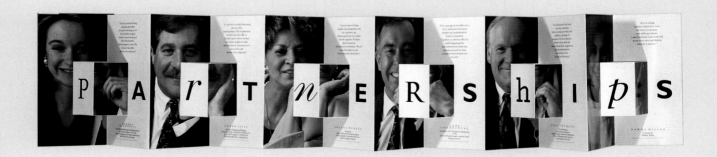

BROCHURE

DESIGNERS Victor Rivera and Daniel Koh, New York, New York TYPOGRAPHIC SOURCE Addison Technology Company
STUDIO Addison Corporate Annual Reports Inc. CLIENT Chesebrough-Pond's USA Co.
PRINCIPAL TYPES Gill Sans and Bembo DIMENSIONS 36 × 6¼ in. (91.4 × 15.9 cm)

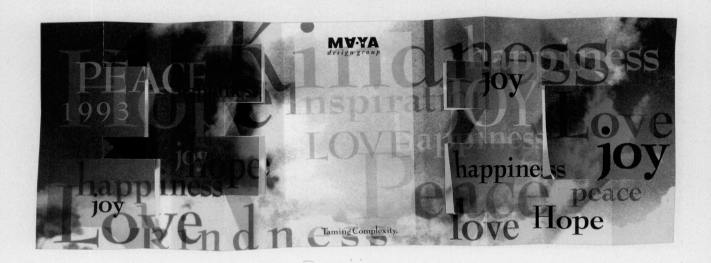

GREETING CARD

DESIGNER Hugo T. Cheng, Pittsburgh, Pennsylvania TYPOGRAPHIC SOURCE In-house STUDIO MAYA Design Group
CLIENT MAYA Design Group PRINCIPAL TYPE Bernhard Modern
DIMENSIONS Folded: 3 × 5 in. (7.6 × 12.7 cm) Flat: 15 × 5 in. (38.1 × 12.7 cm)

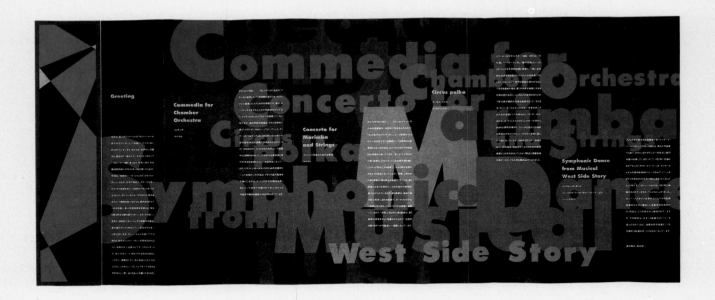

BROCHURE

DESIGNER Zempaku Suzuki, Ginza, Tokyo, Japan LETTERERS Zempaku Suzuki, Norio Nishikawa, and Masayuki Kudoh
TYPOGRAPHIC SOURCE In-house AGENCY DENTSU INC. STUDIO B•BI Studio Incorporated CLIENT Fuji Bank
PRINCIPAL TYPES Futura Extra Bold and BG-A-KL DIMENSIONS 2¾ × 11⅝ in. (7 × 29.7 cm)

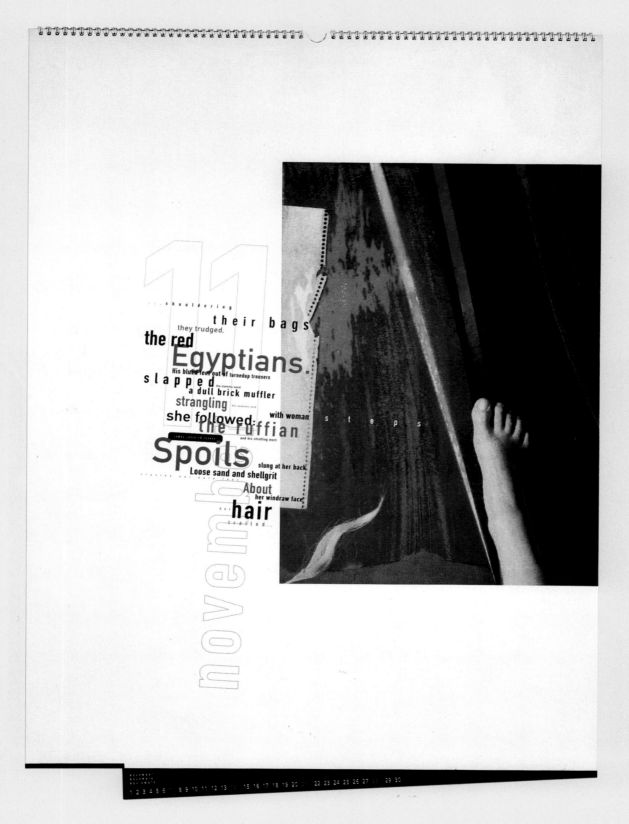

CALENDAR

DESIGNER Klaus Bietz, Frankfurt, Germany TYPOGRAPHIC SOURCE In-house STUDIO Klaus Bietz
CLIENT Fachhochschule Wiesbaden, Fachbereich Gestaltung PRINCIPAL TYPE Various
DIMENSIONS 23⅝ × 32 in. (60 × 83 cm)

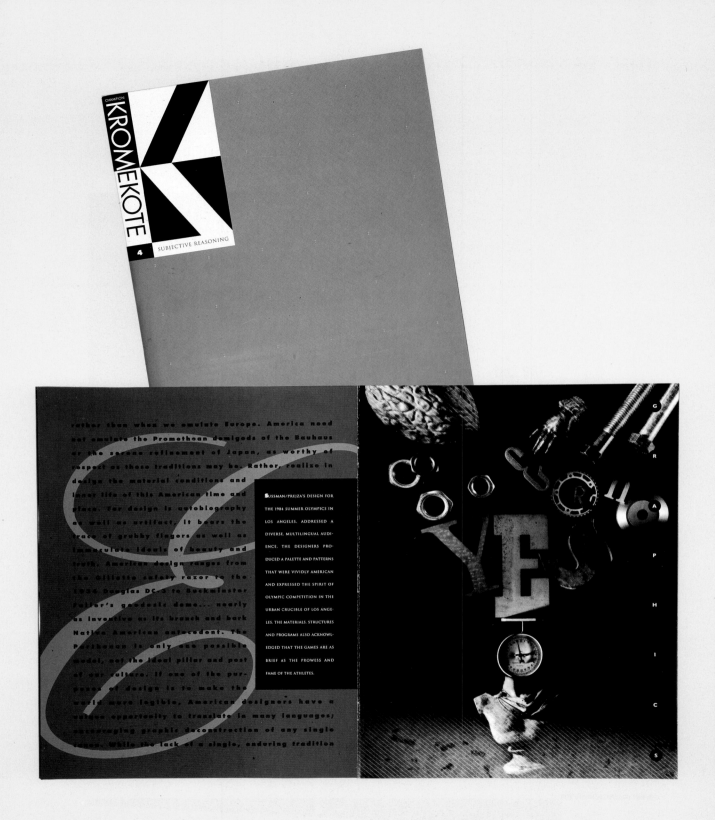

BROCHURE

DESIGNER Michael Vanderbyl, San Francisco, California ART DIRECTORS Paula Scher and Bill Drenttel
PHOTOGRAPHER Michele Clement, New York, New York TYPOGRAPHIC SOURCE In-house STUDIOS Pentagram Design
and Drenttel Doyle Partners CLIENT Champion International Corporation PRINCIPAL TYPES Futura Extra Bold,
Futura Book, and Trajan DIMENSIONS 9¼ × 11⅝ in. (23.5 × 29.5 cm)

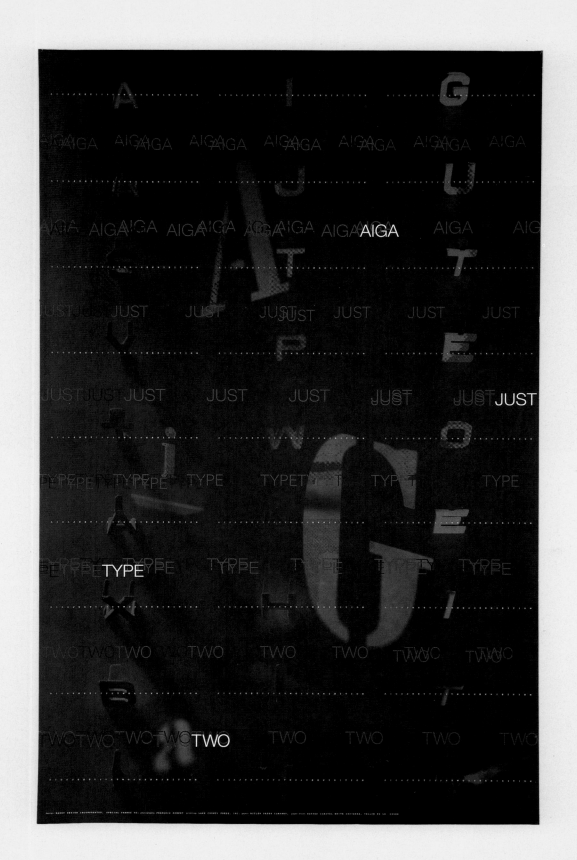

POSTER

DESIGNER Jane Gittings, Chicago, Illinois PHOTOGRAPHER François Robert TYPOGRAPHIC SOURCE In-house
AGENCY Bagby Design Incorporated CLIENT American Institute of Graphic Arts/Chicago
PRINCIPAL TYPES Helvetica, Univers, and B Courier Bold DIMENSIONS 24 × 38 in. (61 × 96.5 cm)

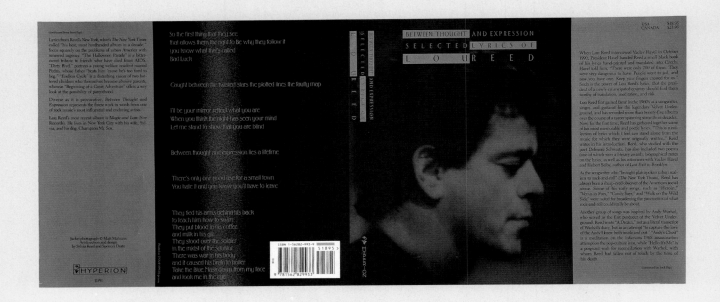

BOOK COVER

DESIGNERS Sylvia Reed and Spencer Drate, New York, New York TYPOGRAPHIC SOURCE JCH Group
STUDIO JustDesign CLIENT Hyperion PRINCIPAL TYPE Florentine
DIMENSIONS 6 × 8½ in. (15.2 × 21.6 cm)

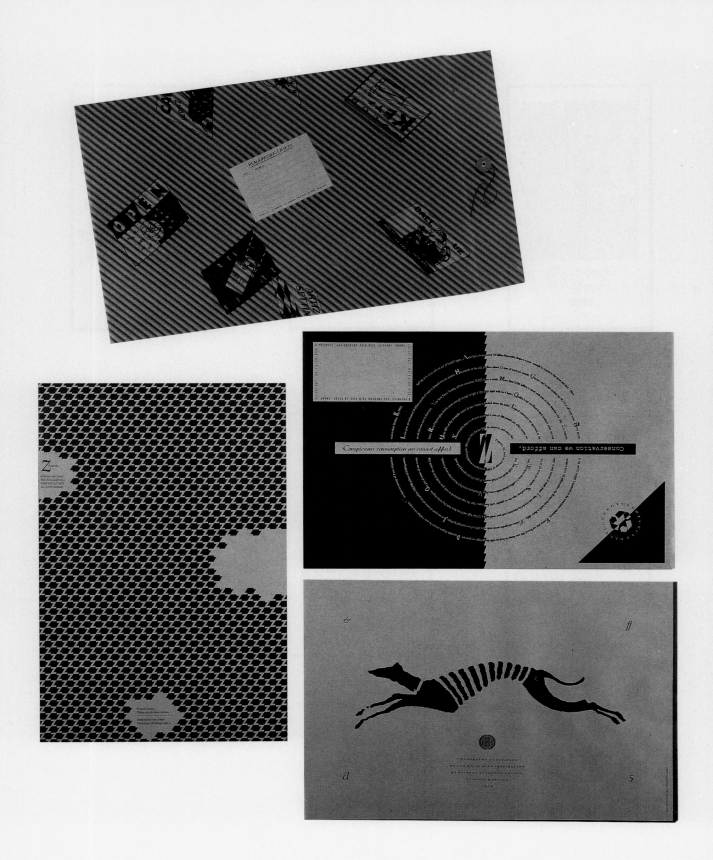

ENVELOPES

DESIGNERS Mark Anderson, Mauricio Arias, Michael Chikamura, Sam Smidt, and Lai-kit Chan, Palo Alto
and San Francisco, California TYPOGRAPHIC SOURCE Z PrePress, Inc. STUDIOS Mark Anderson Design,
Mauricio Arias Design, Michael Chikamura Design, and Sam Smidt Design CLIENT Z PrePress, Inc.
PRINCIPAL TYPE Various DIMENSIONS Large: 15 × 20 in. (38.1 × 50.8 cm) Small: 10 × 15 in. (25.4 × 38.1 cm)

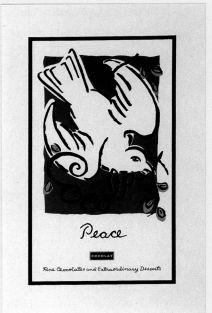
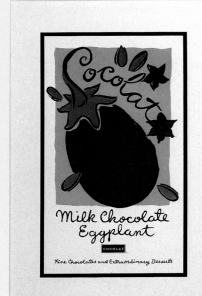
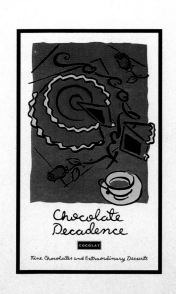
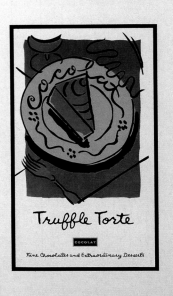

POSTERS

DESIGNERS Paul Curtin and Benta Lloyd, San Francisco, California LETTERER Tim Clark
TYPOGRAPHIC SOURCE In-house AGENCY Paul Curtin & Partners STUDIO Paul Curtin Design Ltd.
CLIENT Cocolat, Inc. PRINCIPAL TYPES Parsons Bold and handlettering
DIMENSIONS 40 × 60 in. (101.6 × 152.4 cm)

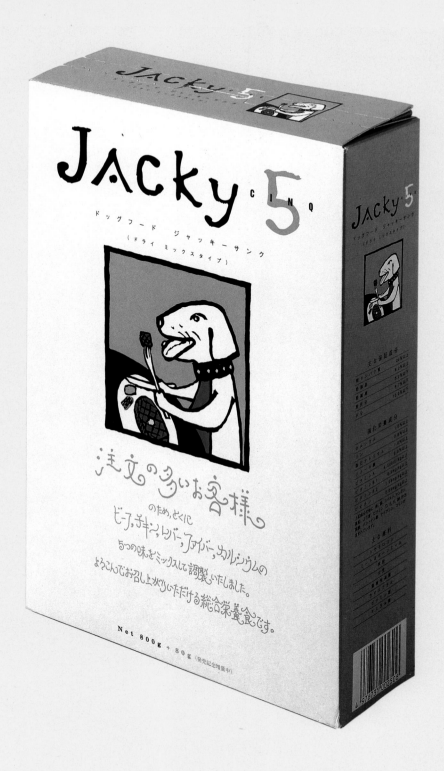

DESIGNER Yoshitaka Sasaki, Tokyo, Japan LETTERERS Mao Yamaguchi and Hodaka Ishino
ILLUSTRATOR Mao Yamaguchi ART DIRECTOR Toshiaki Itoh TYPOGRAPHIC SOURCE In-house
AGENCY Grafix International CLIENT Jewelry Corporation PRINCIPAL TYPE Handlettering
DIMENSIONS 10⅓ × 7 × 2⅝ in. (26.3 × 17.9 × 6 cm)

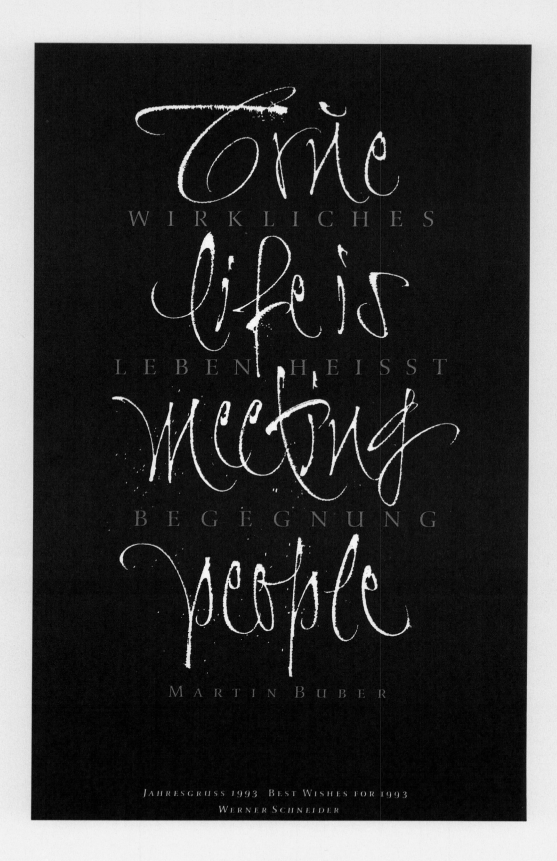

True
WIRKLICHES
life is
LEBEN HEISST
meeting
BEGEGNUNG
people

MARTIN BUBER

JAHRESGRUSS 1993 BEST WISHES FOR 1993
WERNER SCHNEIDER

GREETING CARD

120

DESIGNER Werner Schneider, Bad Laasphe, Germany CALLIGRAPHER Werner Schneider
TYPOGRAPHIC SOURCE In-house STUDIO Werner Schneider CLIENT Werner Schneider
PRINCIPAL TYPES Schneider-Antiqua and handlettering DIMENSIONS 7 × 11⅔ in. (17.8 × 29.6 cm)

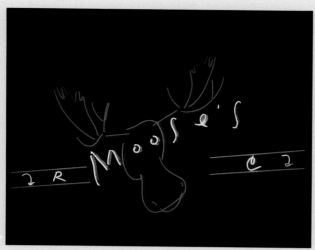

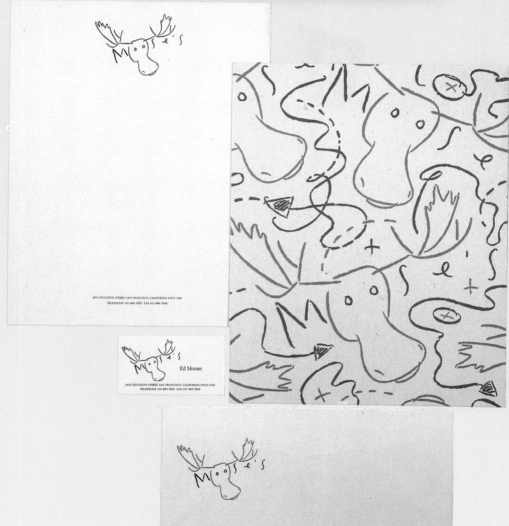

CORPORATE IDENTITY

DESIGNER Ward Schumaker, San Francisco, California CALLIGRAPHER Ward Schumaker
TYPOGRAPHIC SOURCE Display Lettering STUDIO Schumaker CLIENT Moose's
PRINCIPAL TYPES ITC Berkeley Old Style and handlettering DIMENSIONS Various

BROCHURE

Designer Adam Bronson McIsaac, Portland, Oregon Typographic Source In-house
Studio SmithGroup Communications Client Arjo Wiggins Fine Papers Export Ltd.
Principal Types Gill Sans, Joanna, and News Gothic
Dimensions 10¼ × 12 in. (26 × 30.3 cm) and 11¼ × 11¼ in. (28.5 × 28.5 cm)

Architects and painters have often worked in close association with printers since the 15th century, when in Italy & France they furnished many of the decorative borders and initials that were used.

BRUCE ROGERS

POSTCARD

DESIGNER J. Michael Marriner, San Francisco, California TYPOGRAPHIC SOURCE In-house
STUDIO Scooter Engineering and Design CLIENT Scooter Engineering and Design
PRINCIPAL TYPE ATF Post Antiqua DIMENSIONS 4¼ × 5½ in. (10.8 × 14 cm)

I WAS IN SUCH A SITUATION in the Netherlands that had I delighted in amassing money, instead of aiming to help my country, in the belief that the common good must come before the private, then I could easily have amassed forty or fifty thousand forints. Had I remained there, I would not now change places with many lords in Transylvania, as far as money is concerned.

During the five years in Amsterdam when I was occupied with printing, how different things might have been; at times they pushed money to my lodgings by the barrowload. I could easily have squandered a great income there, upon all the pleasures of the flesh, if I had followed all the other good master craftsmen, whose usual practice was to waste all they earned with a day's work in taverns and other vile places. Despite all my money, I begrudged even what I spent on bread to feed my wretched body. Sometime I drank no wine for as long as a month: I was so parsimonious that I might accomplish those things I undertook at the Lord's behest. Frequently I laid out all my money with printers so there was not even one penny left to buy bread. This thrift and my great diligence and industriousness the Lord blessed, since he helped me to do so much. And what if I had got married there? As it was, I was offered a woman with a dowry of sixty thousand forints...

If it were mere worldly success that counted for me, I could have gone on living there for ever, and my fame would have spread ever further. But I decided that my knowledge should not be reserved for me alone. As soon as I saw that God had helped the Christians by lifting the heathen yoke, I left that fat marrow-bone behind, and in good hope and heart I returned home.

I believed that when I returned to my homeland I would easily gain that which I held more important than riches: to be in favour before my God and my nation. This can be gained by all virtuous men: Proverbs 22 is confirmation. Even the heathen sages recognised that this desire is something we hang on to until the last; as Plato puts it: 'This desire for glory, the spirit discards only as the final garment.'

I would not speak out against these reverend gentlemen if only they had held their peace as the Lord Bishop begged them to, but

BOOK

DESIGNER Charles Whitehouse, Zürich, Switzerland TYPOGRAPHIC SOURCE In-house STUDIO Die Handpresse
CLIENT International Typeface Corporation PRINCIPAL TYPE D. Stempel's Janson
DIMENSIONS 7½ × 13 in. (19.1 × 33 cm)

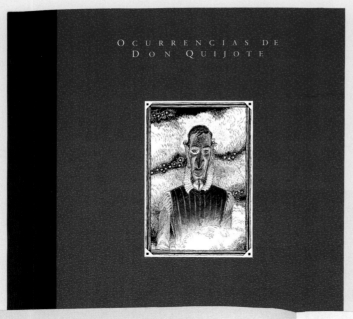

OCURRENCIAS DE
DON QUIJOTE

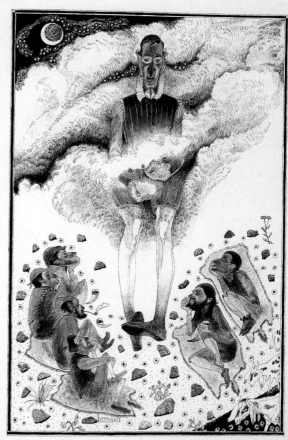

Quijote es luz y sol, es alegría y cortesía,

es caminar por los montes entre aires de

romero y tomillo, no eso otro que algunos

han hecho de él, no esa acumulación de

saurios y anfisbenas que más son dibujos

de penitencia que láminas de regocijo.

Porque artistas hay que convirtieron en

negruras costrientas lo que en literatura

son blancas paredes manchegas, y

concibieron a un educado caballero

español en forma de enteco viejo vesánico.

Algunos de esos grabados son preciosos,

magistrales incluso, pero sobre opresión y

angustia, sobre pesadilla y depresión.

Quijote no es eso.

BOOK

125

DESIGNERS Chris Hill and Jeff Davis, Houston, Texas TYPOGRAPHIC SOURCE In-house AGENCY Quali Comunicación
STUDIO The Hill Group CLIENT Instituto Tecnológico Y De Estudios Superiores De Monterrey
PRINCIPAL TYPES Adobe Garamond and Adobe Garamond Italic DIMENSIONS 5½ × 8½ in. (14 × 21.6 cm)

Press release

Department of External Relations
Press and Publications Office

Press Office
Cornwall House Annexe
Waterloo Road
London SE1 8TX
Tel 071-872 3202
Fax 071-872 0214

KING'S
College
LONDON
Founded 1829

Postgraduate
prospectus *of courses*
for the Schools of Humanities;
Education; Life, Basic Medical
& Health Sciences; Physical
Sciences & Engineering; Law;
and Medicine & Dentistry

Entry 1993

KING'S
College
LONDON
Founded 1829

DESIGNERS John Rushworth and Chiew Yong, London, England TYPOGRAPHIC SOURCE Alan Kitching
STUDIO Pentagram Design CLIENT Kings College PRINCIPAL TYPE Caslon Old Face
DIMENSIONS 5¾ × 4⅛ in. (14.5 × 10.5 cm)

TELEVISION TITLES

Designers Jennifer Morla and Craig Bailey, San Francisco, California Typographic Source In-house
Studio Morla Design Client Fox Broadcasting Company Principal Type Various

TELEVISION COMMERCIAL

DESIGNERS Antony Redman and Gordon Tan, Singapore CREATIVE DIRECTORS Jim Aitchison and Norman Alcuri
TYPOGRAPHIC SOURCE The Fotosetter AGENCY The Ball Partnership Euro RSCG CLIENT Yet Con Restaurant
PRINCIPAL TYPE Trade Gothic Bold

A Cold Call *from* Mighty Mouse

In 1974, Ron Alghini was transferred from New York to manage a small Jefferies branch in Chicago. That same year, Frank Baxter was hired as an institutional salesman. The plan was to train him in Los Angeles and eventually have him open an office in San Francisco. Instead, he was sent to New York in 1975 to run the office there, which had grown by this time to a sales staff of six, with ten people in back-office operations.

In this era of a slumping marketplace, Frank found the enthusiasm, persistence and intensity of the team spirit at Jefferies an energizing experience.

Congress finally moved on lessening restrictions in the industry with the Exchange Act of 1975. The act was designed to promote competition within exchanges, between exchanges and between the exchanges and the OTC market. Along with a more competitive framework that maintained the characteristics of the traditional central marketplace, the ruling also brought an end to fixed commission rates. Now a major fiscal reason for dealing in the third market was no longer an issue and the outlook for off-exchange trading on May Day was grim.

But price savings was not the only reason to deal in the third market, and Jefferies, with several years of experience under its belt, was prepared. Institutions were still looking for bids and offerings in size, without the restrictions of when and where to deal. The company was able to use its familiarity with the market to execute the orders faster and place them with other institutions. As commissions per share fell, the third market began to change from a principal to an agency market. A broker's capital would often be used, but now traders would attempt to line up a buyer and seller simultaneously. "There was more than one company doing that," said Jim Owens, "but Boyd was the best."

Jefferies was working within a relatively narrow base, trading big blocks for institutions without making continuous two-sided markets, or block positioning, and without specializing in a particular list of stocks. When Boyd was asked how he did it, he responded: "There's no secret to it. We just

When Boyd was asked how he did it, he responded: "There's no secret to it. We just work hard."

1979 The Ayatollah Khomeini returns from exile to Iran, the Three Mile Island nuclear plant in Pennsylvania is severely damaged and Margaret Thatcher becomes Britain's Prime Minister.

1980 Akira Kurosawa's *Kagemusha* wins top honors at the Cannes Film Festival, the Polish government is forced by strikes to allow the formation of the Solidarity Union and *Voyager I* flies by Saturn.

BROCHURE

Designers Mark Meyer and Mark Oldach, Chicago, Illinois **Typographic Source** In-house
Studio Mark Oldach Design **Client** Jefferies & Company **Principal Types** Garamond and Frutiger Bold
Dimensions 7 × 10 in. (17.8 × 25.4 cm)

Аа	Зз	Њњ	Цц
Бб	Ss	Оо	Чч
Вв	Ии	Пп	Џџ
Гг	Ii	Рр	Шш
Ѓѓ	Її	Сс	Щщ
Дд	Йй	Тт	Ъъ
Ђђ	Јј	Ћћ	Ыы
Ѓѓ	Кк	Ќќ	Ьь
Ее	Лл	Уу	Ээ
Єє	Љљ	Ўў	Юю
Ёё	Мм	Фф	Яя
Жж	Нн	Хх	

Adobe Originals

Adobe Systems introduces Minion™ Cyrillic, a new font software package in the growing library of Adobe Originals,™ typefaces designed specifically for today's digital technology. Adobe Originals combine the power of PostScript® language software technology and the most sophisticated electronic design tools with the spirit of craftsmanship that has inspired type designers since Gutenberg. Comprising both new designs and revivals of classic typefaces, Adobe Originals packages set a new standard for typographic excellence.

Minion Cyrillic is the first non-Latin typeface in the Adobe Originals library. The Adobe Originals type development program includes text and display typefaces in all major typeface categories. Each Adobe Originals text family has a full complement of weights, characters, and kerning pairs that designers and desktop publishers alike will find extremely useful.

Minion Cyrillic

Adobe designer Robert Slimbach conceived the Minion Cyrillic typeface family as a non-Latin counterpart to his Minion typeface families. Inspired by old style typefaces from the Italian Renaissance, Minion and Minion multiple master are contemporary text families suitable for today's most advanced digital typesetting environments. Like the Latin Minion families, Minion Cyrillic is available in three weights with companion italics, offering the user a large and varied typographic palette. Minion Cyrillic contains a complete set of characters for setting Belarussian, Bulgarian, Macedonian, Russia, Serbocroatian, and Ukrainian. For bilingual settings, the Minion Cyrillic package contains a set of Latin characters that complements the Cyrillic in weight, overall design, and alignment.

Ѓг Дд Пп Тт Цц

BROCHURE

Designers Laurie Szujewska, Ewa Gavrielov, and James Young, Mountain View, California
Typographic Source In-house Studio Adobe Systems Incorporated Client Adobe Systems Incorporated
Principal Types Minion and Minion Cyrillic Dimensions 5⅝ × 8¹⁵⁄₁₆ in. (14.3 × 22.7 cm)

bewitching bastarda
elegant edition
fanciful forms
historiated hymn
incised initials
justified jotting
kingly kestrel
lavish ligatures
meandering minuscules
natural nibs
princely printing
refined romans
single stroke
timeless texts
ultimate uncials
vertical virgule
wondrous writing
yielding yellow

bold borders
elemental edges
fine figures
high humanism
inspired imprint
jutting joins
keepsake knots
lengthy lines
mannered marks
narrow numeral
pure pattern
rustic rarity
silent scribes
tempered touch
uniform undulation
variegated vellum
wavy watermark
young yore

Lowercase Beginnings I

char	shift char	char	shift char

Lowercase Beginnings II

char	shift char	char	shift char

DESIGNERS Laurie Szujewska and James Young, Mountain View, California TYPOGRAPHIC SOURCE In-house
STUDIO Adobe Systems Incorporated CLIENT Adobe Systems Incorporated PRINCIPAL TYPE Poetica
DIMENSIONS 5⅝ × 8¹⁵⁄₁₆ in. (14.3 × 22.7 cm)

The Minion weight axis

Before multiple master technology, large type families were limited to a fixed selection of weights. While these weights provide enough variety for basic typesetting needs, they may be inadequate for more complex work. For instance, a particular job may call for a specific overall color of type that harmonizes with headlines and graphics on the page. Another may require a slight modification in weight to adjust for changes in leading or white space. A slight weight adjustment may also be needed to accommodate different printing surfaces and printing methods. With Minion multiple master, typeface weight can be fine-tuned to meet particular tastes or specifications. The Minion weight axis covers a dynamic range that extends from slightly lighter than the regular weight primary font to a little heavier than the bold weight primary font.

| The graphic signs called letters are so completely blended with the stream of written thought that their presence therein is as | The graphic signs called letters are so completely blended with the stream of written thought that their presence therein is as |

The shapes of letters
The shapes of letters
The shapes of letters
The shapes of letters
The shapes of letters
The shapes of letters
The shapes of letters
The shapes of letters
The shapes of letters
The shapes of letters
The shapes of letters
The shapes of letters
The shapes of letters

Above: The weight of Minion has been increased to compensate for ink spread in reversed type. Below: Thirteen instances showing a sampling of the dynamic range of the Minion multiple master weight axis.

GGGGG
GGGGG
GGGGG
GGGGG
GGGGG
GGGGG
GGGGG
GGGGG
GGGGG
GGGGG
GGGGG

BROCHURE

DESIGNERS Laurie Szujewka, Margery Cantor, and James Young, Mountain View, California
TYPOGRAPHIC SOURCE In-house STUDIO Adobe Systems Incorporated CLIENT Adobe Systems Incorporated
PRINCIPAL TYPE Minion Multiple Master DIMENSIONS 5⅝ × 8¹⁵⁄₁₆ in. (14.3 × 22.7 cm)

RaggedRight

THOMSON NEWSPAPERS · TYPOGRAPHY, DESIGN & JOURNALISM · SPRING 1992

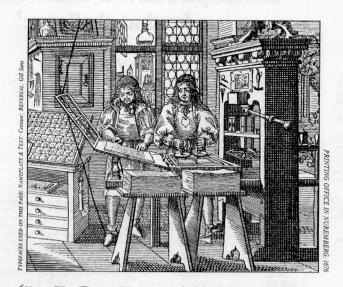

TYPEFACES USED ON THIS PAGE: NAMEPLATE & TEXT: Centaur. REVERSAL: Gill Sans

PRINTING OFFICE IN NUREMBERG, 1676

'NO MATTER how great the author's wisdom or how vital the message or how remarkable the printer's skill, unread type is merely a lot of paper and a little ink. The true economics of printing must be measured by how much is read and understood and not by how much is produced' **HERBERT SPENCER,** *The Visible Word*

NEWSPAPER

DESIGNER Tony Sutton, Toronto, Canada TYPOGRAPHIC SOURCE In-house STUDIO News Design Associates
CLIENT Thomson Newspapers PRINCIPAL TYPES Centaur and Gill Sans
DIMENSIONS 13½ × 11½ in. (34.3 × 29.2 cm)

133

Two groups of community leaders provide this guidance for WBEZ—a Governing Board of Directors and the Community Advisory Council. The Governing Board has policy responsibility and meets regularly. The function of the Community Advisory Council is just that—purely advisory in nature, and its existence is mandated by law. The Advisory Council facilitates public input into the planning and decision making of the station by reviewing the station's programming goals and significant policy decisions for their impact on the community.

Specifically, the Advisory Council makes recommendations to the Program Director and General Manager, and also periodically reviews the programming currently on the air to measure how well it addresses the needs of various constituencies.

The existence of this Board is a tangible commitment to the principles under which public radio stations were established—that these stations are held in trust for the public to serve the needs of our communities.

Here in Chicago, we have a unique opportunity to develop a model public radio station. By reflecting Chicago's own blending of cultures, we bring a world of ideas to our audience on a daily basis, making WBEZ the only resource for tapping into news.

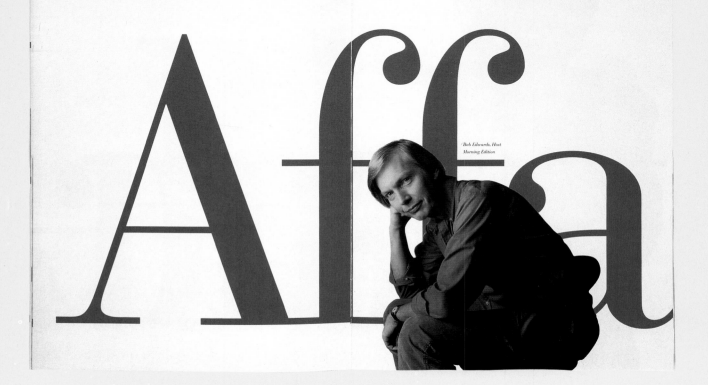

*Bob Edwards, Host
Morning Edition*

ANNUAL REPORT

DESIGNER Kym Abrams, Chicago, Illinois TYPOGRAPHIC SOURCE Paul Baker Typography
STUDIO Kym Abrams Design CLIENT WBEZ 91.5 FM Public Radio Station PRINCIPAL TYPE Bauer Bodoni
DIMENSIONS 7¾ × 12 in. (19.9 × 30.5 cm)

kterého nemá zdejší vláda v lásce, mohli tuto vládu zbytečně
provokovat, a tím křehké základy rodící se détente ohrožovat.
Nemluvím o tom samozřejmě kvůli sobě jako takovému,
a už vůbec ne proto, že bych se litoval. Vždyť já už tehdy litoval
spíš je, než sebe, protože jsem to nebyl já, ale oni, kdo se
dobrovolně vzdával své svobody. Zmiňuji se o tom proto, abych jen
z jiné strany znovu osvětlil, jak snadno se může dobře míněná věc
změnit ve zradu svého vlastního dobrého úmyslu – a to opět jen
skrze slovo, jehož smysl nebyl zřejmě dost bedlivě střežen.
Taková věc se může stát velmi snadno, člověk si toho téměř
nevšimne, stane se to nenápadně, tiše, pokradmu – a když to nakonec
člověk zjistí, zbývá mu už jen jediná možnost : pozdní údiv.

Jenomže to je přesně onen ďábelský způsob, jímž nás
dokážou slova zrazovat, nejsme-li při jejich užívání trvale obezřetní.
A často – bohužel – i docela malá a jen chvilková ztráta
obezřetnosti může mít tragické a neodčinitelné následky.
Následky dalekosáhle překračující nehmotný svět pouhých slov a
dalekosáhle vstupující do světa až po čertech hmotného.

Dostávám se konečně ke krásnému slovu "mír."

Čtyřicet let ho čtu v naší zemi na každé střeše a v každém
výkladu. Čtyřicet let jsem tak, jako všichni mí spoluobčané,
vychováván k alergii na toto krásné slovo, protože vím,
co čtyřicet let znamená : mohutné a stále mohutnější armády
jakožto údajnou záštitu míru.

Navzdory tomuto dlouhému procesu systematického
vyprazdňování slova mír ; ba víc než jen vyprazdňování :
jeho naplňování právě opačným významem, než jaký podle

BOOK

DESIGNERS George Sadek and Charles F. Nix, New York, New York TYPOGRAPHIC SOURCE In-house
STUDIO The Cooper Union Center for Design & Technology CLIENT The Cooper Union for
the Advancement of Science and Art PRINCIPAL TYPE Baskerville
DIMENSIONS 11 × 17 in. (27.9 × 43.2 cm)

FIRST. SECOND. STOP.
FIRST. SECOND. THIRD.
STOP. FIRST. STOP.
FIRST. SECOND. STOP.
FIRST. SECOND. THIRD.
FOURTH. STOP. FIRST.
STOP. FIRST. STOP.
FIRST. SECOND. THIRD.
STOP. FIRST. SECOND.
STOP. FIRST. SECOND.
STOP. FIRST. STOP.

Drive a Mitsubishi Colt GLXi automatic instead.

POSTER

136

DESIGNERS Antony Redman and Grover Tham, Singapore CREATIVE DIRECTORS Jim Aitchison and Norman Alcuri
TYPOGRAPHIC SOURCE In-house AGENCY The Ball Partnership Euro RSCG CLIENT Cycle & Carriage Mitsubishi
PRINCIPAL TYPE Franklin Gothic Condensed DIMENSIONS 19½ × 15½ in. (49.5 × 39.4 cm)

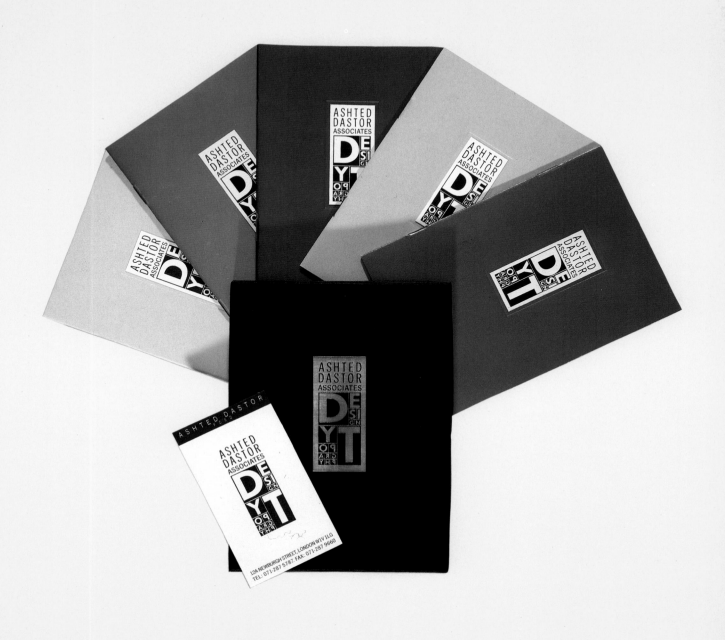

CORPORATE IDENTITY

DESIGNER Ashted Dastor, London, England LETTERER Ashted Dastor TYPOGRAPHIC SOURCE Diamond Graphics Ltd.
STUDIO Ashted Dastor Associates CLIENT Ashted Dastor Associates PRINCIPAL TYPES Gill Sans, ITC Novarese Italic,
Frutiger 55, Bodoni, and Zapf Renaissance Antiqua Swash DIMENSIONS 4⅛ × 5⅞ in. (10.5 × 14.9 cm)

LOGOTYPE

DESIGNER Woody Pirtle, New York, New York LETTERER Woody Pirtle STUDIO Pentagram Design
CLIENT Fine Line Features PRINCIPAL TYPE Handlettering

LOGOTYPE

DESIGNER Allen Weaver, Dallas, Texas LETTERER Allen Weaver AGENCY The Design Group, JRSK
CLIENT Toole Floor Coating, Inc. PRINCIPAL TYPE Handlettering

Lieutenant Kijé · Young Vitushish-nikov Yury Tynyanov

The

Baphomet

Pierre

Klossowski

One, No One & One Hundred Thousand Luigi Pirandello

René's

Flesh

Virgilio

Piñera

BOOK

DESIGNER Louise Fili, New York, New York TYPOGRAPHIC SOURCE In-house STUDIO Louise Fili Ltd.
CLIENT Marsilio PRINCIPAL TYPE Centaur DIMENSIONS 5¼ × 8½ in. (13.3 × 21.6 cm)

Marlene Marks + Associates
Marketing Communications
3642 North Seeley Street
Chicago, Illinois 60618
Phone/Fax 312 868 4301

"m^r!ene:m@rks."

"m^r!ene:m@rks."

Marlene Marks + Associates
Marketing Communications
3642 North Seeley Street
Chicago, Illinois 60618

"m^r!ene:m@rks."

STATIONERY

DESIGNERS Mark Meyer and Mark Oldach, Chicago, Illinois TYPOGRAPHIC SOURCE In-house
STUDIO Mark Oldach Design CLIENT Marlene Marks & Associates
PRINCIPAL TYPE ITC New Baskerville DIMENSIONS 8½ × 11 in. (21.6 × 27.9 cm)

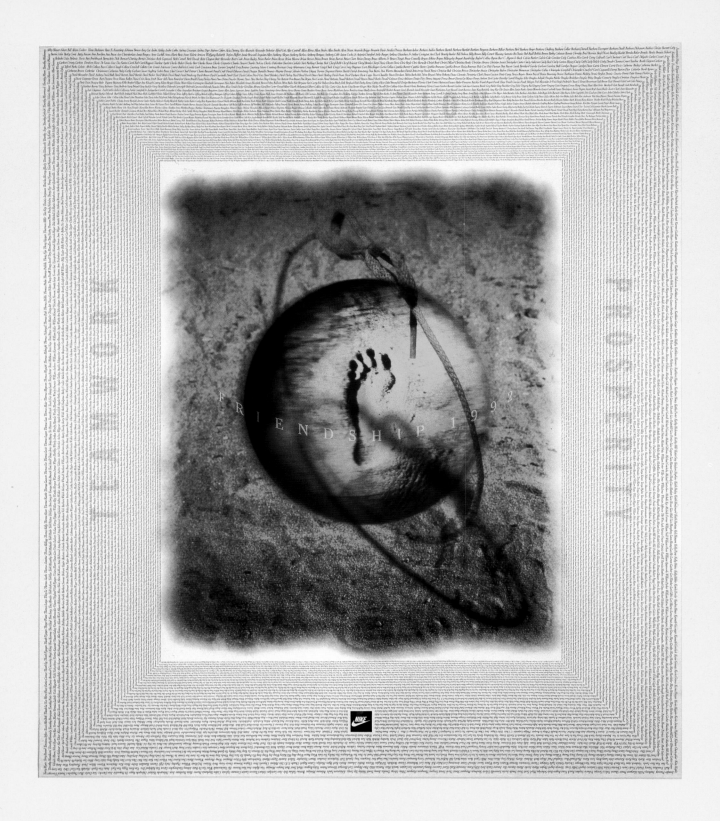

POSTER

DESIGNER John Norman, Portland, Oregon LETTERER Greg Maffei PHOTOGRAPHERS Alan Abrams
and Francesca Lacagnina TYPOGRAPHIC SOURCE Grey Matter STUDIO NIKE Design CLIENT NIKE, Inc.
PRINCIPAL TYPES Cochin and Cheltenham Condensed DIMENSIONS 27 × 32 in. (68.6 × 81.3 cm)

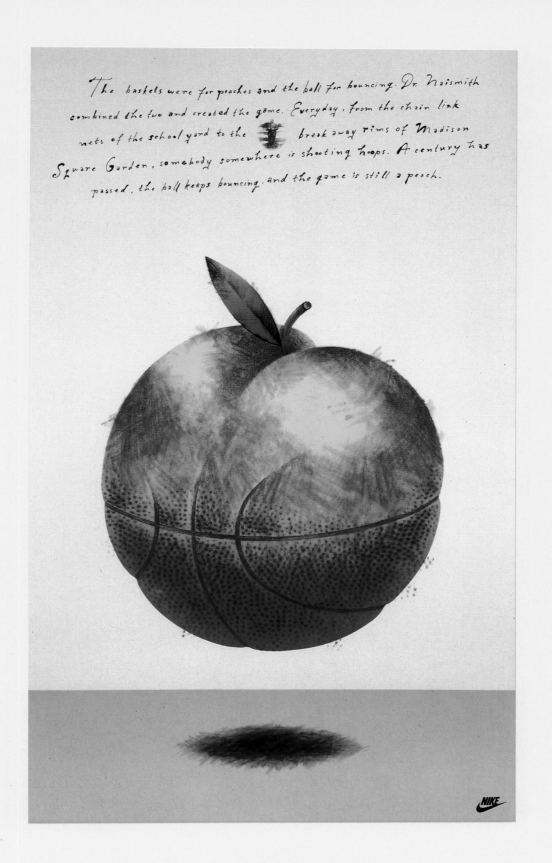

The baskets were for peaches and the ball for bouncing. Dr. Naismith combined the two and created the game. Everyday, from the chain link nets of the school yard to the break away rims of Madison Square Garden, somebody somewhere is shooting hoops. A century has passed, the ball keeps bouncing, and the game is still a peach.

POSTER

DESIGNER John Norman, Portland, Oregon LETTERER John Norman ILLUSTRATOR John Norman
STUDIO NIKE Design CLIENT NIKE, Inc. PRINCIPAL TYPE Handlettering
DIMENSIONS 24 × 38 in. (61 × 96.5 cm)

MANGOS

A GUIDE TO MANGOS IN FLORIDA

BOOK

DESIGNER Claudia DeCastro, Miami, Florida DESIGN DIRECTOR Joel Fuller TYPOGRAPHIC SOURCE In-house
STUDIO Pinkhaus Design Corp. CLIENT Fairchild Tropical Garden PRINCIPAL TYPES Futura and Matrix
DIMENSIONS 5⅜ × 8½ in. (13.6 × 21.6 cm)

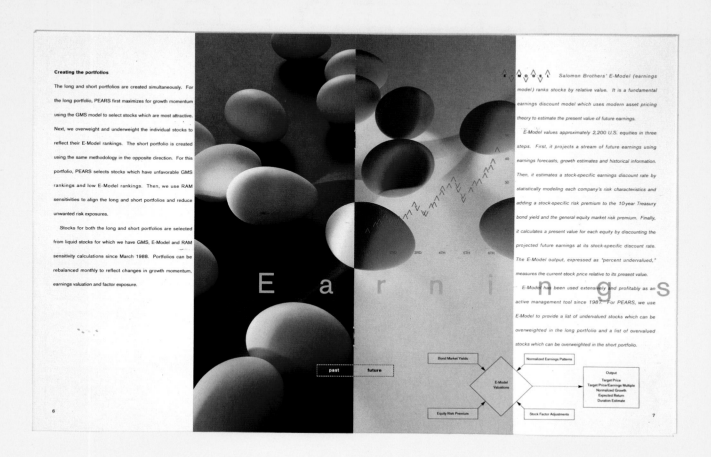

Creating the portfolios

The long and short portfolios are created simultaneously. For the long portfolio, PEARS first maximizes for growth momentum using the GMS model to select stocks which are most attractive. Next, we overweight and underweight the individual stocks to reflect their E-Model rankings. The short portfolio is created using the same methodology in the opposite direction. For this portfolio, PEARS selects stocks which have unfavorable GMS rankings and low E-Model rankings. Then, we use RAM sensitivities to align the long and short portfolios and reduce unwanted risk exposures.

Stocks for both the long and short portfolios are selected from liquid stocks for which we have GMS, E-Model and RAM sensitivity calculations since March 1988. Portfolios can be rebalanced monthly to reflect changes in growth momentum, earnings valuation and factor exposure.

Salomon Brothers' E-Model (earnings model) ranks stocks by relative value. It is a fundamental earnings discount model which uses modern asset pricing theory to estimate the present value of future earnings.

E-Model values approximately 2,200 U.S. equities in three steps. First, it projects a stream of future earnings using earnings forecasts, growth estimates and historical information. Then, it estimates a stock-specific earnings discount rate by statistically modeling each company's risk characteristics and adding a stock-specific risk premium to the 10-year Treasury bond yield and the general equity market risk premium. Finally, it calculates a present value for each equity by discounting the projected future earnings at its stock-specific discount rate. The E-Model output, expressed as "percent undervalued," measures the current stock price relative to its present value.

E-Model has been used extensively and profitably as an active management tool since 1987. For PEARS, we use E-Model to provide a list of undervalued stocks which can be overweighted in the long portfolio and a list of overvalued stocks which can be overweighted in the short portfolio.

6

7

BROCHURE

DESIGNER David Suh, New York, New York TYPOGRAPHIC SOURCE In-house AGENCY Frankfurt Gips Balkind
CLIENT Salomon Brothers Inc. PRINCIPAL TYPE Akzidenz-Grotesk DIMENSIONS 8½ × 11 in. (21.6 × 27.9 cm)

WOULD YOU PAY MORE ATTENTION IF YOU COULD HEAR THE SOUND OF TREES SCREAMING? YOU SEE THE PROBLEM. HELP FIND A SOLUTION.

CONTRIBUTE: SEND A TAX-DEDUCTIBLE DONATION TO THE EARTH ISLAND INSTITUTE, 300 BROADWAY, SUITE 28, SAN FRANCISCO, CALIFORNIA 94133.
NAME
ADDRESS
CITY STATE ZIP

VOLUNTEER: TAKE AN ACTIVE ROLE IN SUPPORTING THE EARTH ISLAND INSTITUTE, 300 BROADWAY, SUITE 28, SAN FRANCISCO, CALIFORNIA 94133.
NAME
ADDRESS
CITY STATE ZIP

GET INFORMED: WRITE FOR MORE DETAILS ABOUT THE EARTH ISLAND INSTITUTE, 300 BROADWAY, SUITE 28, SAN FRANCISCO, CALIFORNIA 94133.
NAME
ADDRESS
CITY STATE ZIP

DECIMATING PLANTS DECIMATES AIR WHICH DECIMATES LIFE. YOURS INCLUDED. YOU SEE THE PROBLEM. HELP FIND A SOLUTION.

CONTRIBUTE: SEND A TAX-DEDUCTIBLE DONATION TO THE EARTH ISLAND INSTITUTE, 300 BROADWAY, SUITE 28, SAN FRANCISCO, CALIFORNIA 94133.
NAME
ADDRESS
CITY STATE ZIP

VOLUNTEER: TAKE AN ACTIVE ROLE IN SUPPORTING THE EARTH ISLAND INSTITUTE, 300 BROADWAY, SUITE 28, SAN FRANCISCO, CALIFORNIA 94133.
NAME
ADDRESS
CITY STATE ZIP

GET INFORMED: WRITE FOR MORE DETAILS ABOUT THE EARTH ISLAND INSTITUTE, 300 BROADWAY, SUITE 28, SAN FRANCISCO, CALIFORNIA 94133.
NAME
ADDRESS
CITY STATE ZIP

TAKE A LONG, HARD LOOK THROUGH SOME BINOCULARS AND WITNESS THE SIGHT OF EXTINCTION. YOU SEE THE PROBLEM. HELP FIND A SOLUTION.

CONTRIBUTE: SEND A TAX-DEDUCTIBLE DONATION TO THE EARTH ISLAND INSTITUTE, 300 BROADWAY, SUITE 28, SAN FRANCISCO, CALIFORNIA 94133.
NAME
ADDRESS
CITY STATE ZIP

VOLUNTEER: TAKE AN ACTIVE ROLE IN SUPPORTING THE EARTH ISLAND INSTITUTE, 300 BROADWAY, SUITE 28, SAN FRANCISCO, CALIFORNIA 94133.
NAME
ADDRESS
CITY STATE ZIP

GET INFORMED: WRITE FOR MORE DETAILS ABOUT THE EARTH ISLAND INSTITUTE, 300 BROADWAY, SUITE 28, SAN FRANCISCO, CALIFORNIA 94133.
NAME
ADDRESS
CITY STATE ZIP

ADVERTISEMENT

DESIGNER Michael Rylander, San Francisco, California TYPOGRAPHIC SOURCES In-house and Fuse 1
AGENCY The Ivory Tower CLIENT Earth Island Institute PRINCIPAL TYPES Can You (and Do You Want to) Read Me?
and Gill Sans DIMENSIONS 13 × 5 in. (12.7 × 33 cm)

LOGOTYPE

DESIGNER David Kampa, Austin, Texas LETTERER David Kampa STUDIO Kampa Design
CLIENT Loophole Entertainment PRINCIPAL TYPE Handlettering

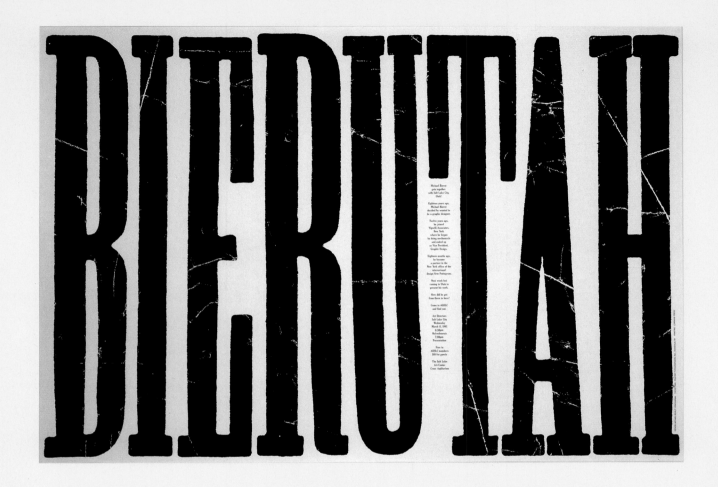

POSTER

148

DESIGNER Michael Bierut, New York, New York LETTERER Michael Bierut
TYPOGRAPHIC SOURCE Characters Graphic Services, Inc. STUDIO Pentagram Design
CLIENT Art Directors Club of Salt Lake City PRINCIPAL TYPES Cheltenham Bold Condensed
and American Wood Type DIMENSIONS 34 × 24 in. (86.4 × 61 cm)

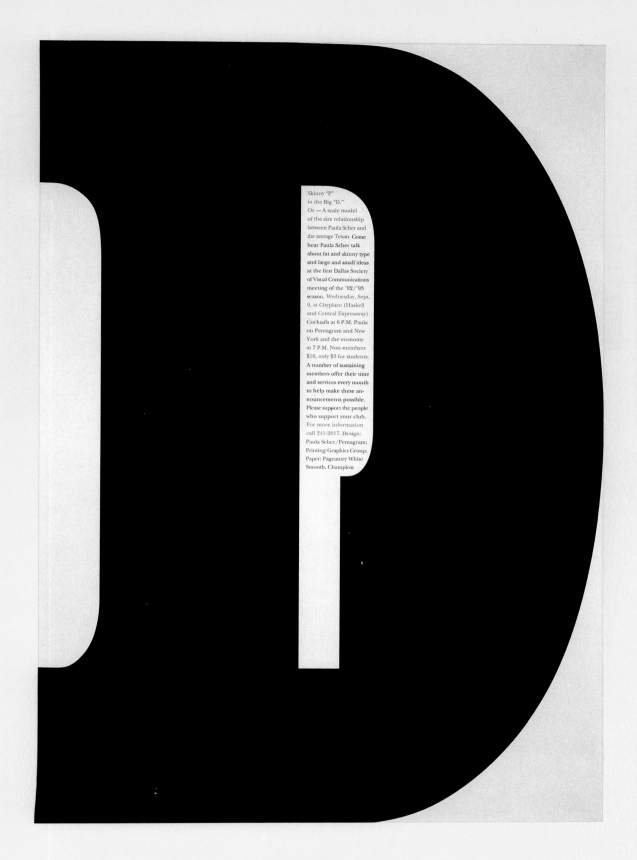

Skinny "P"
in the Big "D."
Or — A scale model
of the size relationship
between Paula Scher and
the average Texan. **Come
hear Paula Scher talk
about fat and skinny type
and large and small ideas
at the first Dallas Society
of Visual Communications
meeting of the '92/'93
season.** Wednesday, Sept.
9, at Cityplace (Haskell
and Central Expressway).
Cocktails at 6 P.M. Paula
on Pentagram and New
York and the economy
at 7 P.M. Non-members
$10, only $3 for students.
A number of sustaining
members offer their time
and services every month
to help make these an-
nouncements possible.
Please support the people
who support your club.
For more information
call 241-2017. Design:
Paula Scher/Pentagram;
Printing: Graphics Group;
Paper: Pageantry White
Smooth, Champion

POSTER

DESIGNER Paula Scher, New York, New York LETTERER Paula Scher TYPOGRAPHIC SOURCE In-house
STUDIO Pentagram Design CLIENT Dallas Society of Visual Communications
PRINCIPAL TYPES Times Roman and handlettering DIMENSIONS 23½ × 16¼ in. (59.7 × 41.3 cm)

Adding new products to the intelligent workspace demands more than just novelty: it demands research, imagination and bold new thinking. Innovation has been a fundamental Knoll value ever since Hans and Florence Knoll revolutionized the furniture industry by enlisting the world's greatest architects and artists – names such as Marcel Breuer, Eero Saarinen and Ludwig Mies van der Rohe.

The same dedication to customer-inspired innovation drives Knoll product development today. Knoll continues working closely with the world's best designers, including Charles Gwathmey, Robert Siegel, Frank Gehry, Peter Eisenman, Bruce Hannah, Andrew Morrison, Raul de Armas and Richard Sapper. Their work encompasses the most sophisticated research into what people do in the workplace, and how the workplace affects people. They

World-renowned architect Frank Gehry, known for his unconventional use of materials, has developed an innovative new line of bentwood furniture made from laminated maple strips. Lightweight, economical and durable, the Gehry Collection includes side chairs, lounge chairs and tables.

Knoll develops products with innovative thinking.

share the Knoll belief that design and engineering improvements must be built into every product.

New technology, new products and new applications flow from product development centers around the world. Research, design and product development draw on diverse regions and cultures. The highly successful results include Morrison Network, the Bulldog Chair, Calibre Files and Storage, and a range of innovations for KnollTextiles, KnollExtra and KnollStudio.

Knoll offers a complete line of systems accessories to meet applications from high-profile executive offices to value-driven ballpens. Orchestra Universal Storage is shown above.
Planning the intelligent workspace means more than just specifying existing products. Teams of Knoll associates work with clients to develop new ways of thinking about the workplace. This model of three conceptual workstations shows how custom capabilities can be adapted to each client's needs.

12

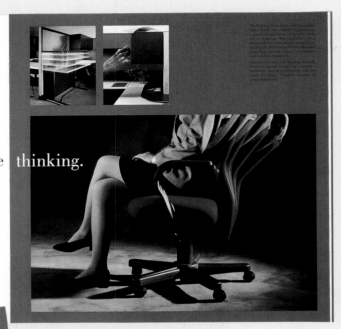

The Bulldog Chair, below, and innovative folder for the latest Knoll ergonomic research in comfort and adjustability, set on the KnollWeb and the Ambrose "With Flexibility," Anyone well as take on research on comfort in controlling Ub's Bulldog Chair easily adjustable from base seat to-tension, height adjustment and lumbar support.

Engineered to work with Morrison Network, Bulldog Equipment Storage, and Ambrose, a padded file door desk option helps with total finish of settings. Complexity exceeds 46 easily understand.

Planning and furnishing the workplace today means thinking far beyond metal, wood and plastic. The people who work are changing, and so are the tools that they use. Demographic trends, leaps in computer and communications technology, reconfigured organizational structures, new sensitivity to workers' well-being and the environment —all make the workplace a focal point for unfamiliar and complex concerns. At **Knoll,** a company uniquely founded on the concept of **design,** we are redefining form and function to accommodate these new dimensions.

BROCHURE

DESIGNER Cathy Schaefer, New York, New York DESIGN DIRECTOR Tom Geismar TYPOGRAPHIC SOURCE In-house
STUDIO Chermayeff & Geismar CLIENT The Knoll Group PRINCIPAL TYPES Helvetica Heavy and Bodoni Book
DIMENSIONS 11 × 11 in. (27.9 × 27.9 cm)

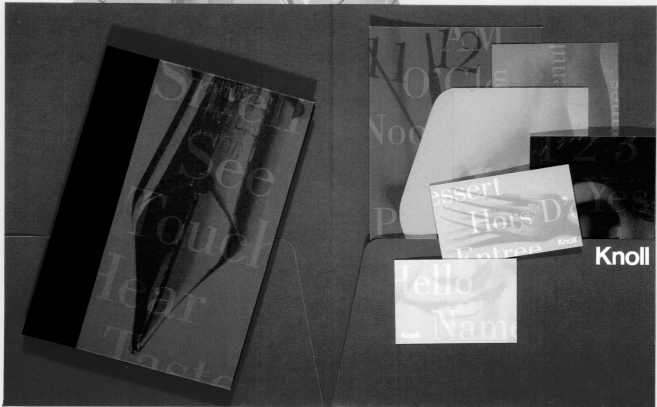

PROMOTIONAL KIT

DESIGNER Weston Bingham, New York, New York DESIGN DIRECTOR Tom Geismar TYPOGRAPHIC SOURCE In-house
STUDIO Chermayeff & Geismar CLIENT The Knoll Group PRINCIPAL TYPE Bodoni Book DIMENSIONS Various

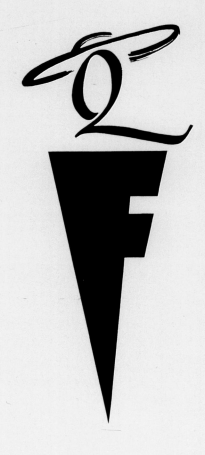

LOGOTYPE

DESIGNER Andrew Dolan, Washington, D.C. LETTERER Andrew Dolan ART DIRECTOR Supon Phornirunlit
TYPOGRAPHIC SOURCE Phil's Photo STUDIO Supon Design Group, Inc. CLIENT Michael Brannon/Queen of Fashion
PRINCIPAL TYPES Le Griffe and handlettering

BROCHURE

DESIGNERS Vickie Schafer and Suzanne McCallum, Baltimore, Maryland ART DIRECTOR Vickie Schafer
TYPOGRAPHIC SOURCE In-house AGENCY Siquis, Ltd. CLIENT The Schwab Company
PRINCIPAL TYPES Poliphilus and Liberty DIMENSIONS 7 × 7 in. (17.8 × 17.8 cm)

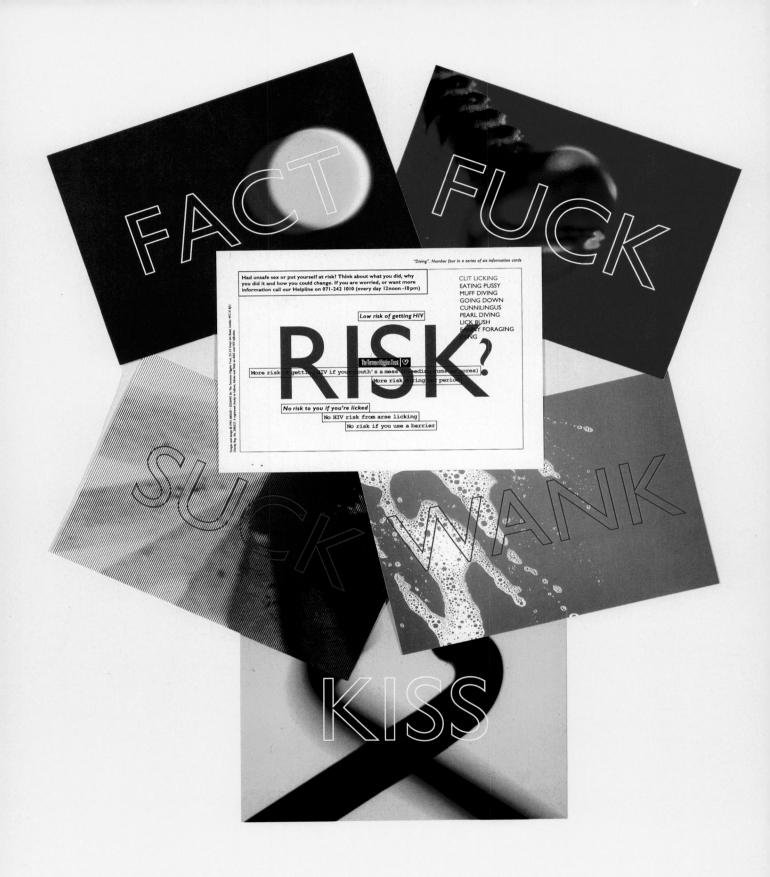

POSTCARDS

DESIGNERS Alan Aboud and Sandro Sodano, London, England TYPOGRAPHIC SOURCE In-house
AGENCY Aboud•Sodano CLIENT Terrence Higgins Trust PRINCIPAL TYPES Gill Sans and Courier
DIMENSIONS 5⅞ × 4⅛ in. (14.9 × 10.5 cm)

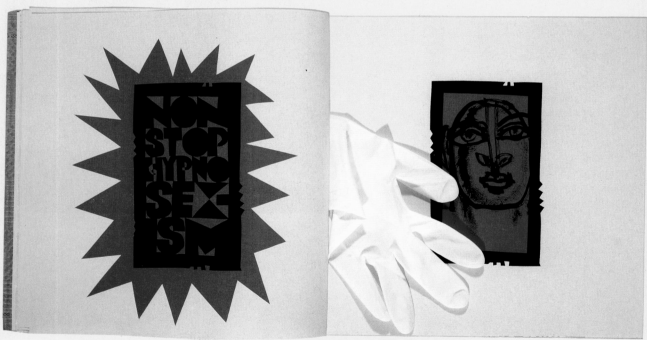

BOOK

DESIGNERS David Diaz and Cecelia Diaz, Rancho La Costa, California TYPE DESIGNER David Diaz
TYPOGRAPHIC SOURCE In-house STUDIO David Diaz Illustration CLIENT ICON Books
PRINCIPAL TYPE Sweet Gabrielle DIMENSIONS 12 × 11 in. (30.5 × 27.9 cm)

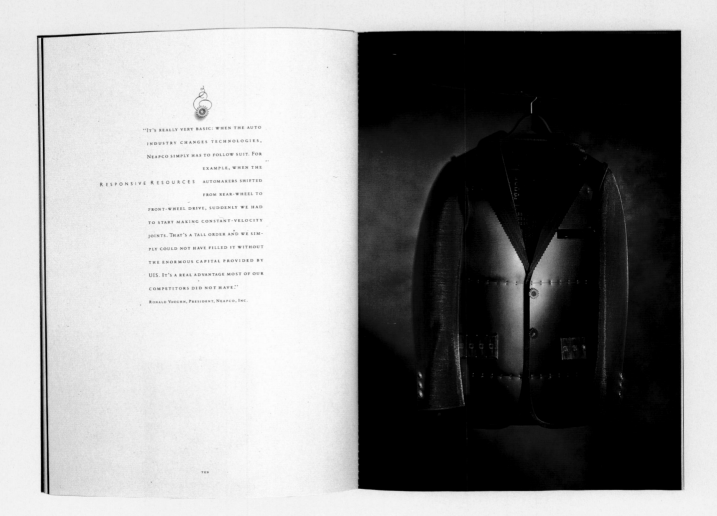

"IT'S REALLY VERY BASIC: WHEN THE AUTO INDUSTRY CHANGES TECHNOLOGIES, NEAPCO SIMPLY HAS TO FOLLOW SUIT. FOR EXAMPLE, WHEN THE RESPONSIVE RESOURCES AUTOMAKERS SHIFTED FROM REAR-WHEEL TO FRONT-WHEEL DRIVE, SUDDENLY WE HAD TO START MAKING CONSTANT-VELOCITY JOINTS. THAT'S A TALL ORDER AND WE SIMPLY COULD NOT HAVE FILLED IT WITHOUT THE ENORMOUS CAPITAL PROVIDED BY UIS. IT'S A REAL ADVANTAGE MOST OF OUR COMPETITORS DID NOT HAVE."
RONALD VAUGHN, PRESIDENT, NEAPCO, INC.

TEN

BROCHURE

DESIGNER Tim Sauer, Minneapolis, Minnesota TYPOGRAPHIC SOURCE Great Faces Inc. STUDIO The Kuester Group
CLIENT UIS, Inc. PRINCIPAL TYPES Garamond and Futura DIMENSIONS 8½ × 12 in. (21.6 × 30.5 cm)

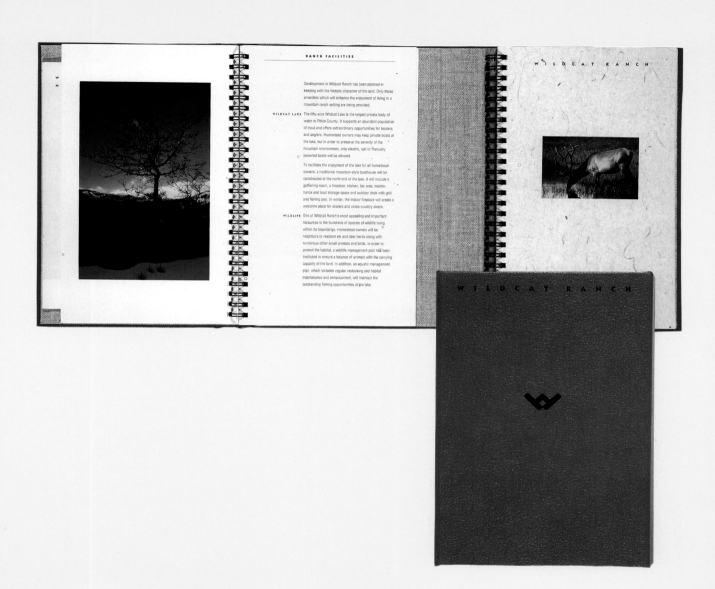

BROCHURE

DESIGNERS Chris Hill, Laura Menegaz, and Jeff Davis, Houston, Texas TYPOGRAPHIC SOURCE In-house
AGENCY Impact Group STUDIO The Hill Group CLIENT Wildcat Ranch
PRINCIPAL TYPES Helvetica Condensed and ITC Kabel Ultra DIMENSIONS 6½ × 9¼ in. (16.5 × 23.5 cm)

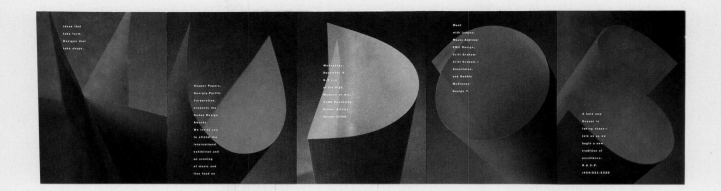

INVITATION

DESIGNERS Ted Fabella, Raquel C. Miqueli, and Bob Wages, Atlanta, Georgia CREATIVE DIRECTOR Bob Wages
PHOTOGRAPHER Raquel C. Miqueli TYPOGRAPHIC SOURCE In-house STUDIO Wages Design CLIENT Hopper Papers
PRINCIPAL TYPE Franklin Gothic DIMENSIONS 7 × 25 in. (17.8 × 63.5 cm)

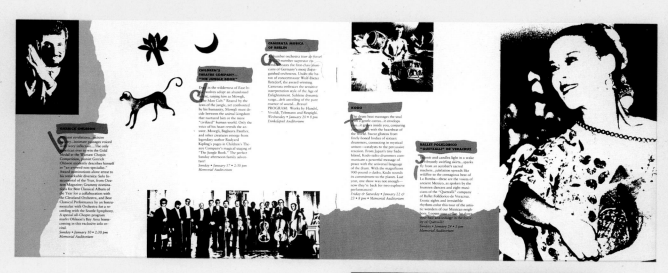

BROCHURE

159

DESIGNER Jeffrey Whitten, Stanford, California CALLIGRAPHER Jeffrey Whitten TYPOGRAPHIC SOURCE In-house
STUDIO Stanford Publication Services CLIENT The Lively Arts at Stanford
PRINCIPAL TYPES Sabon, Futura Extra Bold, and handlettering DIMENSIONS 11 × 8½ in. (27.9 × 21.6 cm)

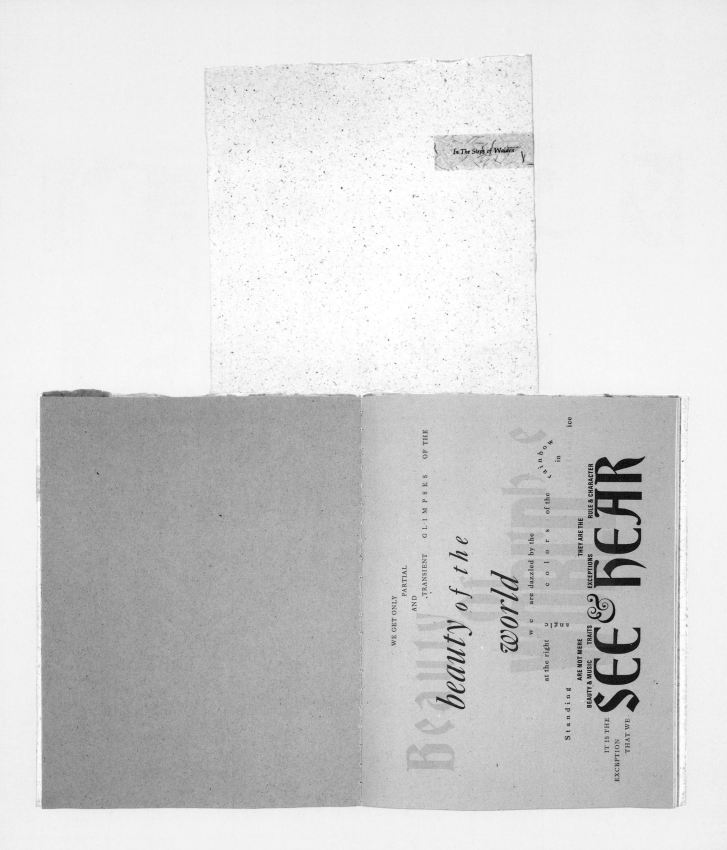

BOOK

DESIGNERS Vance Studley and 37 Students, Pasadena, California TYPOGRAPHIC SOURCE Archetype Press
AGENCY Art Center College of Design STUDIO Archetype Press CLIENT Art Center College of Design
PRINCIPAL TYPE Various DIMENSIONS 9 × 12 in. (22.9 × 27.9 cm)

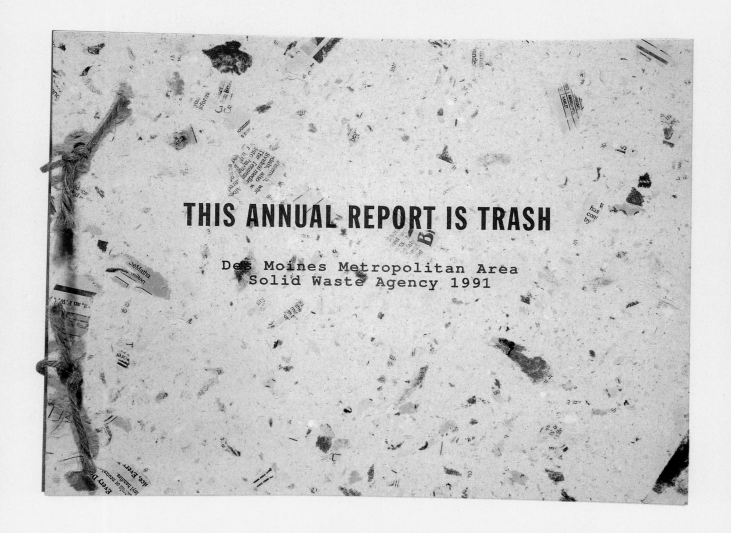

ANNUAL REPORT

DESIGNERS Steve Pattee and Kelly Stiles, Des Moines, Iowa TYPOGRAPHIC SOURCE In-house STUDIO Pattee Design
CLIENT Des Moines Metropolitan Area Waste Agency PRINCIPAL TYPES Franklin Gothic, Times Roman, and Courier
DIMENSIONS 12 × 9 in. (30.5 × 22.9 cm)

Hausmagazin der Lindner Unternehmensgruppe

neqql Ansichten

2
August
92

MAGAZINE

DESIGNERS Stefan Nowak, Erika Hillemacher, and Klaus Hesse, Düsseldorf, Germany
LETTERERS Stefan Nowak and Erika Hillemacher PHOTOGRAPHER Gerd George TYPOGRAPHIC SOURCE In-house
AGENCY Hesse Designagentur CLIENT Lindner Unternehmensgruppe PRINCIPAL TYPES Walbaum and Frutiger
DIMENSIONS 13⅓ × 9½ in. (33.9 × 24.1 cm)

DESIGNER Rita Marshall, Lakeville, Connecticut TYPOGRAPHIC SOURCE Dix Type, Syracuse, New York
STUDIO Delessert & Marshall CLIENT Musée Jenisch, Vevey, Switzerland PRINCIPAL TYPE Fournier
DIMENSIONS 8½ × 11 in. (21.6 × 27.9 cm)

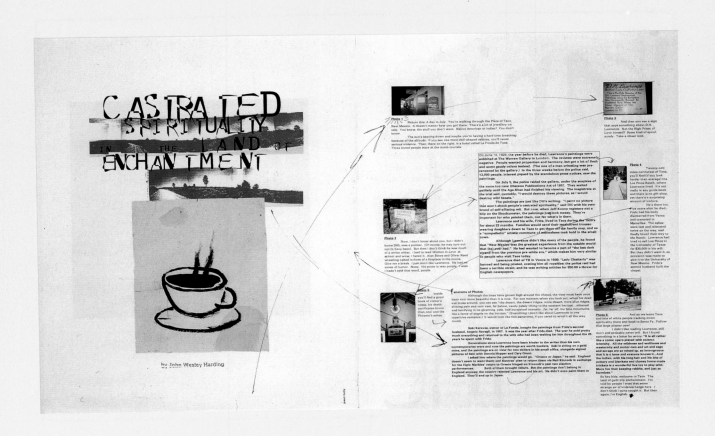

MAGAZINE SPREAD

DESIGNERS David Carson and Lisa Vorhees, Del Mar, California TYPOGRAPHIC SOURCE In-house
STUDIO David Carson Design CLIENT Ray Gun magazine PRINCIPAL TYPE Inside Out
DIMENSIONS 12 × 20 in. (30.5 × 50.8 cm)

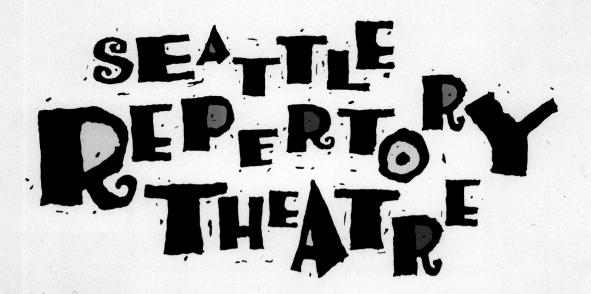

DESIGNER Robynne Raye, Seattle, Washington TYPOGRAPHIC SOURCE Solotype STUDIO Modern Dog
CLIENT Seattle Repertory Theatre PRINCIPAL TYPE Sara Elizabeth

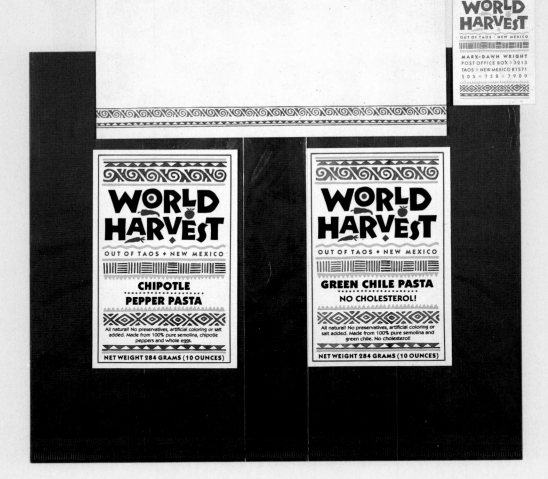

CAMPAIGN

DESIGNER K.C. Kierst, Taos, New Mexico LETTERER K.C. Kierst TYPOGRAPHIC SOURCE WD Type
STUDIO Webb Design Studio CLIENT World Harvest PRINCIPAL TYPES Kabel and handlettering
DIMENSIONS Various

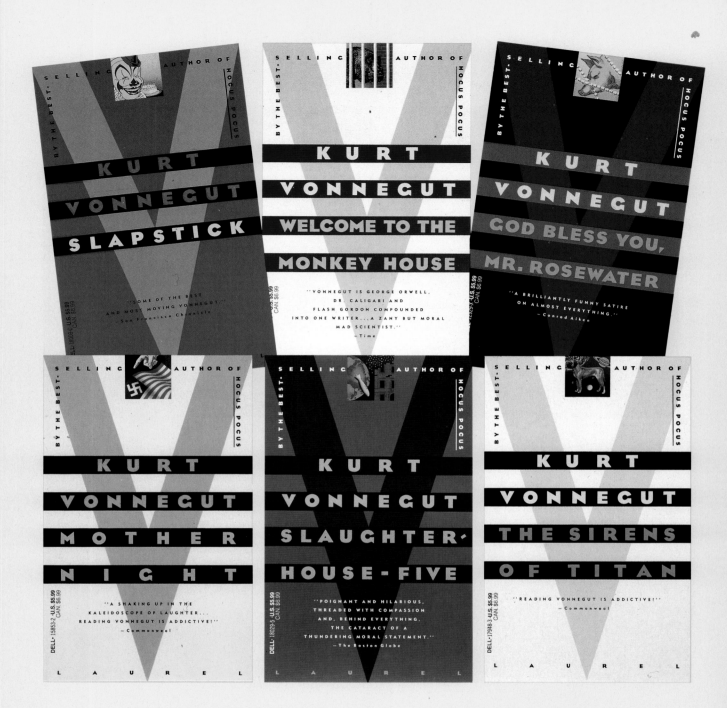

BOOK COVERS

DESIGNER Carin Goldberg, New York, New York TYPOGRAPHIC SOURCE The Type Shop Inc.
STUDIO Carin Goldberg Design CLIENT Dell Publishing PRINCIPAL TYPE Eagle Bold
DIMENSIONS 4³⁄₁₆ × 6¾ in. (10.6 × 17.1 cm)

TO MAKE GOOD LETTERS IS NOT NECESSARILY
TO "DESIGN" THEM — THEY HAVE BEEN
DESIGNED LONG AGO — BUT IT IS TO TAKE
THE BEST LETTERS WE CAN FIND, AND TO
ACQUIRE THEM AND MAKE THEM OUR OWN.

EDWARD JOHNSTON

POSTER

DESIGNER Kevin Horvath, Overland Park, Kansas LETTERER Kevin Horvath TYPOGRAPHIC SOURCE In-house
STUDIO Horvath Design CLIENT Horvath Design PRINCIPAL TYPE Centaur
DIMENSIONS 10½ × 22 in. (26.7 × 55.9 cm)

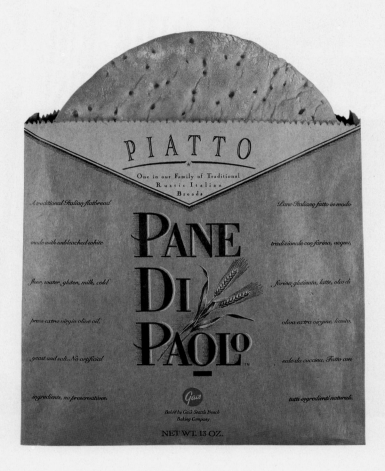

PACKAGING

DESIGNERS Jack Anderson, Mary Hermes, and Leo Raymundo, Seattle, Washington TYPOGRAPHIC SOURCES In-house
and Type Gallery STUDIO Hornall Anderson Design Works, Inc. CLIENT Broadmoor Baker
PRINCIPAL TYPES Bodoni, Goudy Open, Snell Roundhand, and Bernhard Modern
DIMENSIONS 11 × 11¼ in. (27.9 × 28.6 cm)

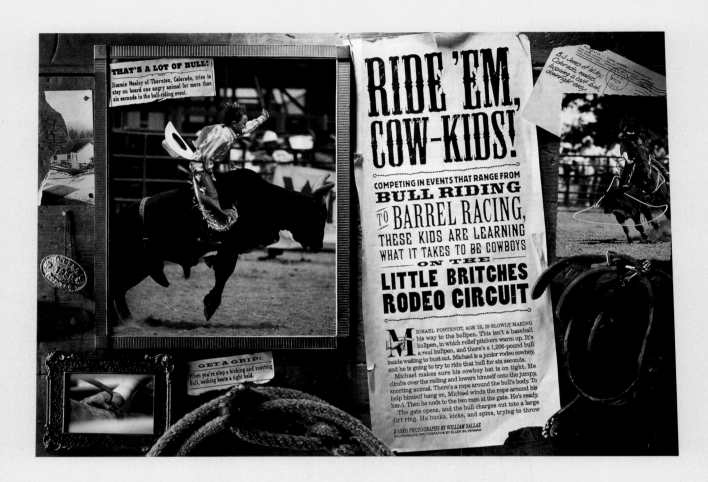

MAGAZINE SPREAD

DESIGNER Sarah Micklem, New York, New York TYPOGRAPHIC SOURCE In-house STUDIO Sports Illustrated For Kids
CLIENT Sports Illustrated For Kids PRINCIPAL TYPE Various DIMENSIONS 16 × 10¾ in. (40.6 × 27.3 cm)

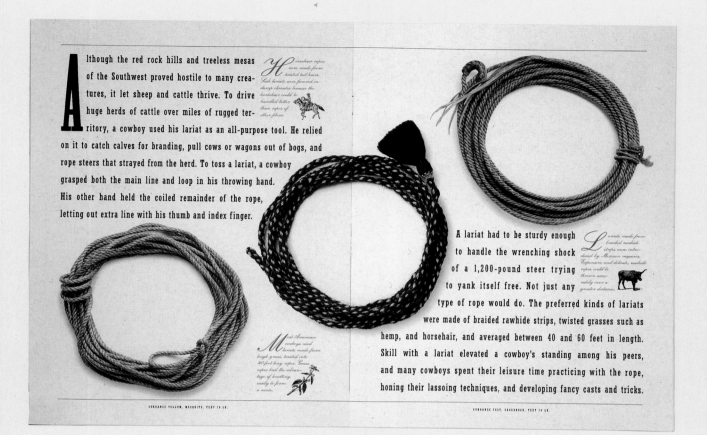

Although the red rock hills and treeless mesas of the Southwest proved hostile to many creatures, it let sheep and cattle thrive. To drive huge herds of cattle over miles of rugged territory, a cowboy used his lariat as an all-purpose tool. He relied on it to catch calves for branding, pull cows or wagons out of bogs, and rope steers that strayed from the herd. To toss a lariat, a cowboy grasped both the main line and loop in his throwing hand. His other hand held the coiled remainder of the rope, letting out extra line with his thumb and index finger.

Horsehair ropes were made from twisted tail hairs. Such lariats were favored in damp climates because the horsehair could be handled better than ropes of other fibers.

Most American cowboys used lariats made from tough grass, twisted into 40-foot long ropes. Grass ropes had the advantage of knotting easily to form a noose.

A lariat had to be sturdy enough to handle the wrenching shock of a 1,200-pound steer trying to yank itself free. Not just any type of rope would do. The preferred kinds of lariats were made of braided rawhide strips, twisted grasses such as hemp, and horsehair, and averaged between 40 and 60 feet in length. Skill with a lariat elevated a cowboy's standing among his peers, and many cowboys spent their leisure time practicing with the rope, honing their lassoing techniques, and developing fancy casts and tricks.

Lariats made from braided rawhide strips were introduced by Mexican vaqueros. Expensive and delicate, rawhide ropes could be thrown accurately over a greater distance.

SUNDANCE VELLUM, MESQUITE, TEXT 70 LB.

SUNDANCE FELT, SAGEBRUSH, TEXT 70 LB.

BROCHURE

DESIGNER Belle How, San Francisco, California ART DIRECTOR Kit Hinrichs TYPOGRAPHIC SOURCE Eurotype
STUDIO Pentagram Design CLIENT Simpson Paper PRINCIPAL TYPE Rockwell Condensed
DIMENSIONS 9 × 11¾ in. (22.9 × 29.8 cm)

DESIGNERS Jennifer Morla and Craig Bailey, San Francisco, California LETTERER Craig Bailey STUDIO Morla Design
CLIENT Ristorante Ecco PRINCIPAL TYPE Handlettering DIMENSIONS Various

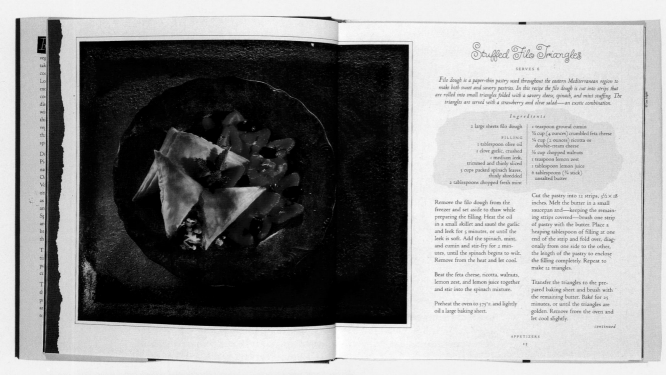

Stuffed Filo Triangles

SERVES 6

Filo dough is a paper-thin pastry used throughout the eastern Mediterranean region to make both sweet and savory pastries. In this recipe the filo dough is cut into strips that are rolled into small triangles folded with a savory cheese, spinach, and mint stuffing. The triangles are served with a strawberry and olive salad—an exotic combination.

Ingredients

2 large sheets filo dough

FILLING
1 tablespoon olive oil
1 clove garlic, crushed
1 medium leek,
trimmed and thinly sliced
3 cups packed spinach leaves,
thinly shredded
2 tablespoons chopped fresh mint

1 teaspoon ground cumin
½ cup (4 ounces) crumbled feta cheese
¼ cup (2 ounces) ricotta or
double-cream cheese
⅓ cup chopped walnuts
1 teaspoon lemon zest
1 tablespoon lemon juice
6 tablespoons (¾ stick)
unsalted butter

Remove the filo dough from the freezer and set aside to thaw while preparing the filling. Heat the oil in a small skillet and sauté the garlic and leek for 5 minutes, or until the leek is soft. Add the spinach, mint, and cumin and stir-fry for 2 minutes, until the spinach begins to wilt. Remove from the heat and let cool.

Beat the feta cheese, ricotta, walnuts, lemon zest, and lemon juice together and stir into the spinach mixture.

Preheat the oven to 375°F. and lightly oil a large baking sheet.

Cut the pastry into 12 strips, 3½ × 18 inches. Melt the butter in a small saucepan and—keeping the remaining strips covered—brush one strip of pastry with the butter. Place a heaping tablespoon of filling at one end of the strip and fold over, diagonally from one side to the other, the length of the pastry to enclose the filling completely. Repeat to make 12 triangles.

Transfer the triangles to the prepared baking sheet and brush with the remaining butter. Bake for 25 minutes, or until the triangles are golden. Remove from the oven and let cool slightly.

continued

APPETIZERS
15

The Inspired Vegetarian

LOUISE PICKFORD
Photographs by Gus Filgate

BOOK

DESIGNER Lynn Pieroni Fowler, New York, New York TYPOGRAPHIC SOURCES In-house and Photo-Lettering, Inc.
STUDIO Stewart Tabori & Chang CLIENT Stewart Tabori & Chang PRINCIPAL TYPES Steinweiss Scrawl and Centaur
DIMENSIONS 8 × 9 in. (20.3 × 22.9 cm)

LOGOTYPE

CALLIGRAPHER Iskra Johnson ART DIRECTOR Patricia Belyea, Seattle, Washington CLIENT Pompeii Ristorante
PRINCIPAL TYPE Handlettering

BOOK

DESIGNER Rita Marshall, Lakeville, Connecticut TYPOGRAPHIC SOURCES Affolter & Gschwend, Basel, Switzerland, and Dix Type, Syracuse, New York STUDIO Delessert and Marshall PRINCIPAL TYPES Old Foundry and Fournier
DIMENSIONS 8½ × 12 in. (21.6 × 30.5 cm)

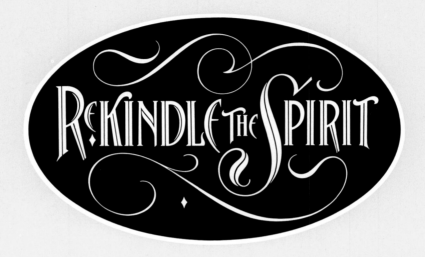

LOGOTYPE

DESIGNER Bruce Hale, Seattle, Washington LETTERER Bruce Hale STUDIO Bruce Hale Design Studio
CLIENT The Bon Marché PRINCIPAL TYPE Handlettering

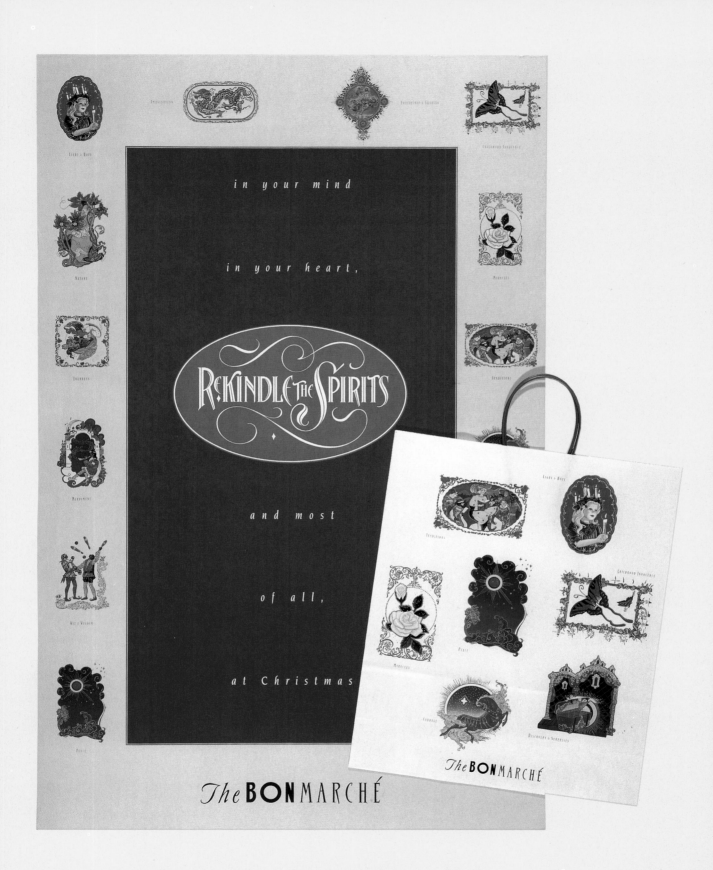

POSTER AND BAG

DESIGNER Mary Hubert, Seattle, Washington LETTERER Bruce Hale ART DIRECTOR Jean DeLatyreé
TYPOGRAPHIC SOURCE Thomas & Kennedy AGENCY The Bon Marché Advertising CLIENT The Bon Marché
PRINCIPAL TYPES ITC Novarese Italic, Bon Marché Medium, and handlettering
DIMENSIONS Poster: 28 × 44 in. (71.1 × 111.8 cm) Bag: 19 × 16 in. (48.3 × 40.6 cm)

BUSINESS CARD

DESIGNER Carlos Segura, Chicago, Illinois LETTERER Carlos Segura TYPOGRAPHIC SOURCE In-house
AGENCY Segura, Inc. CLIENT Segura, Inc. PRINCIPAL TYPES Exocet Light and handlettering
DIMENSIONS 3½ × 2⅛ in. (8.9 × 5.4 cm)

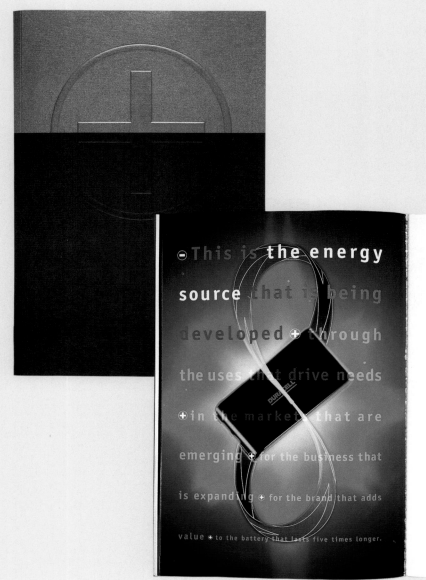

ANNUAL REPORT

DESIGNER Ruth Diener, New York, New York TYPOGRAPHIC SOURCE In-house AGENCY Frankfurt Gips Balkind
CLIENT Duracell International Inc. PRINCIPAL TYPE ITC Officina Sans DIMENSIONS 8 × 12 in. (20.3 × 30.5 cm)

You've found yourself face to face with something basic, something familiar. A bridge, perhaps. What does it look like? Wait! Before you describe it, ask: What time of day is it? Am I in love? Is it raining? How well do I swim? Does this bridge remind me of Venice? Do I like surprises? Would other people call ugly the things I'd defend as beautiful? What happened at work today? What is a bridge, anyway? An extension of the road, or an end in itself? Because it's you, looking at the world through your eyes, from your unique point of view, no bridge is familiar. There's no such thing as just your basic bridge. Now it's time to put pen to paper and show the world what the bridge looks like to you. If you're of a classical temperament, you'll search for papers that are frightfully elegant. If you're a romantic, only appallingly lovely paper will do. And if you're practical (who isn't?), you'll want paper that's hardworking and accessible as well as terribly extraordinary. Your search for peculiarly unique paper begins in your eyes, at your unique point of view. Your search ends at Mohawk.

WARNING Mohawk has determined that exposure to the enclosed papers may produce altered perception of the familiar.

BROCHURE

180

DESIGNERS Jilly Simons and Cindy Chang, Chicago, Illinois TYPOGRAPHIC SOURCE In-house STUDIO Concrete
CLIENT Mohawk Paper Mills, Inc. PRINCIPAL TYPES Garamond and Franklin Gothic
DIMENSIONS 8 × 11½ in. (20.3 × 29.2 cm)

POSTCARD

DESIGNER Uwe Loesch, Düsseldorf, Germany TYPOGRAPHIC SOURCE In-house
CLIENT Alliance Graphique Internationale PRINCIPAL TYPE Tannenberg
DIMENSIONS 5⅞ × 8¼ in. (14.8 × 21 cm)

Les maîtres **typo**graphes
Zibra

3981, boulevard Saint-Laurent
Bureau 810
Montréal (Québec) H2W 1Y5

Téléphone 514 288 6635
Télécopieur 514 288 1599
Modem 514 288 0392

Dwight W.A. Smith

Les maîtres **typo**graphes
Zibra

3981, boulevard Saint-Laurent
Bureau 810
Montréal (Québec) H2W 1Y5

Téléphone 514 288 6635
Télécopieur 514 288 1599
Modem 514 288 0392

Les maîtres **typo**graphes
Zibra

3981, boulevard Saint-Laurent
Bureau 810
Montréal (Québec) H2W 1Y5

CORPORATE IDENTITY

182

DESIGNER Daniel Picard, Montréal, Canada CALLIGRAPHER Daniel Picard LETTERER Ken Searle
TYPOGRAPHIC SOURCE Les Maîtres Typographes Zibra STUDIO Majuscule Design
CLIENT Les Maîtres Typographes Zibra PRINCIPAL TYPES Frutiger, Glypha (modified),
Torino (modified), and handlettering DIMENSIONS 7¼ × 10½ in. (18.4 × 26.7 cm)

GELFAND, RENNERT & FELDMAN

A Division of
Coopers & Lybrand

Certified Public
Accountants

Los Angeles
New York
London
Palm Springs

1880 Century
Park East
Suite 900
Los Angeles,
California
90067
Telephone:
310.553.1707
Telecopier:
310.557.8412

Marshall M. Gelfand, CPA
Irwin L. Rennert, CPA
Martin Feldman, CPA
David Jackel, CPA
Edwin N. London
John R. Phillips, CPA
Nicholas Brown
William L. Harper, CPA
Todd E. Gelfand, CPA
Steven L. Cantrock
Bradley R. Jonas, CPA
Peter M. Levine, CPA
Ronald E. Nash, CPA
Mario Tiscani, CPA
Stephen Brackman
Alan S. Lewis
Jeffrey Kaye

Joyce B. Levine, CPA
Don Peterson, CPA
George J. Calvelli, CPA
Cathy L. Berry
Jerald D. Schneider, CPA
Annette Welch
Michele D. Bolaños, CPA
Martin P. Leder
Carolyn H. Spectz, CPA
Jay L. Reiosman
Dennis F. Kennedy
Stephen Marks
John Nitzkorf, CPA
Kim Keuten-Summers, CPA

GELFAND, RENNERT & FELDMAN

A Division of
Coopers & Lybrand

1880 Century
Park East
Suite 900
Los Angeles,
California
90067

Marshall M. Gelfand, CPA
Managing Partner
310.556.6601

GELFAND, RENNERT & FELDMAN

A Division Certified 1880 Century Telephone:
of Coopers Public Park East 310.553.1707
& Lybrand Accountants Suite 900 Telecopier:
 Los Angeles, 310.557.8412
 California
 90067

GELFAND, RENNERT & FELDMAN

A Division of
Coopers & Lybrand

STATIONERY

DESIGNER Tricia Rauen, Culver City, California TYPOGRAPHIC SOURCE In-house STUDIO Evenson Design Group
CLIENT Gelfand, Rennert & Feldman PRINCIPAL TYPES Bembo Semi Bold and Semi Bold Italic
DIMENSIONS 8½ × 11 in. (21.6 × 27.9 cm)

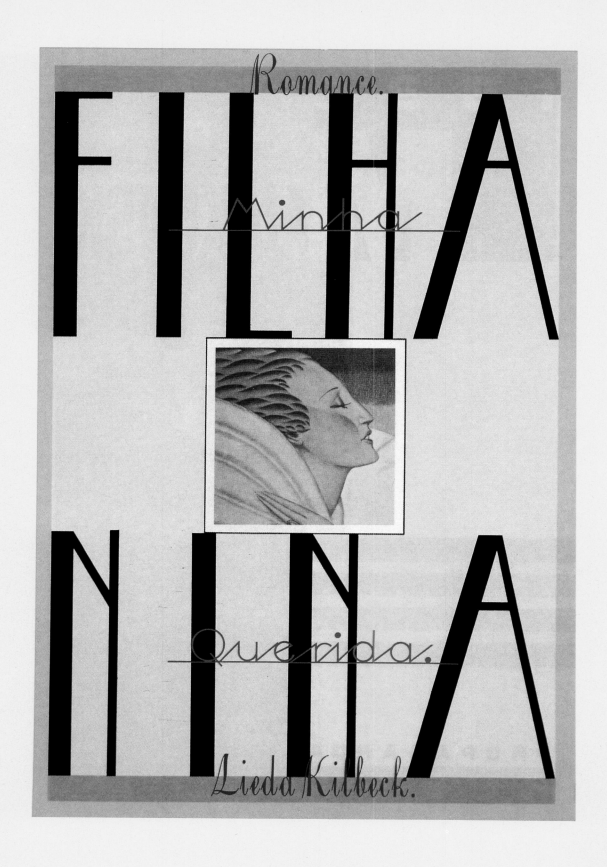

BOOK COVER

184

DESIGNER Oswaldo Miranda (Miran), Curitiba, Paraná, Brazil LETTERER Oswaldo Miranda (Miran)
STUDIO Casa de Idéias CLIENT State Library of Paraná PRINCIPAL TYPE Handlettering
DIMENSIONS 5⅞ × 8¹¹⁄₁₆ in. (15 × 22 cm)

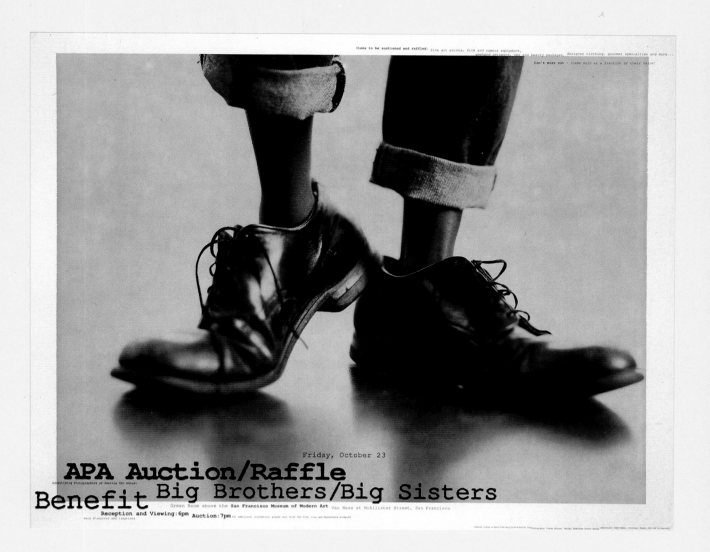

POSTER

DESIGNER Madeleine Corson, San Francisco, California PHOTOGRAPHER Thomas Heinser
TYPOGRAPHIC SOURCE In-house STUDIO Madeleine Corson Design CLIENT Advertising Photographers of America
PRINCIPAL TYPE Courier DIMENSIONS 20 × 16 in. (50.8 × 40.6 cm)

POSTERS

Designers Andy Clarke, Norman Alcuri, and Gordon Tan, Singapore
Creative Directors Jim Aitchison and Norman Alcuri Typographic Source The Fotosetter
Agency The Ball Partnership Euro RSCG Client Yet Con Restaurant Principal Type Trade Gothic Bold
Dimensions 24 × 17 in. (61 × 43.2 cm)

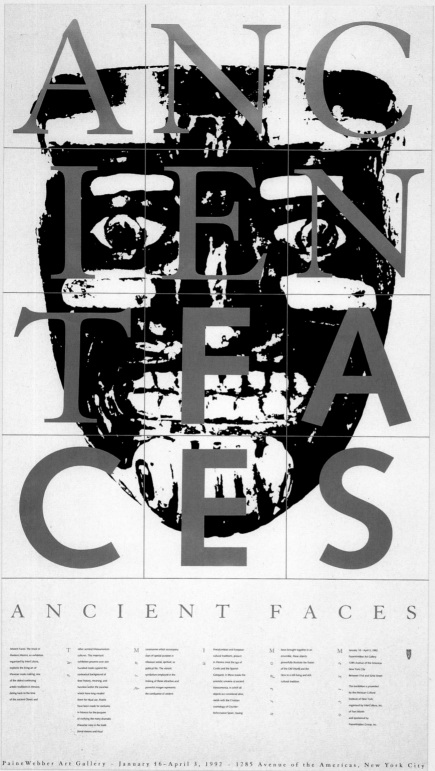

CAMPAIGN

187

DESIGNERS Scott Williams and Rishi Seth, Fort Worth, Texas ART DIRECTOR Scott Williams
TYPOGRAPHIC SOURCE In-house AGENCY The Summit Group CLIENT Intercultura
PRINCIPAL TYPES Granjon and Syntax DIMENSIONS Brochure: 71½ × 6½ in. (181.6 × 16.5 cm)
Poster: 20¼ × 37¼ in. (51.4 × 94.6 cm)

KPMG Deutsche Treuhand Grüppe

Karriere ohne Branchengrenzen

BROCHURE

DESIGNERS Klaus Bietz and Fritz Hofrichter, Frankfurt, Germany CALLIGRAPHER Klaus Bietz
TYPOGRAPHIC SOURCE Con Composition STUDIO HWL & Partner Design GmbH
CLIENT KPMG Deutsche-Treuhand-Gruppe PRINCIPAL TYPES Univers 49, Frutiger 75, 56, and 45
DIMENSIONS 8¼ × 11⅝ in. (21 × 29.7 cm)

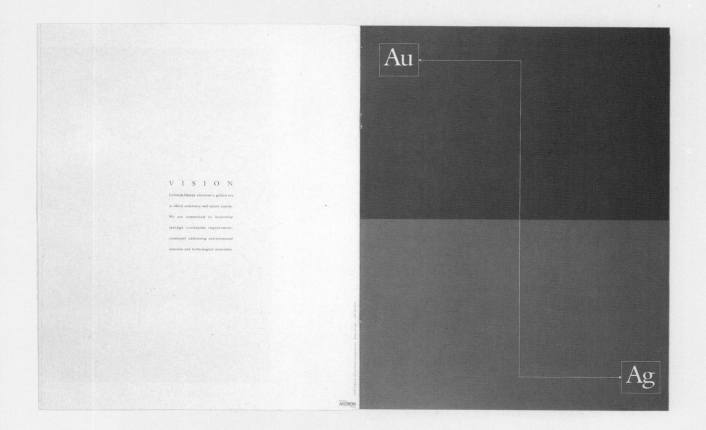

VISION

Collins&Aikman envisions a golden era
in which commerce and nature coexist.
We are committed to leadership
through continuous improvement,
constantly addressing environmental
concerns and technological innovation.

BROCHURE

DESIGNER Russ Ramage, Dalton, Georgia PHOTOGRAPHER Maria Robledo TYPOGRAPHIC SOURCE In-house
STUDIO DESIGN! CLIENT Collins & Aikman Floor Coverings PRINCIPAL TYPE ITC Galliard
DIMENSIONS 12 × 15 in. (30.5 × 38.1 cm)

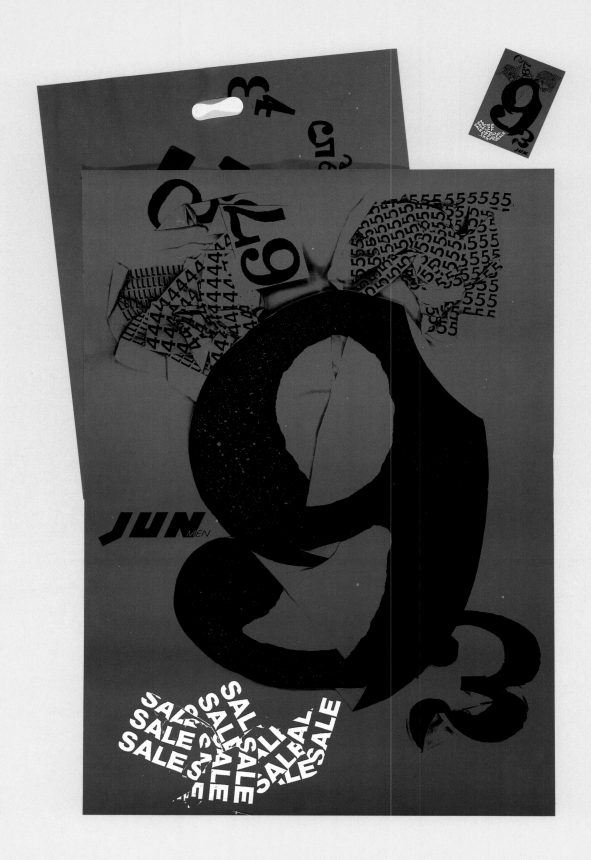

CAMPAIGN

DESIGNER Keisuke Unosawa, Shibuya-ku, Tokyo, Japan LETTERER Keisuke Unosawa TYPOGRAPHIC SOURCES In-house
and Letraset Instant Lettering STUDIO Keisuke Unosawa Design CLIENT Jun Co., Ltd.
PRINCIPAL TYPES Clarendon Medium, Univers 75, and Futura Demi Bold DIMENSIONS Various

VIDEO TRAILER

DESIGNERS Jens Deusner and Frank Hildmann, Frankfurt, Germany CALLIGRAPHER Jens Deusner
CREATIVE DIRECTOR Patricia Kunkel TYPOGRAPHIC SOURCE In-house AGENCY Patricia Kunkel Design
STUDIO Instant Media Lab CLIENT VOX TV PRINCIPAL TYPES Clarendon and handlettering

DESIGNER Jerry Ketel, Portland, Oregon CREATIVE DIRECTOR George Taylor TYPOGRAPHIC SOURCE In-house
AGENCY Cyrano CLIENT GeVa Theatre PRINCIPAL TYPE Adobe Caslon

POSTER

DESIGNER John Muller, Kansas City, Missouri LETTERER John Muller AGENCY Muller & Company
CLIENT Kansas City Jazz Commission PRINCIPAL TYPE Handlettering
DIMENSIONS 28⅜ × 45¾ in. (72.1 × 116.2 cm)

BINDER

DESIGNER Roger Wagner, New York, New York TYPOGRAPHIC SOURCE In-house STUDIO Wagner Design Labs
CLIENT Warner Bros. Pay-TV, Cable & Network Features PRINCIPAL TYPES OCR-A and Folio Bold
DIMENSIONS 9 × 11 in. (22.9 × 27.9 cm)

POSTER

DESIGNER Kit Hinrichs, San Francisco, California TYPOGRAPHIC SOURCE In-house STUDIO Pentagram Design
CLIENT Pacific Design Center PRINCIPAL TYPE Futura DIMENSIONS 37½ × 11 in. (40 × 27.9 cm)

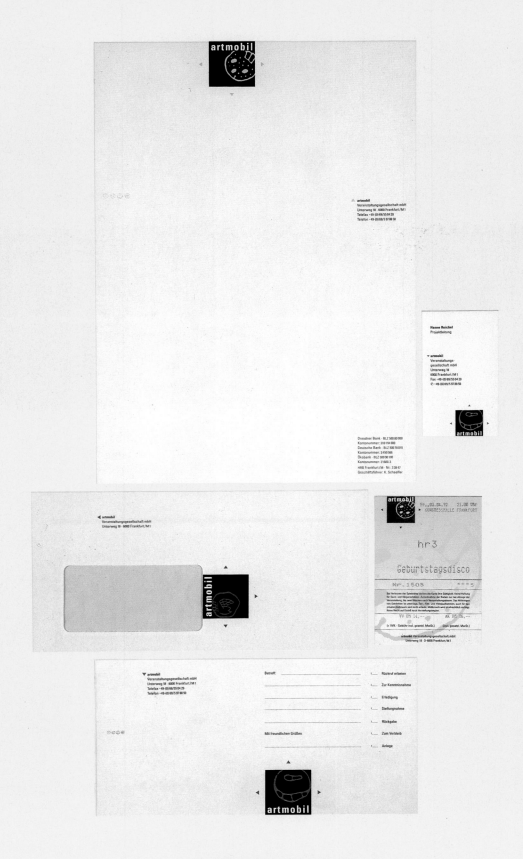

CORPORATE IDENTITY

DESIGNER Christine Bahl, Frankfurt, Germany TYPOGRAPHIC SOURCE In-house
AGENCY Fuhr & Wolf Design-Agentur GmbH CLIENT artmobil Veranstaltungsgesellschaft mbH
PRINCIPAL TYPES Univers Condensed 57 Regular and Univers Condensed 67 Bold DIMENSIONS Various

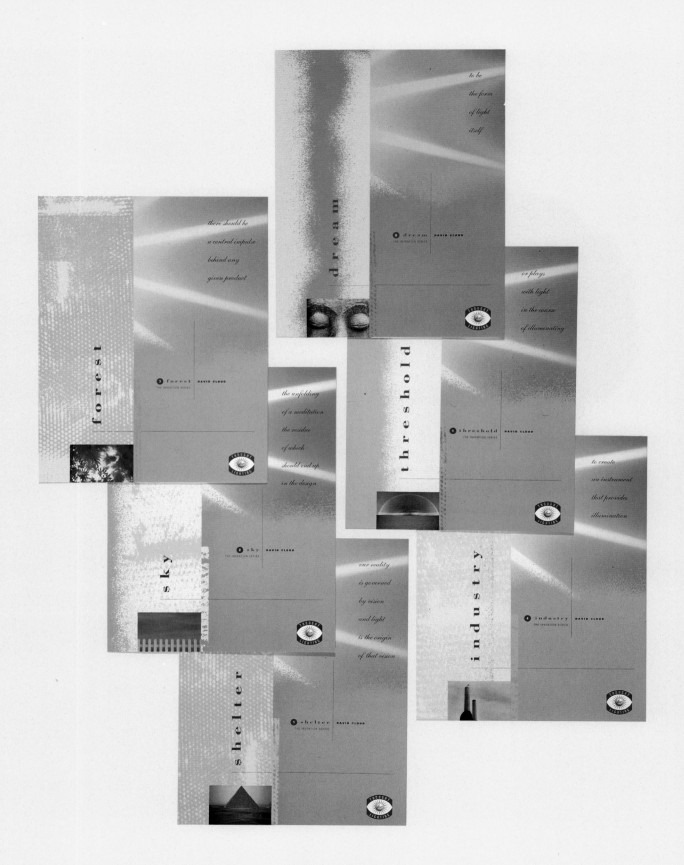

BROCHURE

DESIGNER Barbara Coleman, Chicago, Illinois PHOTOGRAPHER Howard Bjornson TYPOGRAPHIC SOURCE In-house
STUDIO Coleman Design CLIENT David Cloud PRINCIPAL TYPE Various DIMENSIONS 8½ × 11 in. (21.6 × 27.9 cm)

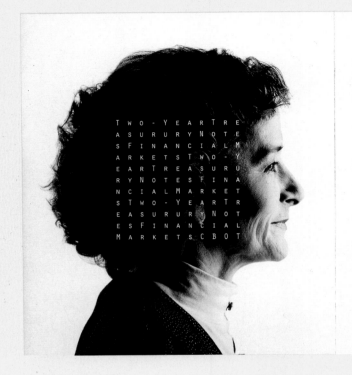

ANNUAL REPORT

198

DESIGNERS Dana Arnett and Curtis Schreiber, Chicago, Illinois TYPOGRAPHIC SOURCE In-house
AGENCY VSA Partners, Inc. CLIENT Chicago Board of Trade PRINCIPAL TYPE Letter Gothic
DIMENSIONS 10 × 11 in. (25.4 × 27.9 cm)

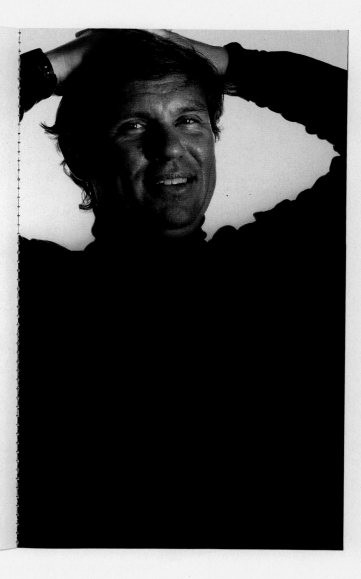

Dr. Jerry Nelson *Astrophysicist* University of California, Berkeley

In September 1985, the W. M. Keck Foundation announced a special $70 million grant to Caltech to fund the W. M. Keck ten-meter telescope project. That grant, believed to be the largest single gift ever made for a scientific project, was hailed throughout the nation and was in keeping with the Foundation's primary philosophy, to aid in the advancement of pre-eminent scientific endeavors.

The project required the talents, efforts and energies of top astronomers, engineers, and physicists, to bring to reality the long-held tenet that a telescope as large as ten meters could hold the promise of new discoveries and far-reaching benefits for mankind. The greatest obstacle for this instrument was the mirror, for it was widely believed that the size limit for telescope mirrors was already in place in the five-meter Hale Telescope on Mt. Palomar in California.

On November 7, 1991, the W. M. Keck Telescope located at the 13,600 foot level of Mauna Kea, on the Island of Hawaii, was dedicated. With only one-half of its 36 unique hexagonal mirrors in place this magnificent instrument became the world's largest operational telescope. The final 18 mirrors, which were installed in April 1992, gave the ten-meter telescope twice the diameter and four times the light-gathering power of the world-renowned Hale.

Achieving the highly unlikely, turning hypothesis into affirmation, or daring to test the waters of the unknown, requires the genius and characteristics of a true visionary. Jerry Nelson, a professor of astronomy at the University of California, Berkeley and a senior staff scientist at Lawrence Berkeley Laboratory, is just such a person. During the late 1970s Jerry Nelson was involved in astronomical research and engaged in finding solutions to the problems of building larger telescopes. A telescope of ten meters was the goal and designing a functional mirror of such magnitude presented the greatest challenge. It was Jerry Nelson, now the Keck Telescope project scientist, who conceived the idea to build a mirror in segments and although it was thought by many to be beyond possible, Jerry persevered. His ultimate successful design of a honeycombed mirror composed of 36 hexagonal segments, each six feet across and three inches thick, is now in place in the Keck Telescope. A breakthrough for the science of astronomy, enabling mankind to peer back billions of years in search of the beginning.

The W. M. Keck Foundation takes exceptional pride in its participation with outstanding scientists and institutions that continue to foster research and discovery.

8.

ANNUAL REPORT

DESIGNER Douglas Oliver, Santa Monica, California TYPOGRAPHIC SOURCE In-house STUDIO Morava Oliver Berté
CLIENT W.M. Keck Foundation PRINCIPAL TYPE Centaur DIMENSIONS 8 × 14 in. (20.3 × 35.6 cm)

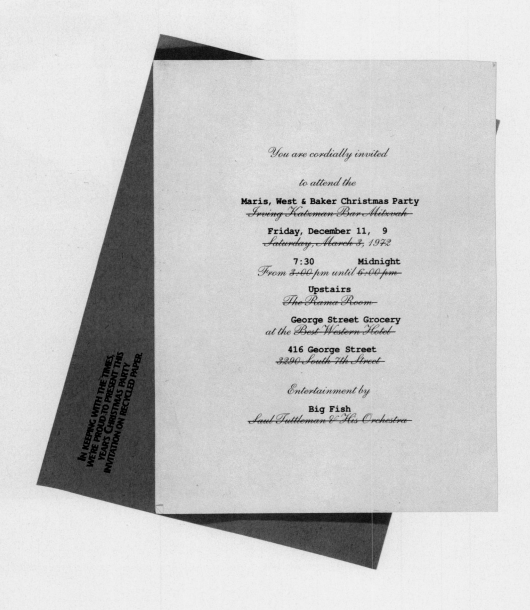

You are cordially invited

to attend the

Maris, West & Baker Christmas Party
~~Irving Katzman Bar Mitzvah~~

Friday, December 11, 9
~~Saturday, March 3, 1972~~

7:30 Midnight
~~From 3:00 pm until 6:00 pm~~

Upstairs
~~The Rama Room~~

George Street Grocery
~~at the Best Western Hotel~~

416 George Street
~~3290 South 7th Street~~

Entertainment by

Big Fish
~~Saul Tuttleman & His Orchestra~~

In keeping with the times, we're proud to present this year's Christmas party invitation on recycled paper.

INVITATION

DESIGNER Bill Porch, Jackson, Mississippi TYPOGRAPHIC SOURCE Heritage Graphics
AGENCY Maris, West & Baker, Inc. CLIENT Maris, West & Baker, Inc. PRINCIPAL TYPES ITC Stone Sans Bold,
Shelley Andante, and Courier Bold DIMENSIONS 5⅛ × 7 in. (13 × 17.8 cm)

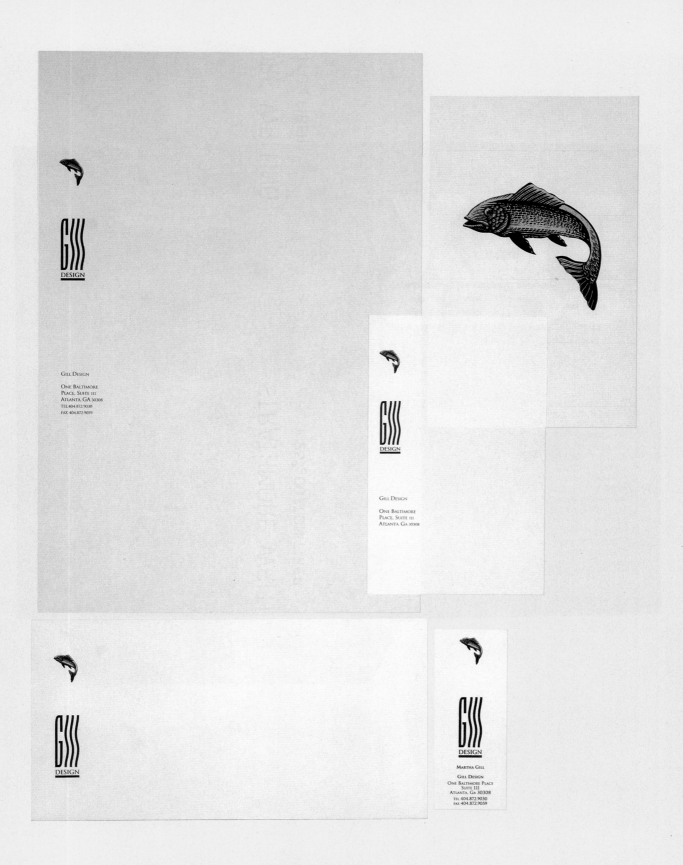

STATIONERY

DESIGNER Martha Gill, Atlanta, Georgia LETTERER Martha Gill TYPOGRAPHIC SOURCE In-house STUDIO Gill Design
CLIENT Gill Design PRINCIPAL TYPE Trajan DIMENSIONS 8½ × 11 in. (21.6 × 27.9 cm)

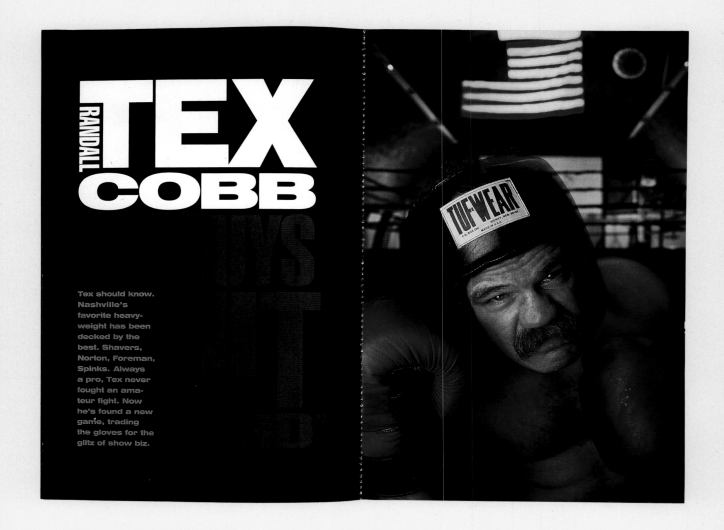

RANDALL TEX COBB

Tex should know. Nashville's favorite heavyweight has been decked by the best. Shavers, Norton, Foreman, Spinks. Always a pro, Tex never fought an amateur fight. Now he's found a new game, trading the gloves for the glitz of show biz.

BROCHURE

DESIGNERS Laurie and Jan Ellis, Nashville, Tennessee TYPOGRAPHIC SOURCE In-house STUDIO Ellis Design
CLIENT Athens Paper PRINCIPAL TYPE Swiss DIMENSIONS 6 × 9 in. (15.2 × 22.9 cm)

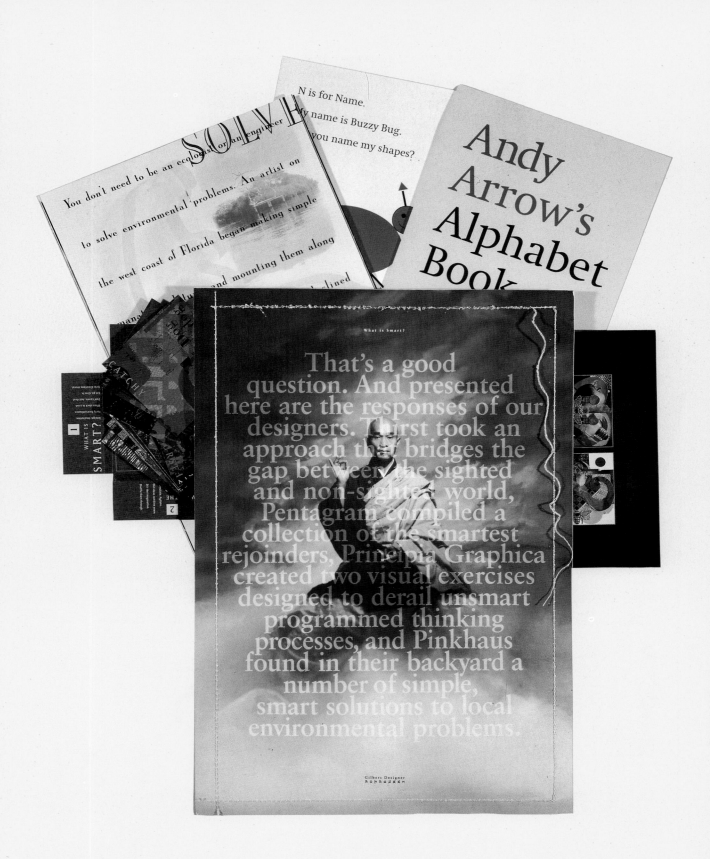

PACKAGING

DESIGNERS Joel Fuller and Tom Sterling, Miami, Florida LETTERER Ralf Schuetz TYPOGRAPHIC SOURCE In-house
STUDIO Pinkhaus Design Corp. CLIENT Gilbert Paper PRINCIPAL TYPES Sabon and Oblong
DIMENSIONS 14⅜ × 21 in. (36.5 × 53.3 cm)

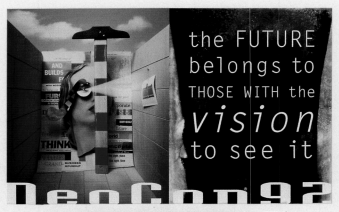

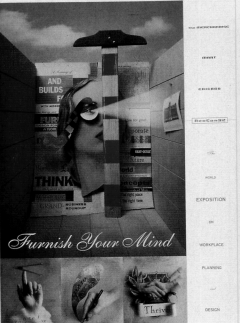

DIRECT MAIL

204

DESIGNER Carlos Segura, Chicago, Illinois PHOTOGRAPHER Geof Kern, Dallas, Texas TYPOGRAPHIC SOURCE In-house
AGENCY Segura, Inc. CLIENT The Merchandise Mart PRINCIPAL TYPES Letter Gothic, Copperplate, and Badlock
DIMENSIONS Various

T-SHIRT

DESIGNER Bart Crosby, Chicago, Illinois LETTERERS Bart Crosby and Harvey Hunt
TYPOGRAPHIC SOURCE Digital Composition Incorporated AGENCY Crosby Associates Inc.
CLIENT Digital Composition Incorporated PRINCIPAL TYPES Gill Sans and handlettering

A Celebration...

...of work?

For our 1992 calendar we wanted to say something meaningful about the challenges of the coming year. *There* are a lot of buzz-words to choose from. Competitiveness. Globalization. Continuous improvement. Motherhood and maple syrup. *But* we think it can be said much more simply. The way to meet any big challenge is through plain old-fashioned hard work. Just getting down and doing it. *And* rather than drag out the soapbox, we'd prefer to communicate this simple message through a few strong images. After all, that's what our business is all about. *So* in the following pages we present portraits of 12 working people doing what they do best. As people have always done when it was most needed. *This* ain't exactly Hegelian metaphysics. All we're saying is, with the right initiative, energy and pride in achievement, we can make anything happen. *And* once we've got that licked, maybe we can try a new national anthem: "Heigh ho, heigh ho..."

Happy holidays and best wishes for a prosperous New Year
from all of us at Concrete.

CONCRETE
EM6-9908
THREE BRIGHT IDEAS EVERY DAY!

CALENDAR

DESIGNERS John Pylypczak and Diti Katona, Toronto, Canada TYPOGRAPHIC SOURCE In-house
STUDIO Concrete Design Communications, Inc. CLIENT Concrete Design Communications, Inc.
PRINCIPAL TYPES Franklin Gothic and Monterey DIMENSIONS 8 × 10 in. (20.3 × 25.4 cm)

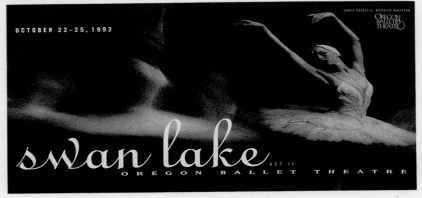

ADVERTISEMENT

DESIGNER Hal Wolverton, Portland, Oregon TYPOGRAPHIC SOURCE In-house AGENCY Johnson & Wolverton
CLIENT Oregon Ballet Theatre PRINCIPAL TYPES Maximus, Cochin, Linoscript, and Trade Gothic
DIMENSIONS 10½ × 5 in. (26.7 × 12.7 cm)

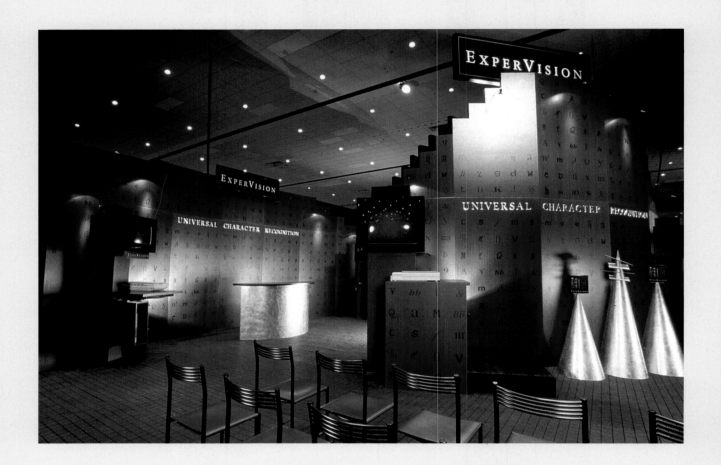

EXHIBIT

DESIGNERS Mitchell Mauk and Frances Packer, San Francisco, California FABRICATOR Bluepeter
TYPOGRAPHIC SOURCE Design & Type STUDIO Mauk Design CLIENT ExperVision
PRINCIPAL TYPES Trajan and Garamond

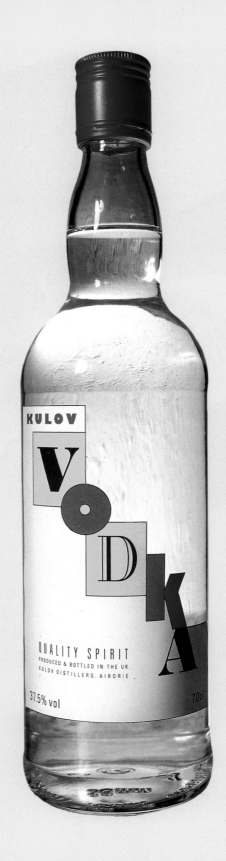

PACKAGING

DESIGNER Ashted Dastor, London, England LETTERERS Ashted Dastor and Steve Paris
TYPOGRAPHIC SOURCE Diamond Graphics Limited STUDIO Ashted Dastor Associates CLIENT Kulov Distillers
PRINCIPAL TYPES Bodoni Black, Gill Sans, Kayo Bold, Univers 49 Light, Burlington, and handlettering
DIMENSIONS 4¾ × 3⅓ in. (12 × 8.5 cm)

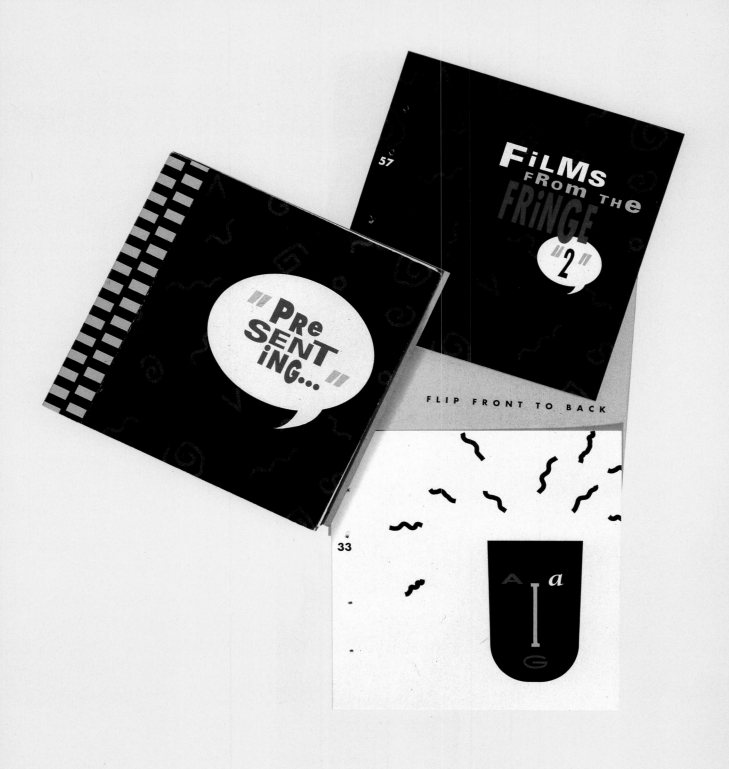

INVITATION

DESIGNERS Melanie Bass, Julie Sebastianelli, Richard Hamilton, Andres Tremols, Jim Jackson, and Jake Pollard, Alexandria, Virginia LETTERERS Julie Sebastianelli and Melanie Bass TYPOGRAPHIC SOURCE In-house
CLIENT American Institute of Graphic Arts/Washington PRINCIPAL TYPES Futura, Univers, and ITC Berkeley Old Style
DIMENSIONS 3 × 3 in. (7.6 × 7.6 cm)

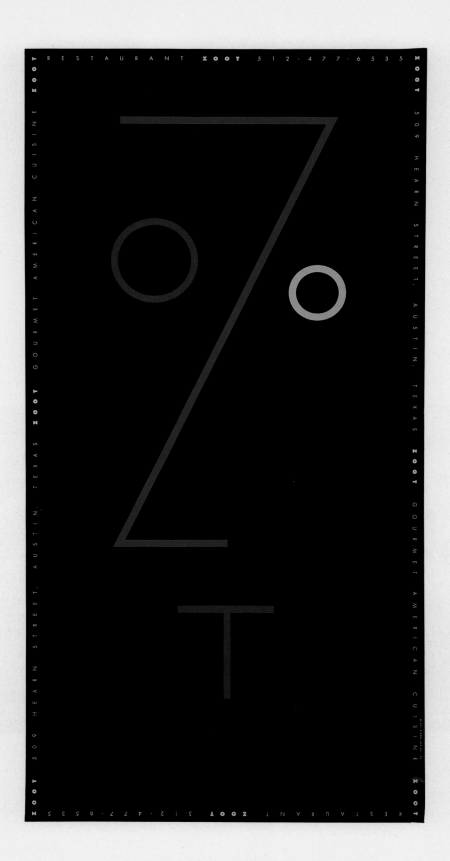

IDENTITY PROGRAM

DESIGNER Lana Rigsby, Houston, Texas LETTERER Lana Rigsby TYPOGRAPHIC SOURCE Characters
STUDIO Rigsby Design, Inc. CLIENT ZOOT restaurant, Austin, Texas PRINCIPAL TYPES Futura and handlettering
DIMENSIONS Various

BROCHURE

DESIGNERS Michael Bierut, Lisa Cervency, P. Scott Makela, and Dana Arnett, New York, New York
ART DIRECTOR Michael Bierut TYPOGRAPHIC SOURCE Typogram STUDIO Pentagram Design CLIENT Mohawk Paper
Mills, Inc. PRINCIPAL TYPES Baskerville and Headline Gothic DIMENSIONS 8½ × 9 in. (21.6 × 22.9 cm)

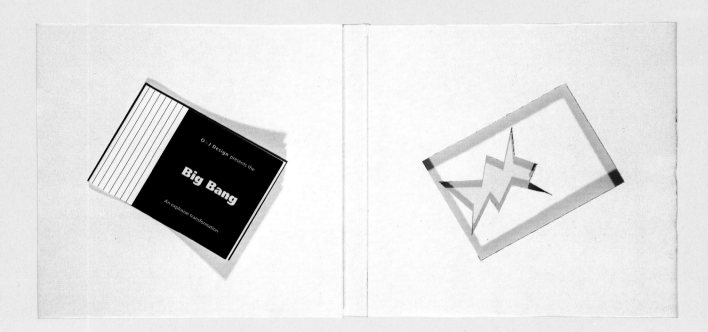

FLIP BOOK

DESIGNERS Inhi Clara Kim and Andrzej J. Olejniczak, New York, New York TYPOGRAPHIC SOURCE In-house
STUDIO O&J Design, Inc. CLIENT O&J Design, Inc. PRINCIPAL TYPES Times Roman and Frutiger
DIMENSIONS 2¼ × 3⅛ in. (5.7 × 7.9 cm)

Type Directors Club

OFFICERS 1992/93

PRESIDENT	Allan Haley
VICE PRESIDENT	Kathie Brown
SECRETARY/TREASURER	B. Martin Pedersen
DIRECTORS-AT-LARGE	Ed Colker
	Mara Kurtz
	Roy Podorson
	Dirk Rowntree
	Howard Salberg
	Mark Solsburg
	Ilene Strizver
CHAIRPERSON, BOARD OF DIRECTORS	Ed Benguiat

OFFICERS 1993/94

PRESIDENT	Allan Haley
VICE PRESIDENT	Kathie Brown
SECRETARY/TREASURER	B. Martin Pedersen
DIRECTORS-AT-LARGE	Ed Colker
	Cynthia Hollandsworth
	Gerard Huerta
	Mara Kurtz
	Dirk Rowntree
	Mark Solsburg
	Ilene Strizver
CHAIRPERSON, BOARD OF DIRECTORS	Ed Benguiat

COMMITTEE FOR TDC39

CHAIRPERSON	Mark Solsburg
CALL FOR ENTRIES DESIGNER	Rick Valicenti
TYPOGRAPHY 14 DESIGNER	Mark van Bronkhorst
COORDINATOR	Carol Wahler
ASSISTANT COORDINATOR	Klaus Schmidt
CALLIGRAPHER	Robert Boyajian
ASSISTANTS TO JUDGES	Peter Bain, Kathie Brown, Laurie Burns, Adam Greiss, Cheryl Miller, Eric Neuner, Alexa Nosal, Roy Podorson, Gisela Schmidt, Juergen Schroeder, Agatha Sohn, Martin Solomon, Ed Vadala, Allan R. Wahler and Samantha Wahler

TYPE DIRECTORS CLUB
PRESIDENTS

Frank Powers 1946, 1947	Saadyah Maximon 1969
Milton Zudeck 1948	Louis Lepis 1970, 1971
Alfred Dickman 1949	Gerard O'Neill 1972, 1973
Joseph Weiler 1950	Zoltan Kiss 1974, 1975
James Secrest 1951, 1952, 1953	Roy Zucca 1976, 1977
Gustave Saelens 1954, 1955	William Streever 1978, 1979
Arthur Lee 1956, 1957	Bonnie Hazelton 1980, 1981
Martin Connell 1958	Jack George Tauss 1982, 1983
James Secrest 1959, 1960	Klaus F. Schmidt 1984, 1985
Frank Powers 1961, 1962	John Luke 1986, 1987
Milton Zudeck 1963, 1964	Jack Odette 1988, 1989
Gene Ettenberg 1965, 1966	Ed Benguiat 1990, 1991
Edward Gottschall 1967, 1968	Allan Haley 1992, 1993

TDC MEDAL RECIPIENTS

Hermann Zapf 1967	Herb Lubalin 1984
R. Hunter Middleton 1968	(posthumously)
Frank Powers 1971	Paul Rand 1984
Dr. Robert Leslie 1972	Aaron Burns 1985
Edward Rondthaler 1975	Bradbury Thompson 1986
Arnold Bank 1979	Adrian Frutiger 1987
Georg Trump 1982	Freeman Craw 1988
Paul Standard 1983	Ed Benguiat 1989
	Gene Federico 1991

SPECIAL CITATIONS TO
TDC MEMBERS

Edward Gottschall 1955	William Streever 1984
Freeman Craw 1968	Klaus F. Schmidt 1985
James Secrest 1974	John Luke 1987
Olaf Leu 1984, 1990	Jack Odette 1989

INTERNATIONAL LIAISON
CHAIRPERSONS

AUSTRALIA
David Minnett, President
Australian Type Directors Club
P.O. Box 1887
North Sydney 2060

ENGLAND
David Quay
Studio 12
10–11 Archer Street
SoHo
London W1V 7HG

FRANCE
Christopher Dubber
6 bis Avenue du Rocher
94100 Saint Maur des Fossés

GERMANY
Bertram Schmidt-Friderichs
Universitatsdruckerei und Verlag
H. Schmidt GmbH & Co.
Robert Koch Straße 8
Postfach 42 07 28
D 6500 Mainz 42

JAPAN
Japan Typography Association
C C Center
4–8–15 Yushima
Bunkyo-ku
Tokyo 113

REPUBLIC OF SINGAPORE
Gordon Tan
The Fotosetter
41 Middle Road #40–00
Singapore 0718

SOUTH AMERICA
Diego Vainesman
160 East 26th Street
New York, NY 10010

SWEDEN
Ernst Dernehl
Dernehl & Son Designers
Box 8073
S 10420 Stockholm

Type Directors Club
60 East 42nd Street, Suite 721
New York, NY 10165
212-983-6042 FAX 212-983-6043

Carol Wahler, Executive Director

For membership information please
contact the Type Directors Club
offices.

TDC MEMBERSHIP

Mary Margaret Ahern '83
Jim Aitchison '93
Victor Ang '91
Martyn Anstice '92
Herman Aronson '92
Peter Bain '86
Bruce Balkin '93
Nick Ballard '91
Maria Helena Ferreira Braga
 Barbosa '93 s
Clarence Baylis '74
Felix Beltran '88
Ed Benguiat '64
Jesse Berger '92
Anna Berkenbusch '89
Peter Bertolami '69
Roger Black '80
Anthony Bloch '88
Susan Cotler Block '91
Sharon Blume '86
Art Boden '77
Karlheinz Boelling '86
Friedrich Georg Boes '67
Garrett Boge '83
Bud Braman '90
Ed Brodsky '80
Anthony Brooks '91
Kathie Brown '84
Werner Brudi '66
Bill Bundzak '64
Jason Calfo '88
Ronn Campisi '88
Paul S. Carroll '92 s
Matthew Carter '88
Ken Cato '88
Art Chantry '91
Kai-Yan Choi '90
Alan Christie '77

Andrew Clarke '93
Ed Cleary '89
Travis Cliett '53
Mahlon A. Cline* '48
Elaine Coburn '85
Tom Cocozza '76
Angelo Colella '90
Ed Colker '83
Freeman Craw* '47
David Cundy '85
Rick Cusick '89
Susan Darbyshire '87
Ismar David '58
Cosmo De Maglie '74
Josanne De Natale '86
Robert Defrin '69
Ernst Dernehl '87
Ralph Di Meglio '74
Claude Dieterich '84
Lou Dorfsman '54
John Dreyfus** '68
Christopher Dubber '85
Lutz Dziarnowski '92
Rick Eiber '85
Dr. Elsi Vassdal Ellis '93
Garry Emery '93
Nick Ericson '92
Joseph Michael Essex '78
Leon Ettinger '84
Leslie Evans '92
Florence Everett '89
Bob Farber '58
Gene Federico** '91
Sidney Feinberg** '49
Janice Prescott Fishman '91
Kristine Fitzgerald '90
Mona Fitzgerald '91
Yvonne Fitzner '87
Norbert Florendo '84

Tony Forster '88
Dean Franklin '80
Carol Freed '87
H. Eugene Freyer '88
Adrian Frutiger** '67
Patrick Fultz '87
András Fűrész '89
Fred Gardner '92
Christof Gassner '90
David Gatti '81
Jeremy Gee '92
Stuart Germain '74
Lou Glassheim* '47
Howard Glener '77
Tama Alexandrine Goen '93
Jeff Gold '84
Alan Gorelick '85
Edward Gottschall '52
Norman Graber '69
Diana Graham '85
Austin Grandjean '59
James Jay Green '91
Adam Greiss '89
Jeff Griffith '91
Rosanne Guararra '92
Kurt Haiman '82
Allan Haley '78
Mark L. Handler '83
William Paul Harkins '83
Sherri Harnick '83
John Harrison '91
Knut Hartmann '85
Reinhard Haus '90
Bonnie Hazelton '75
Richard Henderson '92
Elise Hilpert '89
Michael Hodgson '89
Fritz Hofrichter '80
Alyce Hoggan '91

TDC MEMBERSHIP (CONTINUED)

Cynthia Hollandsworth '91
Kevin Horvath '87
Gerard Huerta '85
Harvey Hunt '92
Donald Jackson** '78
Helen Kahng Jaffe '91 s
John Jamilkowski '89
Jon Jicha '87
Allen Johnston '74
R.W. Jones '64
Scott Kelly '84
Michael O. Kelly '84
Steven J. Kennedy '92
Renee Khatami '90
Hermann Killian '92
Zoltan Kiss '59
Robert C. Knecht '69
Steve Kopec '74
Myosook Koo '93 s
Bernhard J. Kress '63
Madhu Krishna '91
John Krumpelbeck '91
Tara Kudra '91a
Ralf Kunz '93
Mara Kurtz '89
Sasha Kurtz '91 s
Gerry L'Orange '91
Raymond F. Laccetti '87
Jim Laird '69
Guenter Gerhard Lange '83
Jean Larcher '81
Kyung Sun Lee '92 s
Yoo-mi Lee '92 s
Judith Kazdym Leeds '83
Olaf Leu '65
Jeffery Level '88
Mark Lichtenstein '84
Wally Littman '60

Sergio Liuzzi '90
John Howland Lord** '47
Gregg Lukasiewicz '90
John Luke '78
Sol Malkoff '63
Marilyn Marcus '79
Michael Marino '91
Stanley Markocki '80
Adolfo Martinez '86
Rogério Martins '91
Les Mason '85
Douglas May '92
James L. McDaniel '92
Roland Mehler '92
Frederic Metz '85
Douglas Michalek '77
John Milligan '78
Michael Miranda '84
Oswaldo Miranda (Miran) '78
Richard Moore '82
Ronald Morganstein '77
Minoru Morita '75
Gerald Moscato '93
Tobias Moss* '47
Richard Mullen '82
Antonio Muñoz '90
Keith Murgatroyd '78
Erik Murphy '85
Jerry King Musser '88
Louis A. Musto '65
Alexander Nesbitt '50
Robert Norton '92
Alexa Nosal '87
Robert O'Connor '92
Brian O'Neill '68
Gerard O'Neill* '47
Jack Odette '77
Tony Owen '92
Bob Paganucci '85

Mike Parker '92
Rosina Patti '91 a
B. Martin Pedersen '85
Daniel Pelavin '92
Robert Peters '86
Roy Podorson '77
Will Powers '89
Vittorio Prina '88
Richard Puder '85
David Quay '80
Elissa Querzé '83
Robert Raines '90
Erwin Raith '67
Adeir Rampazzo '85
Paul Rand** '86
Hermann Rapp '87
Jo Anne Redwood '88
Hans Dieter Reichert '92
Bud Renshaw '83
Edward Rondthaler* '47
Kurt Roscoe '93
Robert M. Rose '75
Dirk Rowntree '86
Erkki Ruuhinen '86
Gus Saelens '50
Howard J. Salberg '87
Bob Salpeter '68
David Saltman '66
Irene Santoso '93 s
John Schaedler '63
Jay Schechter '87
Hermann J. Schlieper '87
Hermann Schmidt '83
Klaus Schmidt '59
Markus Schmidt '93
Bertram Schmidt-Friderichs '89
Werner Schneider '87
Eileen Hedy Schultz '85
Eckehart Schumacher-Gebler '85

Michael Scotto '82
Paul Shaw '87
Philip Shore, Jr. '92
Gil A. Silva '92
Mark Simkins '92
Dwight D.A. Smith '92
George Sohn '86
Martin Solomon '55
Jan Solpera '85
Mark Solsburg '89
Barbara Sommer '92
Jong-Hyun Song '92 s
Ronnie Tan Soo Chye '88
Bill Sosin '92
Erik Spiekermann '88
Vic Spindler '73
Walter Stanton '58
Rolf Staudt '84
Mark Steele '87
Charles Stewart '92
Sumner Stone '88
William Streever '50
Ilene Strizver '88
Hansjorg Stulle '87
Tony Sutton '93
Zempaku Suzuki '92
Gunnar Swanson '92
Ken Sweeny '78
Paul Sych '93
Gordon Tan '90
Michael Tardif '92
William Taubin '56
Jack Tauss '75

Pat Taylor '85
Anthony J. Teano '62
Mark Tenga '93
Bradbury Thompson '58
Paula Thomson '91
Harry Title '93
D.A. Tregidga '85
Susan B. Trowbridge '82
Paul Trummel '89
Lucile Tuttle-Smith '78
Edward Vadala '72
Diego Vainesman '91
Jan Van Der Ploeg '52
James Wageman '88
Jurek Wajdowicz '80
Robert Wakeman '85
Garth Walker '92
Tat S. Wan '91
Ewan Warmbath '93
Julian Waters '86
Janet Webb '91
Kurt Weidemann '66
Seth Joseph Weine '90
Alex White '93
Sue Wickenden '91
Gail Wiggin '90
Richard Wilde '93
James Williams '88
Conny J. Winter '85
Susan Young '93
Hal Zamboni* '47
Hermann Zapf** '52
Roy Zucca '69

SUSTAINING MEMBERS

Adobe Systems, Inc. '90
Boro Typographers '89
Characters Typographic
 Services, Inc. '85
International Typeface
 Corporation '80
Letraset '91
Linotype-Hell Company '63
Monotype Typography, Inc. '91
PDR/Royal Inc. '76
Photo-Lettering, Inc. '75
Sprintout Corporation '88
The Temporary Service '92
Toyota Motor Sales '92
Typographic Images '86
TypoVision Plus '80
Visionary Concepts, Limited '92

* Charter member
** Honorary member
s Student member
a Associate member

Membership as of May 31, 1993

Index

Colophon

Text and captions for Typography 14 are set in ten- and
eight-point Bluetree Text, a typeface designed in 1993
by Mark van Bronkhorst and named for Kanna Aoki, artist,
partner, and wife. Translated from Japanese, one possible
meaning of the Aoki family name is "blue tree."

Bluetree Text

ABCDEFGHIJKLMNOPQRSTUVWXY&Z

ABCDEFGHIJKLMNOPQRSTUVWXY&Z

abcdefghijklmnopqrstuvwxyz

1234567890!?